LOST
MISHAWAKA

LOST
MISHAWAKA

PETER J. DE KEVER

Published by The History Press
Charleston, SC
www.historypress.com

Copyright © 2024 by Peter J. De Kever
All rights reserved

First published 2024

Manufactured in the United States

ISBN 9781467157919

Library of Congress Control Number: 2024941834

Notice: The information in this book is true and complete to the best of our knowledge. It is offered without guarantee on the part of the author or The History Press. The author and The History Press disclaim all liability in connection with the use of this book.

All rights reserved. No part of this book may be reproduced or transmitted in any form whatsoever without prior written permission from the publisher except in the case of brief quotations embodied in critical articles and reviews.

In memory of my dad, Joe DeKever

CONTENTS

Part I. Downtown
1. Indiana City ..11
2. Mishawaka High School's Sesquicentennial Era Begins15
3. Remembering the Great Mishawaka Fire 150 Years Later20
4. Carnival Week of 1901: "The Greatest Experience Mishawaka
 Has Ever Enjoyed" ...35
5. This Mishawaka Picture Is Worth a Thousand Words59
6. Center Point Tower: The Mishawaka Landmark That
 Never Was ...63

Part II. Businesses
1. Kuss House Evokes Memories of Frederick Kuss and
 Kuss Bakery ...85
2. In Search of Mishawaka's Interurban Streetcar Lines88
3. Achille Ally 1923 ..94
4. "For Your Dining Pleasure": Garrett's White Spot Restaurant...........97
5. Ghost Signs: In Search of Mishawaka's Historic Painted
 Advertisements ...101
6. "The Most Beautiful Way of Life": Mishawaka Artist
 Melvin Johnson ..113

Part III. Industries
1. "For God's Greater Honor and Glory": Mishawaka's Famed
 Organ Builder Louis Van Dinter ... 127
2. When Mishawaka Was the "Power City": The Story of the
 Twin Branch Dam and Power Plant... 141
3. From the Rubber Re to Central Park .. 164
4. "Shorty": Dodge Manufacturing's Advertising Icon 176
5. The Kamm's Special: Mishawaka's Entry in the 1938
 Indianapolis 500 ... 183

About the Author.. 191

PART I
DOWNTOWN

Chapter 1

INDIANA CITY

After Alanson Hurd, the "Father of Mishawaka," established the village of St. Joseph Iron Works in 1833, other developers saw the area's potential and began laying out adjacent towns and additions. In 1835, William Barbee and Henry Harman planned Barbee Town east of Union Street, and George Fowler established Fowler's Addition east of Division Street in 1836.

Joseph Battell and brothers James and Grove Lawrence purchased land on the north side of the river on April 28, 1836, and they platted Indiana City on June 28, 1836. Far bigger than Hurd's village, Indiana City stretched from Division on the east to Logan Street on the west and what is now the Canadian National tracks on the north to the river on the south. It covered one hundred blocks and included over 1,500 lots, a "College Green" and a "Court House Square." The plat map also anticipated a railroad, reserved land for waterpower and a planned millrace.

While Battell and the Lawrences may have visited Mishawaka to oversee their development, they did not reside there. Joseph Battell was born in Milford, Connecticut, in 1774 and became a prominent merchant. He also developed an interest in exploring western lands. Battell died in 1841 in Norfolk, Connecticut, where he is buried. Norfolk was also the birthplace of James (1790) and Grove (1795) Lawrence. When they were children, their family moved to Onondaga County, New York. James and Grove became prominent attorneys and shared a legal practice in Camillus before moving to nearby Syracuse. James served in the state assembly, was elected a county judge and later was appointed U.S. attorney for the District of

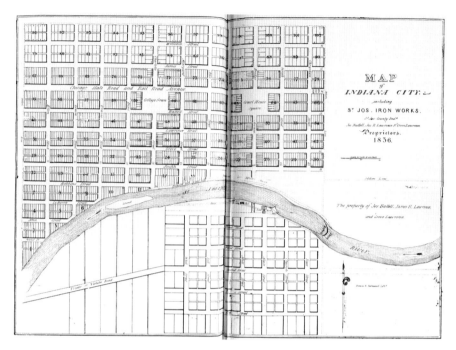

The ambitious plan for Indiana City is shown in this 1836 map. *Mishawaka-Penn-Harris Public Library.*

Northern New York. Grove was appointed first judge of the county court, served as a brigadier general of the local militia and amassed a large fortune. Both men died in Syracuse (Grove in 1866 and James in 1874) and are buried there. In 1852, the Battell family acquired the Lawrences' investments in Mishawaka.

Indiana City existed as a separate entity for only a year and a half. On February 17, 1838, the state legislature consolidated St. Joseph Iron Works, Indiana City and the other nearby towns and additions into one "Mishawaka."

Even though Indiana City disappeared from the map, its basic grid is now the familiar tree-lined streets of the near north side. Included within its boundaries are Battell Park (a gift to the city from the Battell family), Central Park, the beautiful homes of the Oaks and several churches. The Indiana City neighborhood is also appealing because the streets run east–west or north–south, which means the curving lanes and cul-de-sacs of modern subdivisions are nowhere to be found. If it were an independent municipality today, Indiana City would be one of the nicest towns anywhere.

Another notable feature of the Indiana City neighborhood today is that many of its street names are the same ones that Battell and the Lawrences included in the plan for their municipality. These streets are named for members of their families.

Except for Bridge Street (today's Main Street), the 1836 map of Indiana City included north–south streets that were all named for females in the Battell and Lawrence families. Starting at the east end of the settlement, the original streets were Christyann, Sarah, Bridge, Elizabeth, Ann, Margaret, Charlotte, Irene, Urania, Louisa and Ellen. Margaret is now Liberty Drive, Irene has become Forest Avenue and Urania, Louisa and Ellen roughly correspond to Benton, Clay and Webster Streets.

Basic genealogies available on Find a Grave suggest which family members were remembered by these street names. Christyann Street was likely named for James's wife, Christy McLaren Lawrence, who had just died in 1835. Sarah Street could honor Joseph Battell's mother or wife. Elizabeth Street may be named for James's daughter Eliza or Grove's daughter Charlotte Elizabeth. Ann Street could be named for Joseph's sister, and Margaret Street is for James's daughter. Charlotte Street honors either Joseph's sister or Grove's daughter. Irene Street could be named for Joseph's daughter or James's daughter. Urania Street honors Joseph's daughter or sister, and Ellen Street is named for Joseph's daughter. No Louisa was found on Find a Grave.

The east–west streets bear male family members' names, with the exception of Chicago State Road and Rail Road Avenue, where Broadway is today. William Street, named for Joseph Battell's father, and James Street, honoring James Lawrence or his son, are the northernmost streets, and they correspond to the railroad tracks and Marion Street today. Battell Street and Lawrence Street were next and bear the developers' surnames. Grove Street could be named for Grove or for James and Grove's father. Joseph Street (today Mishawaka Avenue) may honor Joseph Battell or his son. South of Joseph Street were Robbins Street, named for Joseph's son; LeBaron Street, bearing a surname and middle name found in Sarah Battell's family; and John Street, named for Joseph's son.

Today's Wilson Boulevard, the attractive tree-lined street along the Riverwalk, had no equivalent in the Indiana City plan. The homes on Wilson and the "senatorial" streets of Benton, Clay, Webster and Calhoun were developed in the early twentieth century, much later than the homes on Charlotte and streets to the east. In fact, an 1890 aerial illustration of Mishawaka shows Joseph Street passing through thick woods on the way to South Bend and Charlotte as the last north–south street.

Subdivision developers today often choose street names that are contrived, artificial and unconnected to the place and its history. Such is not the case in the Indiana City neighborhood, where street names have meaning and a real person is behind each name.

After Indiana City became part of Mishawaka, its former name faded into history, replaced by "the Oaks," which applies to the streets west of North Main, or the generic descriptor "the north side." On Mishawaka's far east side, though, the name Twin Branch has endured for over a century to refer to that geographically distinct area. Almost 190 years after Battell and the Lawrences envisioned Indiana City, it is time to resurrect this lost name from the past and use it once again to identify one of Mishawaka's most treasured and historic neighborhoods.

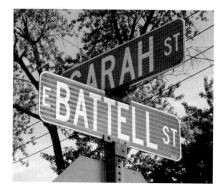

This north side intersection honors the memory of Joseph Battell's wife or mother. *Author's collection.*

Chapter 2

MISHAWAKA HIGH SCHOOL'S SESQUICENTENNIAL ERA BEGINS

There was no cake, champagne toast or party, but a venerable and beloved Mishawaka institution celebrated a milestone anniversary on December 13, 2019. Mishawaka High School quietly turned 150 years old.

It seems like there has always been a Mishawaka High School, so it is difficult to imagine a time when the school did not exist. A predecessor, the Mishawaka Academic and Normal Institute, was built in 1845 at the south end of Main Street, between Fourth Street and what later was the route of the Michigan Southern & Northern Indiana Railroad. Topped by a cupola, the redbrick, two-story schoolhouse had three first-floor classrooms and, on the second floor, a large classroom and two recitation rooms. Pioneer resident George Merrifield, himself a teacher off and on for twenty years, proudly proclaimed, "It was at the time the best school-house in Northern Indiana." The Mishawaka Institute was mainly an elementary school with some advanced classes offered for older students. It served the south side of the river, and another school, first the "Little Red Brick School" and later the North Side School, educated children north of the river. Among the distinguished alumni of the Mishawaka Institute was Rose Hartwick Thorpe, who would pen the world-famous poem "Curfew Must Not Ring Tonight" in 1867.

By 1868, this attractive landmark had deteriorated to the point of being unsafe, and the Mishawaka Institute was demolished, making way for the extension of South Main Street over the railroad tracks. Until a

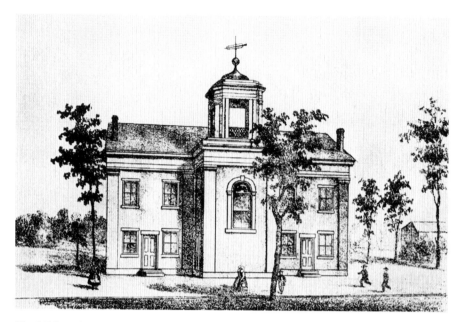

The Mishawaka Academic and Normal Institute opened in 1845 at the intersection of Main and Fourth Streets. *Mishawaka Historical Museum.*

replacement school was ready, students mostly attended classes in "the Corncrib," a commercial building located at the northwest corner of Main and Fourth Streets.

This arrangement was only temporary while a new school, much larger than the old Mishawaka Institute, was being built at the southwest corner of North Hill and West First Streets. The three-story building was designed with a capacity of over three hundred students. Elementary students were in four classrooms on the first floor, and high school students used three classrooms on the second floor, which also held the superintendent's office. The third floor was initially unfinished but became a large lecture room or auditorium with a stage and lighting, suitable for public performances. It was later named Whitson Hall in honor of Joseph H. Whitson, the businessman and town trustee who oversaw the school's construction. In the basement were the furnace room and a residence for the janitor and his family. Above the east entrance, a tower held the school bell.

The new building, which opened for learning on Monday, December 13, 1869, was originally called the Union School. This name was used because that school year, for the first time, schools on the north and south sides of the river were unified under one superintendent, Elisha Sumption.

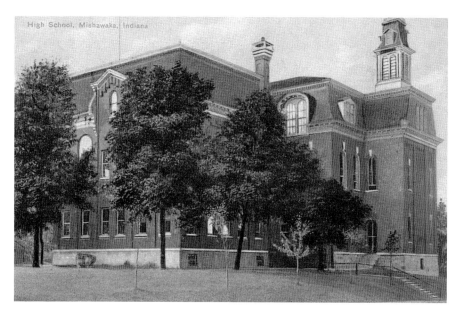

The first Mishawaka High School building, shown circa 1905, stood at the southwest corner of Hill and First Streets. *Mishawaka Historical Museum.*

The *National Union*, a South Bend newspaper, reported in its December 18 edition that the school had opened a few days earlier, despite having just three rooms ready for use. The paper noted that five rooms would be used that winter. The *National Union* reflected the community's proud glow over its new school:

> *The building is unsurpassed by any of the kind in the State. The wainscoting and every thing about it is* par excellence, *and too much praise cannot be lavished on the superior management of our worthy trustee,* J.H. Whitson, *whose talent and wisdom enabled him to conduct the work from its inception till now…The county may well consider this edifice one of its ornaments. We of Mishawaka are proud of it.*

A *Mishawaka Enterprise* article from September 1872 refers to A.S. Zook as the high school's principal. After he left to become superintendent of Elkhart County schools in June 1873, David Zook took his place. Thirty-two students were enrolled at the high school in the fall of 1873.

Mishawaka organized its first school board in 1873. The next year, E.L. Hallock took over as superintendent and principal of the high school

and reorganized Mishawaka schools into the following departments: first primary, second primary, intermediate, grammar and high school.

A reference to "the Union School Building" appears in a May 1874 *Enterprise* article, but eventually, the name Union School was dropped, and the building at Hill and First was known simply as "the High School." It remains unclear when exactly the name Mishawaka High School was formally attached to the building.

The high school graduated its first class in 1878. Belle Milburn and Allie Van den Bosch became the first of thousands of proud Mishawaka High School alumni.

As Mishawaka's population doubled between 1900 and 1910, the original high school building became inadequate for the community's needs. A four-room addition was put on in 1904, but it was soon outgrown, and in 1910, a new school was built immediately to the south at 402 West Second Street. It featured much-needed classroom space, an auditorium on the third floor and in the basement, a gymnasium, industrial arts areas and domestic science labs. The adjacent building became Main School and was used for younger students.

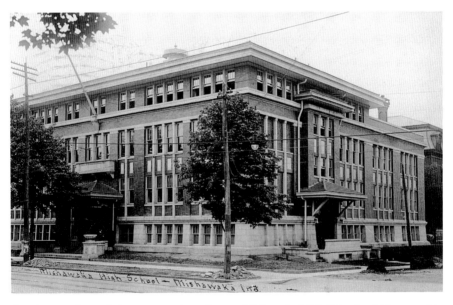

Growing enrollment led to construction of a new Mishawaka High School, which opened in 1910. Part of the 1869 building is visible at right. *Mishawaka Historical Museum.*

Continued enrollment growth soon necessitated the construction of yet another high school building a mile east of downtown. The new MHS welcomed students in the fall of 1924.

The 1910 building then became Main Junior High, and the original 1869 edifice was demolished in August and September 1928. Its site became a playground and parking lot for the junior high, which operated until 1973. Mishawaka Furniture Company then bought the building; its retail business continued there until 2010. The historic structure was renovated and became Mishawaka Main Junior High Apartments in 2013.

Though the name and location of Mishawaka High School have changed over the years, an unbroken lineage stretches from December 1869 to the present. Prior to the 150th anniversary of Mishawaka High School's first graduating class in 2028, the community will have many occasions to reflect on what the school has meant to the people whose lives it has shaped. Enduring through all the vicissitudes of the past century and a half is a remarkable achievement, deserving years of celebration.

Chapter 3

REMEMBERING THE GREAT MISHAWAKA FIRE 150 YEARS LATER

It happened in just about every city and town in the nineteenth century: fire, often horrible conflagrations that devoured large portions of downtowns. The Great Chicago Fire of 1871 was the most infamous and destructive of these urban blazes, but even Mishawaka was not immune. The Great Mishawaka Fire of September 5, 1872, was the most terrifying disaster in the city's history, and it forever changed the central business district.

Perfect conditions made a great fire in Mishawaka almost inevitable: wood-frame buildings, combustible material such as hay, open flames used for light and cooking and inadequate firefighting capability. The massive fire that broke out at 7:45 p.m. was also fueled by hot, dry conditions and strong winds. On the west half of the south side of the 100 block of West Second Street stood the Presbyterian church. Behind it was the parsonage's barn and, to the south, a barn owned by S.H. Stevens (or Stephens). The blaze likely began in the Stevens barn and was spread by high winds to the parsonage's barn and then to the church, a frame building. The parsonage, though, was undamaged.

Flames next leaped a north–south alley and devoured the east half of the block as residents sought in vain to douse the fire with the town's hand-pump engine. "The hand engine was doing its best but seemed to have no effect on the advancing flames," the *Mishawaka Enterprise* later reported.

Telegrams to Elkhart, South Bend and Goshen requested assistance from their fire engines in hopes of limiting the spread of the blaze. The South Bend pump arrived at 9:30 p.m., and the Elkhart engine came an

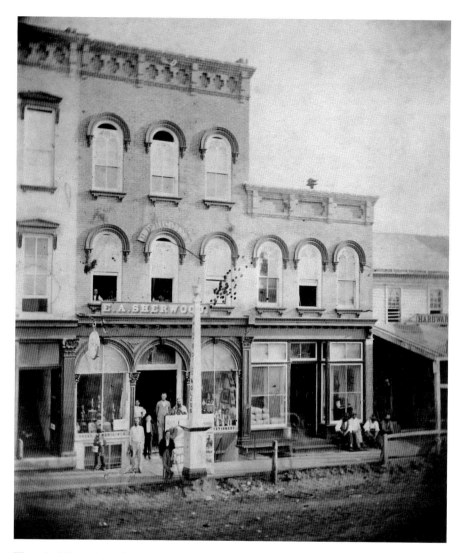

These buildings along the south side of the 100 block of West Second Street were destroyed in the Great Mishawaka Fire of 1872. *Mishawaka-Penn-Harris Public Library.*

hour and a half later. Goshen's hook and ladder company was delayed until it was too late to help, then was telegrammed to return and never arrived in Mishawaka.

Six buildings along the south side of West Second were soon ablaze: Holcomb's grocery, Burt's meat market, Keiner & Keisler's hardware store, Judkins & Son's grocery, Smith & Sherwood's drugstore and Bucheit & Baldwin's dry goods store. On the third floor of the Smith & Sherwood

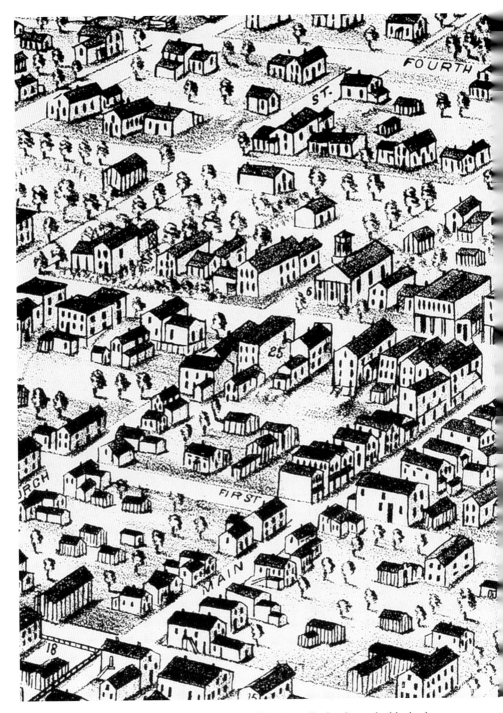

This 1871 aerial illustration of Mishawaka's central business district shows the blocks that would be devastated by the Great Mishawaka Fire. *Mishawaka Historical Museum.*

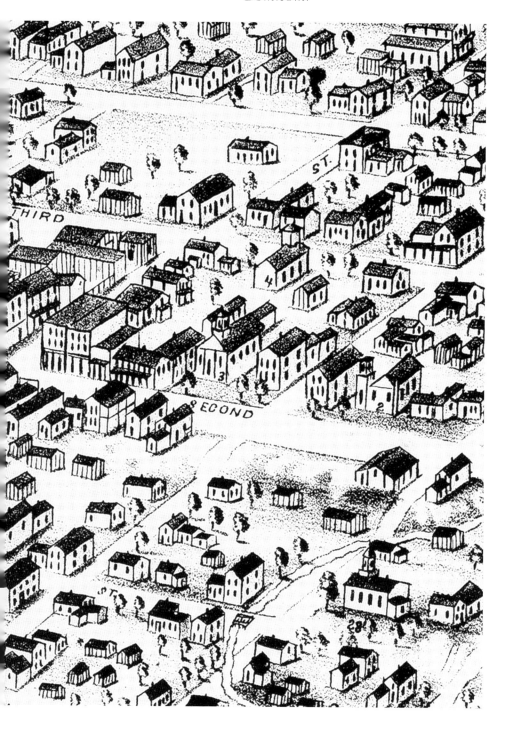

building was the Odd Fellows Hall, and the Masonic Temple occupied the third floor of Bucheit & Baldwin's building. Only the last three of these were brick structures.

One building after another ignited, filling the sky with acrid smoke and an orange-red glow. Wind-whipped sparks made the flames jump to the north side of West Second while the blaze spread to the six buildings—only one of which was brick—along the west side of South Main Street. They included Ward's grocery, Aitken's tailor shop, Mish's clothing store, Skerrit's grocery and express office, Wing's former building and Cowles and Dr. Butterworth's building.

On the west half of the north side of West Second, only H.E. Hurlbut's house and barn were destroyed, but the east half of the block soon became an inferno. The conflagration consumed fifteen buildings along West Second, North Main and West First Streets: Auer's building, Feiten's furniture store, Brown's harness shop, Sawyer's barbershop, a boot and shoe store, a milliner's shop, Kline & Sons hat and shoe store, Mutschler's meat market, Byrket's saloon, Vinson's bakery, Schindler's boardinghouse, Stecher's meat market, Sherman's saloon, Mrs. Armstrong's house and Butler's livery stable. All were frame structures.

The relentless fire then spread across North Main to the west half of the northeast block. According to the *Enterprise*'s account, it was around this time that the engines from South Bend and Elkhart finally arrived. Seven buildings along East Second were ablaze: Beiger's dry goods store, Dixon Bros.' dry goods store and residence, Tascher & Tharp's saloon, Godman & Herzog's shoe store, Hay & Herzog's tailor shop, Booth's furniture store and, across the alley, Byrket & Curtis's bakery. Destroyed along North Main were Wells's grocery, the town hall and engine house, Dr. Clark's house, Zimmerman's tailor shop and residence, Summit's saloon and house and Eller's shoe store and residence. The fire also destroyed Dr. Clark's barn and another barn, both along the alley. The east half of the block was much less damaged. In addition to the bakery, houses belonging to W.H. Hoover and R.H. Fountain were the only other casualties. Of the seventeen buildings lost on the northeast block, only Godman & Herzog's was brick.

As these blocks burned, brave citizens tried extinguishing the blaze, business owners threw goods into the street to avoid losing them in the flames, wagon drivers carted the items to safety or purloined them and others just gawked as Mishawaka burned. "The streets were crowded with people from South Bend, Elkhart and the surrounding country; teams were driving frantically

in all directions, carting away goods; and all was in uproarious confusion," described the *Enterprise*.

In *A Mishawaka Mosaic*, David Eisen describes the chaotic scene:

> *Goods sometimes had to be moved from one place of safety to yet another as the flames advanced. Horses with loaded wagons rushed through the crowded, smoky streets. In the confusion, young rowdies got gloriously drunk on liquor removed from downtown saloons. Thieves stole the lobby furniture from the Milburn Hotel and rifled guests' rooms.*

Historian Vincent Brunner, then a ten-year-old boy watching the fire from the safety of the north bank of the river, wrote decades later, "Throughout the business section things were topsy-turvy; even the next day or two, barrels of sugar, molasses, salt, etc. were lying out on the streets. Much looting took place that night by various individuals; and drunks were by the score."

After the smoke cleared, crowds came to view the devastation. All were stunned to see that forty-nine buildings had been lost. Eighty-two businesses and individuals reported property losses of $140,000, but only $60,000 was covered by insurance. Thirty-one commercial-only buildings were destroyed, and several of these also had business tenants on the second floor. Of the other structures lost, four included both a business and a residence, five were houses only, one was a boardinghouse and six were barns or stables. Also burned were the Presbyterian church and the town hall.

Only five of the forty-nine buildings destroyed were made of brick; the others were frame.

"When the fire was at last conquered," remembered Brunner, "nothing remained in the three principal city blocks, only smoking ruins and streets littered with most everything imaginable, and naturally, it was enough to discourage the stoutest heart."

The fire and ensuing chaos were terrifying, both the immediate danger of the flames and the uncertainty about just how far the blaze would spread. Residents feared for the surrounding residential blocks, several other churches and the commercial and manufacturing enterprises near the river.

As bad as it was, the Great Mishawaka Fire could have been much worse. Mishawaka's blaze pales in comparison to the Great Chicago Fire of October 8–10, 1871, which resulted in three hundred deaths and destroyed 17,500 buildings in an area covering 3.3 square miles. Remarkably, Mishawaka experienced neither loss of life nor any serious injuries, and the factories along the south race—the town's livelihood—were untouched. Likewise,

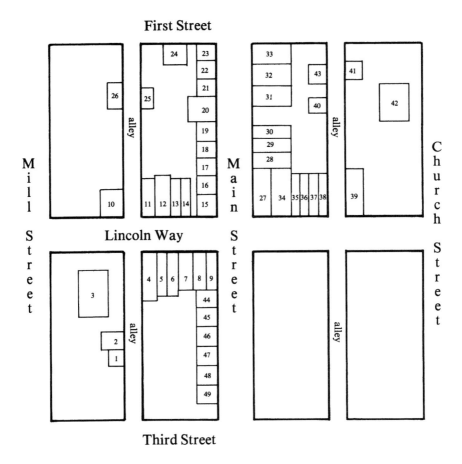

This diagram identifies the forty-nine buildings lost in the fire of September 5, 1872. *Mishawaka-Penn-Harris Public Library.*

nearly all Mishawaka's houses, all but one of its churches and the three-story Union School at Hill and First Streets were untouched. The southeast block of the central business district, including the Milburn Hotel, was also spared.

Charred ruins were what remained of parts—but not all—of the other blocks. The fire had destroyed the Stevens barn, the Presbyterian parsonage's stable and the church, but those were the only structures lost on the west half of the southwest block. The blaze then moved north and east—away from St. Joseph Church, one block southwest—and destroyed all the buildings along the west side of the one hundred blocks of both North and South Main and the east half of the north and south sides of the one hundred block of West Second. Only two buildings were lost on the west half of the

north side of the one hundred block of West Second, and other structures on North and South Mill Street and West Third survived. After the fire crossed North Main, it devastated the west half of the northeast block, structures facing North Main and East Second, but only three buildings were lost east of the alley bisecting the block. An 1871 aerial illustration of Mishawaka shows that other buildings occupied parts of these blocks, and they were not destroyed in the fire.

Among the buildings spared from the conflagration was the post office, located on East Second just past Byrket & Curtis's bakery; though, the *Enterprise* reported, "The signs took fire and the stairway and door were baked to a beautiful brown." The paper credited the two steamers from South Bend and Elkhart with saving the building and checking the flames' eastward advance. Above the post office was the *Enterprise*'s office. It, too, avoided direct damage from the flames, but "officious meddlers" destroyed files, ruined type and threw a printing press down the stairs and other equipment out the window.

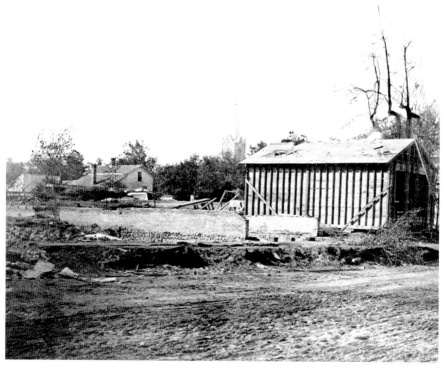

In this photo, looking southwest from Main and Second after the fire, a temporary structure erected by S.H. Judkins & Son is visible. In the background are the S.H. Stevens house and the St. Joseph Church's steeple. *Mishawaka-Penn-Harris Public Library.*

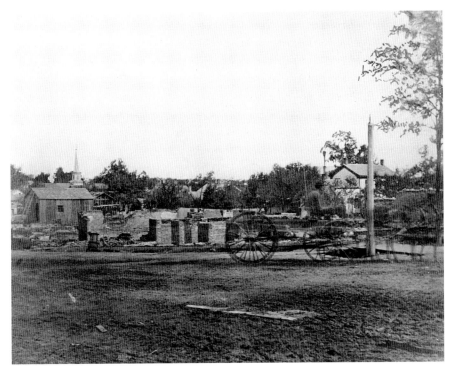

Looking northeast from Main and Second after the fire, remnants of burned buildings are evident in the foreground. The Lutheran church's steeple is in the background at left. *Mishawaka-Penn-Harris Public Library.*

The owner, Edward Jernegan, had just purchased the newspaper on the day of the fire and had not yet been able to buy insurance. Assisted by a printer in South Bend, the *Enterprise* published an issue two days after the fire. With sad irony, Jernegan explained to readers, "Many of the advertisements it will be noticed are of firms whose entire business was swept away Thursday night and are sadly out of place; but this is unavoidable." The *Enterprise* became a valuable source for details about the extent of the devastation and initial efforts to rebuild.

Speculation about the fire's cause began immediately after the blaze was extinguished. The *Enterprise* asserted that the fire "was evidently the work of an incendiary, for the rapidity with which the whole upper portion of the building [presumably the stable where the fire started] was consumed indicated clearly the presence of some inflammable substance." As further evidence for arson, the paper noted that this was the third time since July 1 that someone had attempted to start a fire downtown. Rev. J.D. McCord,

pastor of the Presbyterian church, believed the church was targeted by someone who objected to his preaching against alcohol. Others blamed the fire on a tramp seeking revenge for some wrongdoing or an insurance agent eager to sell fire insurance policies.

The Great Mishawaka Fire of 1872 was far from a mortal wound for the town. Instead, encouraged by the optimism and energy of Ed Jernegan's reporting in the *Enterprise*, Mishawaka quickly rebuilt. In Jernegan's September 7 edition, he wrote,

> *Some forty-nine buildings, including the best part of the business portion of our beautiful town, were smoldering ruins—the work of many years swept down in a few short hours. It is very sad and will prove a severe blow to Mishawaka's prosperity. But we are satisfied it will be but a temporary misfortune. The businessmen generally are plucky and will rebuild as fast as possible, probably a better class of buildings altogether than those burned.*

This hopeful spirit was already in evidence the morning after the fire. Byrket & Curtis's bakery posted a sign on its charred ruins that read, "Will resume business immediately. —*Removed on account of the intense heat!*" Joseph Burt's meat market, which had stood in the middle of the south side of West Second, was destroyed but reopened in a tent on the Presbyterian church's lawn.

Brunner remembered the alacrity with which rebuilding began:

> *The merchants of those days, instead of folding their hands and bemoaning their fate, were imbued with the spirit of progressiveness. They hardly waited for the ashes to cool before they began to clear them away and make room for new buildings. They soon recovered from the terrible effects of the conflagration, and within three days, some were doing business in frame buildings hastily constructed, while others were doing business in tents…. The town in general looked like a new mining town in the business district as so many temporary frame structures sprang up over night.*

On September 7, strong winds stirred up some hot sparks, and the town fire engine was called to douse them before further damage could occur.

Five days after the fire, the town board passed an ordinance that prohibited construction of wooden buildings in the downtown, except for temporary structures. The restriction applied to buildings in the commercial area bounded by Church, First, Third and Mill Streets. Tascher & Tharp's saloon on East Second was the first building to rebuild and reopen.

The *Enterprise* explained that hammers and saws were being heard throughout the downtown amid the ashes and debris from the fire. Merchants published ads requesting that customers pay up their accounts so the businesses would have funds to cover expenses and rebuild. For example, grocer George Wells's notice stated, "All persons knowing themselves indebted to me are earnestly requested to call and settle their accounts immediately. Being burned out in the late fire I am in need of money to enable me to pay my debts." Other businesses advertised their new locations, such as S.H. Simkins, who began his notice by saying, "Burned out but not annihilated." Simkins informed customers that he had moved his stock of boots into a second-floor room in a building on Main Street. Godman & Herzog's shoe store combined a humorous play on words and awareness of the town's losses in this clever ad: "Thursday night was one of those 'times that try men's souls.' If any of our readers had theirs tried too severely we advise them to rush to Godman and Herzog and get a new pair of boots or shoes with soles warranted to stand grief." S.A. Ellis published a small ad thanking several citizens for saving his house on the night of the fire.

A flock of sixteen insurance adjusters took up residence at the Milburn Hotel. Ed Jernegan criticized brick suppliers who greedily raised the price of bricks by one dollar per one thousand.

"On a number of occasions, the Chicago merchants refused to extend credit," explains David Eisen. "All this after Mishawaka sent a great deal of food and supplies to Chicago after the Chicago fire." Instead, Mishawaka merchants took their business to Cleveland.

An apple tree behind the post office was damaged in the fire, according to Eisen. Two weeks later, it developed new leaves and blossoms, a hopeful symbol of the rebirth already underway.

Jernegan looked favorably on the many temporary buildings that had been erected soon after the fire, but he also offered a cautionary note: "Though they are now proud monuments of the vim and enterprise of our citizens, they will eventually become a reproach if allowed to stand too long." The *Enterprise* editor's faith in Mishawaka's future was unwavering: "We predict that within a very few years Mishawaka will have more than recovered from her great disaster and be one of the handsomest cities in the State."

The Presbyterian church, which had been the first major structure destroyed in the conflagration, was also quick to rebuild. On September 14, the *Enterprise* reported that the church had started a subscription drive for a new building, and even merchants who had lost everything were giving with

generosity. Meanwhile, services were held in the Christian Church, half a block to the west. In the next issue, Reverend McCord stated, "The members have unanimously agreed to rebuild in brick upon the old foundation." He then implored the congregation,

> *Now, good Friends,* to the work! *If any would help us who have not the money, give us a day's work, or a week's work; help us with* your team, *with your spade or trowel, or help with words of good cheer and with your prayers. We must have money, too, so help us with your money.*

The pastor's exhortations were successful. Work on the new brick church had already begun by September 28, and the first Sunday service was held there on January 5, 1873. To raise funds, Reverend McCord sold 303 pounds of iron from the melted church bell at nineteen cents per pound.

The First Presbyterian Church's records include a reference to A.M. Wing, whose building and dry goods store had been destroyed in the fire. Despite his own considerable losses, Wing donated to the church's rebuilding and "would give away as a Christmas present to the poor of Mishawaka twenty-five pairs of boots and shoes."

Within a year, twenty-nine brick structures had been built in the downtown, including the aptly named three-story Phoenix Building, which still stands at the southwest corner of Lincolnway West and South Main, just feet from where the devastating fire began. The Phoenix originally stretched from Main to the alley, but the upper stories of the west half of the edifice, which included Burt's Opera House, were demolished in 1937. Several businesses and the Odd Fellows Hall that were in that space before the fire became tenants in the new building. Another of the post-fire buildings that survives is the home of Doc Pierce's Restaurant at 118–120 North Main. The year 1873 can be seen on the parapeted cornice atop the building, a reminder of its origins. Another relic of the fire's aftermath can be seen at 114 Lincolnway East. In the alley alongside the building is a small cornerstone that reads simply, "B&C 1872." B&C stands for Byrket & Curtis, the bakery that quickly made good on its vow to reopen after the fire.

Rebuilding from the fire affected other nearby projects. In March 1873, construction began on St. Joseph parish's rectory, located at the northeast corner of Spring and Fourth Streets. Although this block was undamaged in the fire, labor and materials were at a premium because much of the nearby central business district was being rebuilt at the same time Father August Oechtering was carrying out this construction project. In *A Century of Catholic*

Faith in Mishawaka, Reverend Monsignor Kurt A. Suelzer notes that the cost of the rectory ran $1,600 over the contract price. Day laborers had to be paid $2–2.50 per day and even then were sometimes difficult to find. The former rectory, now the St. Joseph parish office, still stands and is one of the most significant nineteenth-century buildings in Mishawaka.

On the first anniversary of the Great Mishawaka Fire, the *Enterprise* wrote,

> *The terrible fire which so nearly obliterated our beautiful town one year ago…while it at the time seemed an appalling infliction, has in reality proved a blessing to the town.…Here we are on the anniversary of the conflagration with the business district almost entirely covered with a class of buildings that find no equal in any town of its size in the U.S.*

After the fire, numerous manufacturers installed private waterworks or pumps to safeguard their buildings against another catastrophic blaze. In the spring of 1874, a water main was laid from the factories to the central business district, and a demonstration of the new waterworks blasted streams of water into the sky. Spectators cheered, a bonfire was lit and a band added to the celebratory atmosphere. The *Enterprise* proudly proclaimed, "We have the best water works (for the money) in the country."

Just as Mishawaka was recovering from the disastrous fire, the town endured another terrible blow. Milburn Wagon Company had been a major supplier of wagons to the federal government during both the Utah conflict of 1857–58 and the Civil War. When Mishawaka officials refused to build a spur line connecting the Milburn factory, located at Spring and Water Streets, to the railroad, George Milburn decided to move his business to Toledo, and production in Mishawaka ceased in late 1874.

Losing the Milburn Wagon Company was not the end of Mishawaka, as some had feared. In the spring of 1875, the *Enterprise* reported, "The removal of the Works has been so gradual that it has hardly been felt, and the actual depression which Mishawaka feels in their loss is nothing to what was predicted or expected."

The growth of several other manufacturers in the 1870s helped cushion the blow of Milburn's departure and ensured that Mishawaka would remain a major center of industry. They included Mishawaka Woolen Company, Dodge Manufacturing Company, Perkins Wind Mill & Ax Company and Dick & Kamm Brewery (later Kamm & Schellinger Brewery). Neither the loss of a major manufacturer nor the destruction caused by the fire would permanently disrupt the town's growth and prosperity.

Now, 150 years later, the four blocks that were destroyed or threatened on September 5, 1872, have no structures that survived the Great Mishawaka Fire. While each block—especially the southeast block—had buildings that were not destroyed in the blaze, those structures were eventually taken down by other means.

The closest building that witnessed the fire and still stands is the Deming-Towle House, originally located at the southeast corner of Church and Second. The home was built by John and Emily Deming around 1835. Their daughter Mary Ann's 1852 wedding to Charles Crocker (later one of the Big Four who built the Central Pacific Railroad) was held there. Gilman Towle purchased the home in 1856. On the evening of September 5, 1872, the closest the flames got to the Deming-Towle House was the Byrket & Curtis bakery, about two hundred feet away. The Deming-Towle House was moved from this site in 1944, and a two-story section of the building is now a private residence at 830 East Third.

An extraordinary artifact that survived the Great Mishawaka Fire is now in the collection of the Mishawaka Historical Museum. The Milburn Hotel, which stood at the southeast corner of South Main and East Second, was not damaged by the blaze and stood for another fifty years. As was the practice in hotels at the time, the Milburn Hotel kept large bound register books in which guests would sign their name and where they were from. The museum has the Milburn Hotel's register that lists guests from November 1870 until April 1872. While the hotel would have begun a new register book after that, the 1870–72 register likely was still in the building when the fire was raging just across the street.

One of the fire's longest-lasting legacies is that it was the genesis for the Schindler-Richard Insurance Agency. John J. Schindler managed a grocery and hotel at the time of the fire. As the town was rebuilding from the disaster, a representative from the Firemen's Fund Insurance Company convinced Schindler to open an insurance agency. Schindler's sons ran the agency after his death, and Regis Richard retained the historic Schindler name when he became sole owner in 1968. Until it was purchased and moved to South Bend in 2018, Schindler-Richard was the oldest insurance agency in northern Indiana and Mishawaka's second oldest business.

The Great Mishawaka Fire changed forever the appearance of downtown Mishawaka by destroying dozens of structures, including some that dated to the town's earliest years. The fire also resulted in the ordinance mandating that all permanent structures built in the downtown be made of masonry. The frame buildings that had contributed to the fire's swift spread were

thus outlawed. Today, every building on the four blocks surrounding the Main-Lincolnway intersection and the twelve blocks adjacent to them—the area bounded by Fourth, Race, Front and Spring Streets—is of masonry construction. Interestingly, though, the town board's 1872 anti-fire ordinance is now illegal, according to Bo Hundt, Mishawaka's building commissioner: "The State adopts the code for all jurisdictions in Indiana to follow, and this requirement would be in violation of that code. Once uniform building codes came into effect, all those ordinances became obsolete."

Despite all the buildings made of brick, limestone or concrete block, other destructive fires have occurred in downtown Mishawaka, even within the past fifty-five years: Christianson's Furniture (201–205 North Main) in 1969, Larimer Bros. Furniture (114–116 North Main) in 1974, WR's 1800 tavern (107 South Main) in 1984, the Covey Restaurant (101 Lincolnway West) in 1986, Paradise Book Store (207 North Main) and Wallace Sales & Service (209 North Main) in 1988 and the former's Smith's Downtown bar and restaurant (110 Lincolnway East) in 2022. The good news is that none of these blazes spread to other blocks or threatened the entire downtown. In short, there has not been a second Great Mishawaka Fire. Improved building materials, fire suppression technology like sprinkler systems and a highly trained, well-equipped municipal fire department make it unlikely that there ever will be.

Mishawaka commemorated the sesquicentennial of the Great Mishawaka Fire with a walking tour of the three blocks where the fire raged. The event was not an overly somber memorial. There was certainly remembrance of that night's terror and the losses suffered by downtown merchants and residents. However, this anniversary was more of a celebration filled with gratitude that no Mishawakans perished in the blaze and that the town also survived—even flourished—in the wake of its worst disaster.

Chapter 4

CARNIVAL WEEK OF 1901

"The Greatest Experience Mishawaka Has Ever Enjoyed"

Downtown Mishawaka has lots of activity these days. Construction of apartment buildings, ice skating at Ironworks Plaza, pedestrians on the Riverwalk and traffic on the Princess City Parkway are signs of a vibrant central business district. All this bustle and energy, though, pales in comparison to Mishawaka's street carnival of August 12–17, 1901.

A prelude to the thrills of carnival week came several weeks earlier. On July 4, Mishawaka threw what was at the time the biggest party in the city's history to celebrate the 125th anniversary of the United States' independence. The focus of the event, which was sponsored by the Business Men's Association, was a "magnificent industrial parade," according to the *South Bend Tribune*, that was witnessed by most of Mishawaka's six thousand inhabitants and approximately twenty thousand visitors from surrounding communities.

A sunrise salute of thirteen guns, a tribute to the original states, began the day at the Soldiers' Monument in Battell Park, and soon the streets of Mishawaka were filled with enormous crowds as trains and interurbans arrived, all at capacity.

"The city presented an attractive sight in bunting, flags, etc., business houses and private residences having been liberally and handsomely decorated," reported the *Tribune*. "The streets appeared busy with many refreshment stands, fakirs and numerous attractions."

Shortly after eleven o'clock began "the most magnificent pageant ever seen in northern Indiana," as the *Tribune* glowingly described the parade, featuring over fifty entries, including elaborately decorated floats, musical

groups, organizations and prominent individuals. At the front of the parade were the police chief, a squad of mounted police officers and the Queen of the Carnival, Miss Mae Swanger, in a flower-bedecked carriage pulled by two white horses. The queen's white gown enhanced her royal appearance.

Other parade entries included the LaPorte Band, common council members in carriages, the Male Chorus in carriages, four Woodmen of the World floats, the Grand Army of the Republic Drum Corps, the Goshen Band, the Rubber Makers' Union, five Dodge Manufacturing floats, Mishawaka Lumber Company's float, two Kamm & Schellinger Brewery floats, two Perkins Wind Mill Company floats, nine Mishawaka Woolen Manufacturing floats, Beatty Felting Company's float, the Ligonier Band and the Elkhart Martial Band.

Among the highlights of the "industrial parade" were Dodge Manufacturing's foundry float distributing hundreds of souvenir medals with the company name and date, Mishawaka Woolen's floats showing the nine-part process of making footwear and Kamm & Schellinger's depiction of a German beer garden.

The parade's line of march went from West Second Street between Center and Smith east to Laurel, south to Fourth, west to Main, north to Water, west to Bridge, north to Joseph, east to Locust, north to Grove, west to Margaret, south to Joseph, east to Bridge and south to Water. The mile-long parade took forty-five minutes to pass by.

"It was, without doubt, the finest parade Mishawaka ever saw and was worthy of all the unstinted praise showered upon it," beamed the *Mishawaka Enterprise*. "The manufacturers and business men who went to such great pains and expense to make it such a brilliant pageant, are deserving of heartfelt praise. The thousands of visitors who thronged the streets were more than satisfied."

The parade was the most spectacular of Mishawaka's Independence Day festivities, but it was not the only event. A twenty-five-mile bicycle road race took place before the parade. In the afternoon was a program of athletic events, including a hundred-yard dash, greased pole climbing, boys' and men's wheelbarrow races and a sack race. At three o'clock in the afternoon, several thousand people gathered at Battell Park to hear Charles W. Miller's thirty-minute "patriotic oration." Competitive drills were held on South Main near the Hotel Mishawaka at four o'clock. In the afternoon and evening, seven bands performed throughout the city. Dr. Phil Greene attempted a balloon ascension, witnessed by a crowd of several thousand, but the balloon burst less than three hundred feet into its flight, and Greene

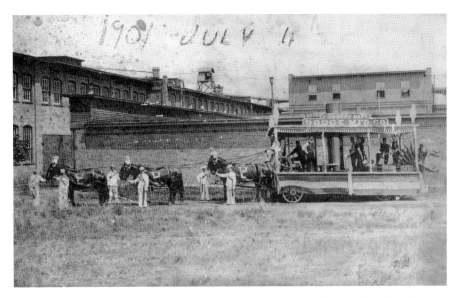

During the July 4, 1901 parade, Dodge Manufacturing's foundry float produced and distributed hundreds of commemorative medals. *Mishawaka-Penn-Harris Public Library.*

had to parachute to safety prematurely. In the evening, an hourlong fireworks display on South Main, near Sixth and Seventh Streets, thrilled spectators. Also decorating the downtown were a large American flag hanging on East Second Street between Main and Church, colored electric lamps on Second Street and an illuminated arch across Main at Second. Provided by the South Bend Fuel & Gas Company, the arch featured one hundred gas burners with white and flowered glass globes. Private residences throughout the city were festooned with Japanese lanterns and other decorations.

Mishawaka's Independence Day celebration was "glorious," according to the *Enterprise*. Temperatures approached one hundred degrees, but there was no rain. Although thousands roamed the streets of Mishawaka, the crowds were orderly, and thieves and pickpockets were almost nonexistent.

Stated the *Enterprise*,

> *Mishawaka has every reason to feel proud of the success that attended her efforts to cultivate the patriotism of her people and show what is being done in this section of the state in a business and commercial way. From start to finish the program was one grand success and nothing like it was ever attempted here before and it may be several years before a repetition will occur.*

Still basking in the excitement and pride of the Independence Day festivities, the Mishawaka Business Men's Association met at the Twentieth Century Club in the Phoenix Building on July 9. Joseph DeLorenzi, chairman of the finance committee, reported that money raised from the July 4 events had been enough to pay all expenses associated with the celebration, and everyone expressed satisfaction with their participation in the affair.

Later in the meeting, H.L. Leavitt, representing the Canton Carnival Company, spoke. His company, founded in 1899 in Canton, Ohio, was the first recorded traveling carnival in the United States. The *Tribune* noted, paraphrasing Leavitt, that the successful Fourth of July event "had advertised the city far and wide." Leavitt informed the gathering that his company had an open week beginning August 12, and he proposed to hold a six-day street carnival in Mishawaka. The Canton Carnival Company would bring twenty-two railcars and two hundred employees, including Professor Achille Philion, a famed aerial performer and brother of Mishawaka residents Joseph and George Philion. It would also include a circus, many standard carnival attractions and an electric fountain from the world's fair. Leavitt asserted that his carnival would attract thousands of people to Mishawaka. The presentation "made a very favorable impression," according to the *Tribune*, and the association voted to hold a special meeting the next evening to discuss and vote on the proposal.

Many Business Men's Association and Twentieth Century Club members and other interested citizens attended that meeting. Leavitt explained what the attractions would be and how the carnival would operate and be advertised. Discussion followed, including about whether funds could be raised to meet the "incidental expenses" the community would be responsible for. A member of the Twentieth Century Club then announced he was authorized to propose that the club and the association jointly proceed with the carnival. The gathering was excited by this information, and soon the motion was approved. Melville Mix, president of the Twentieth Century Club, and Frank Eberhart, president of the Business Men's Association, were directed to sign the contract with Leavitt and appoint members from each organization to form an executive committee to oversee the carnival plans.

The next day, Mix and Eberhart signed the contract for a "carnival and jubilee" starting on August 12, and fundraising began in earnest. "The attraction promises to be the greatest that has ever visited northern Indiana," the *Tribune* gushed. "The carnival if entered into with the spirit which characterized the recent Fourth of July celebration cannot help but

be a boon for the city and a success in every way. Thousands of people will visit the city daily."

In its first report on the "grand street carnival of mammoth proportions and unexcelled attractions," the *Enterprise* explained that the contract with the Canton Carnival Company required that the Business Men's Association and Twentieth Century Club provide water, light, electricity and a band for the carnival, at an estimated cost of $1,000 to $1,400. The company would then give the organizations a share of the profits. The club offered to contribute $300 toward expenses and to "share the risks and the profits" with the association. "It is a big undertaking," acknowledged the *Enterprise*, "but Mishawaka has shown by the successful manner in which the Fourth of July celebration was carried out that she is capable of doing such things right, and the carnival must be undertaken in the same spirit."

Organizers of the carnival worked swiftly to get plans underway. The day after Mix and Eberhart signed the contract, the executive committee met again to name its members and elect officers. They included president Melville Mix, first vice president Frank Eberhart, second vice president W.F. Miller, secretary J.A. Mitchell and treasurer D.A. Shaw. Representing the Business Men's Association were Eberhart, Vincent Brunner, J.A. McMichael, John Herzog and Joseph DeLorenzi. From the Twentieth Century Club were Mix, Shaw, Miller, A.G. Graham and Dr. F.H. Irwin. The club was chosen as the headquarters for the carnival committee. Executive committee members were also assigned to the following standing committees: press, finance, transportation, privileges and program. City Attorney A.G. Graham and Councilman William Hosford were directed to confer with the city council on privileges, or permits, for various attractions and vendors. William Tupper, Leroy Harvey, S.E. Gard and H.A. Waterman formed a committee to oversee decorations, light and water. The press committee was given responsibility for hanging advertising banners in nearby cities and towns.

On July 18, the executive committee met with W.H. Rice, the promoter for the carnival company, who would remain in Mishawaka until the event. Rice explained the company's plans and offered guidance on how best to organize the undertaking. The finance committee reported on its success with fundraising. The meeting also named members of a floral parade committee, a streets and privileges committee and an invitation committee, which would invite mayors, other municipal officials, fraternal organizations and members of the press in surrounding communities. The executive committee then made a preliminary outline for the week's events: Monday, August 12, grand opening and reception; Tuesday, Floral Day parade;

Wednesday, Elkhart and Goshen Day; Thursday, South Bend Day; Friday, LaPorte Day; and Saturday, Mishawaka and Old Settlers Day. The *Enterprise* added, "All the week will be Everybody's Day, with more fun to the square inch than the old town ever saw before."

At the carnival committee's July 22 meeting, the streets and privileges committee reported that it had secured the permission of almost all the property owners for the right-of-way needed to close South Main from Second to the Lake Shore Railroad tracks for the carnival's Midway. The committee was also empowered to grant licenses to attractions such as merry-go-rounds, a German village and vendors of rubber balls, balloons and similar merchandise. The music committee had been making contracts with bands from nearby cities to perform throughout carnival week. The transportation committee was negotiating with all the region's railroads for a rate of one fare for a round trip within one hundred miles. The committee also sought to have the Indiana Railway Company, the local streetcar line, transport passengers directly to Mishawaka from trains arriving in South Bend. Because water would be let out of the south millrace for scheduled maintenance during the carnival, committee members were concerned about whether there would be enough power for the municipal waterworks and electric department to meet the high demand resulting from thousands of visitors to the downtown. To solve this problem, Mishawaka Woolen offered to connect its million-gallon pump to the city's water mains, and Dodge Manufacturing pledged the use of its power plant to the electric department.

Two evenings later, the carnival committee met again. Among the items it addressed was approval of the purchase of five thousand small buttons and two thousand large buttons bearing the face of "Chief Mishawaka," the carnival's official logo. The small buttons would be given away for free, and the larger ones would be sold as souvenirs. At the suggestion of W.H. Rice, the committee also decided to eliminate all "objectionable features" from the carnival so "the affair in Mishawaka will be clean all the way through," the *Tribune* stated.

In its July 26 edition, the *Enterprise* reported the favorable results of recent carnivals put on by the Canton Carnival Company: "From papers detailing the appearance of the Carnival company in other cities, it would appear as if the entertainments given elsewhere have been remarkably popular and successful." From June 18 to 22, the company had been in Bloomington, Illinois, and brought seven to ten thousand out-of-town visitors in one day, part of the largest crowd ever gathered in the city's history. From July 15 to 20, the carnival was in Hannibal, Missouri, where twenty thousand people

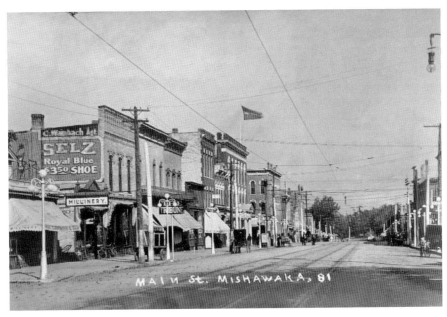

During the street carnival of 1901, the 100 block of South Main Street, shown in this circa 1910 postcard, was the location for part of the Midway. *Mishawaka Historical Museum.*

filled the streets that Friday night. "The local papers are loud in their praise of the jubilee," the *Enterprise* added.

The carnival committee's July 30 meeting brought several new developments. The theme for Tuesday, August 12, was changed to Interurban Day, which would appeal to communities along the Indiana Railway Company's twenty-six-mile route. The committee also planned its first "boom train," a special interurban that would travel to Elkhart and Goshen via the Indiana Railway on Wednesday, August 7, and advertise Mishawaka's upcoming carnival. The construction committee reported that it had purchased 16,000 feet of 1" × 6" × 16' lumber and 3,000 feet of 2 ×4 lumber, most of which would be used to construct an 8'-tall fence around the Midway. The committee was also tasked with hiring carpenters to build the massive enclosure.

At the August 2 carnival committee meeting, C.L. Burgess, a member of the transportation committee and an agent for the Lake Shore, reported that the railroad would offer a special round-trip rate for the carnival from as far west as Chesterton and as far east as Sturgis, Michigan, and Kendallville. H.M. White, another transportation committee member and an agent for the Grand Trunk, stated that his railroad would create

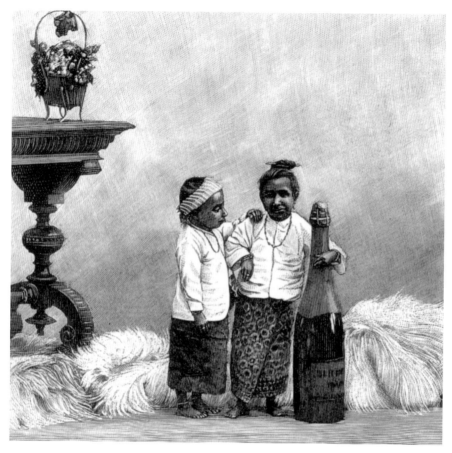

The diminutive Fatma and Smaun (seen here circa 1901) were one of the biggest attractions at Mishawaka's street carnival. *Author's collection.*

a round-trip fare for a radius of fifty miles, from Vicksburg, Michigan, on the east to Valparaiso on the west.

On August 7, construction of the Midway fence began, and the boom train traveled to Elkhart and Goshen. The Third Regiment Band and more than one hundred Mishawakans paid the special fifty-cent fare and participated in the festivities, which included a parade and fireworks in both cities.

The August 7 *Tribune* included a tantalizing paragraph about Professor Achille Philion's letter informing his brother George that Achille had arranged for Fatma and Smaun, two Burmese "midget" siblings, to appear in Mishawaka. Fatma and Smaun had been a sensation at the Paris Exposition of 1900. Fatma was twenty years old, twenty inches tall, and weighed twelve pounds. Her brother, age nineteen, was twenty-four inches tall and weighed

thirteen pounds. Philion had paid $4,000 and $2,500 for the rights to display Fatma and Smaun, respectively. The Mishawaka carnival's Midway would be the first place where Philion would have them on exhibit.

In its August 9 edition, the *Enterprise* previewed the carnival. A front-page article stated,

> On next Monday Mishawaka will be thrown wide open to the world for six days of solid amusement, in the form of a great Street Carnival and Jubilee. It is a big undertaking for a city the size of Mishawaka, but the energetic and enterprising citizens having the affair in hand know no such word as fail, and nothing but weather can prevent its success.

What followed was a list of some of the twenty-two Midway attractions, including Streets of India, Streets of Cairo, the German Village, the Animal Show, the Country Store, the Statue Turning to Life, the French Theatre, a Ferris wheel, "the wonderful little Burmese midgets, the smallest dwarfs in the world," the International College of Dancing Girls, the High Dive, the Electric Theater, "a magnificent Electrical Fountain," "Achille Philion on his wonderful spiral tower feat," "Lunette the Flying Lady," "Joe Grimes, the Giant, weighing 742 pounds" and "Uno, the Snake Eater."

The *Enterprise* noted that construction of the Midway fence was nearly complete. The fence was just outside the sidewalks, and the "grand entrance" to the Midway was underneath the gas company's lighted arch, south of Second Street.

Another article elaborated on the Statue Turning to Life, which was described as

> undoubtedly the most wonderful and interesting exhibition in the country today. A statue of solid stone is slowly transformed into a most beautiful woman before your very eyes. The bewitching beauty of the Stone Lady herself is a powerful magnet that helps to crowd this modern masterpiece of mystery at every performance.

The carnival planned for Mishawaka was reminiscent of the World's Columbian Exhibition that Chicago had held from May to October 1893, an event attended by perhaps half of Mishawaka's then four thousand residents. The mile-long Midway Plaisance, just outside the main entrance to the World's Fair, featured some of the same attractions that the Mishawaka carnival would have eight years later, such as the first Ferris wheel, "A Street

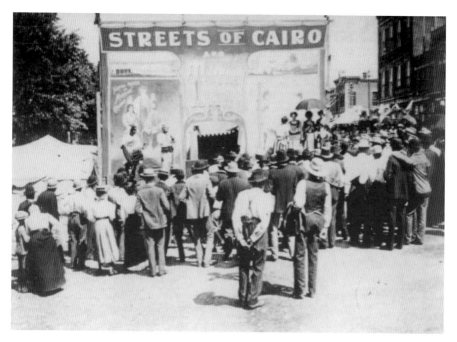

Above: The Streets of Cairo was a popular feature of street carnivals circa 1900–1910, and its appearance in Mishawaka would have resembled this scene. *Author's collection.*

Opposite: The *South Bend Tribune* included this ad for Mishawaka's carnival in the August 10, 1901 edition. *Author's collection.*

in Cairo," a German village and an animal show, along with numerous others. Even today, use of the term *midway* at carnivals pays homage to the Midway Plaisance of 1893. The Mishawaka carnival organizers' plans for themed days, such as Interurban Day and South Bend Day, also borrowed from the World's Columbian Exposition's successful marketing efforts.

All sorts of carnival preparations continued in the following days. Another committee was formed to create a schedule of volunteer ticket takers to work during the carnival. A boom car was sent over the interurban line to South Bend on August 10. It featured music by the Third Regiment Band, which would be performing throughout the week. Mayor Manuel Fisher, the common council and other city officials were invited to visit the Midway and were given complimentary tickets.

In anticipation of large crowds coming to downtown Mishawaka, the potential for criminal activity was a prominent concern. Twenty citizens formed a "law and order league" to supplement the efforts of Marshal Grant Needham. Five men from the committee were to be on duty each day, "and

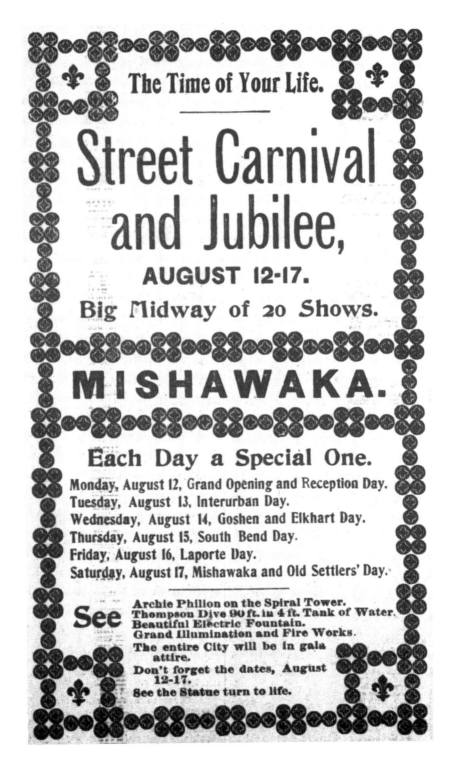

any violation of the law will be prosecuted without fear or favor," warned the *Tribune*. "Confidence men, sharpers and persons operating gambling devices will receive special attention. Carnival week is to be kept as free as possible from these damaging agents." Needham also appointed twelve special police, who went on duty August 12, giving the city sixteen officers available to oversee the carnivalgoers.

On Sunday afternoon, the Canton Carnival Company arrived in Mishawaka from Vandalia, Illinois, and immediately began its preparations.

By Monday, Mishawaka was buzzing with excitement, anticipation and activity. "The city has assumed a gala appearance, business men having decorated their buildings," the *Tribune* reported.

> *The Phoenix block in which is located the Twentieth Century club, presents an especially attractive appearance in bunting and flags. The Third Regiment band is on the scene and is furnishing excellent music. Immense crowds are on the streets and the indications are that the city will be crowded to-night when the doors to Midway will be opened. Many merchants have booths in front of their places of business.*

East of the gas company's arch was the Country Store, a popular attraction that had an element of chance but from which everyone came away with a prize. With a purchased ticket, the customer got an envelope with a number that corresponded to the number on an item in the store. Part of the Country Store's appeal was the surprise of getting whatever item the number indicated.

Other attractions were located nearby, some just south of Second Street and others across the street on North Main. Vendors sold lemonade and other soft drinks, peanuts and candy. A novelty was men roaming about the crowd selling confetti: "bags of colored paper cut fine which the young people, and some of the older ones, too, buy and throw in handfuls at each other in imitation of the flower fete which is such a grand affair in Paris," the *Tribune* reported. Along Second Street, downtown merchants remained open during the carnival but also set up colorfully decorated booths to sell their wares in front of these establishments.

The *Enterprise* described the sights and sounds of the Four Corners:

> *The miniature Ferris wheel is whirling its patrons high in air; near by steam merry-go-rounds with continuous musical accompaniments contend for patronage; at the "country store" lady and gentlemen clerks make*

> *persistent endeavors to attract customers, while on the neighboring streets are the numerous refreshment stands and other concessions striving noisily for trade. The confetti sellers and throwers help to keep up the fun outside.*

Beyond the gas company's arch was the Midway, the heart of the carnival. For a small admission fee, visitors gained entrance to a marvelous world of the bizarre and the entertaining—all on normally mundane South Main Street. Attractions on the Midway often required purchasing an additional ticket, but all could be enjoyed for less than three dollars total. After entering from Second Street, the first feature one would see was an electric fountain that played periodically during the evenings. It sent bursts of water high into the air while multicolored lights were shined on the water, "producing an effect of magnificence," according to the *Tribune*.

The Statue Turning to Life was in a small tent. An optical illusion caused a statue to slowly fade into a young woman wearing a Greek costume. She then disappeared, replaced by a monument of roses. The woman reappeared and then disappeared before the statue returned at the end of the performance. "The illusion is complete and beautiful," the *Tribune* reported.

In what was advertised as an "attraction without a parallel," Professor Achille Philion, "the marvelous equilibrist and originator," ascended and descended a spiral tower while standing on a twenty-eight-inch-diameter, canvas-covered, hollow wooden ball made by Dodge Manufacturing. The spiral track was sixteen inches wide, but a horizontal track high above the ground was just four and a half inches wide. Philion performed at 3:30 p.m. and 10:00 p.m. daily, and the latter show included a blaze of electric lights and fireworks.

At the far end of South Main, the Streets of India featured the aerial thrills of the Oriskani Brothers and Abdellah Ben Hamidy with his group of Arabian acrobats. Ben Hamidy concluded the performance by holding up the acrobats, who weighed 1,540 pounds. Dana Thompson, "the champion high diver of the world," also performed there at 4:00 p.m. and 9:30 p.m., diving from a tower that was eighty-two feet tall into a ten-by-twelve-foot tank of water that was four and a half feet deep.

For a small fee, children could ride camels and donkeys up and down South Main. Trained animal acts, including lions, also performed.

The most unusual stars of the Midway were Fatma and Smaun, the Burmese "midgets." They were shown in a tent and were "the wonder of everyone who has seen them," stated the *Tribune*. "The almost universal opinion was that they were about the best attraction of the carnival." Fatma

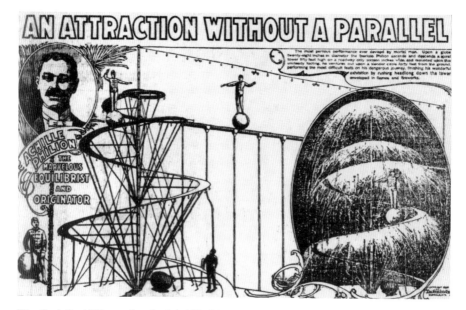

The *South Bend Tribune* advertised Achille Philion's act on August 10, 1901. *Author's collection.*

and Smaun were perfectly formed miniature adults; each was no taller than a doll. The siblings spoke French, German, English and their native Burmese. Possessing an athletic physique, Smaun could lift more than twice his and his sister's combined weight, and he performed gymnastics on chains and rings suspended from an iron frame. Fatma's measurements amazed spectators. Her middle finger was one and a quarter inches long, her arm from the elbow to the tip of the little finger was five and a half inches long and her wrist was two and a half inches in diameter. When they were not performing, Fatma and Smaun enjoyed playing together on stage, seemingly unaware of the gawking spectators.

The *Enterprise* described a walk along the Midway:

> You hear the roar of the lions and the crack of the trainer's whip. The "barker" at the various attractions announces in loud tones and seductive language the merits of his performance. One is bewildered where first to go. Here the Burmese Midgets invite you to see the smallest and most interesting specimens of humanity in the world; there, the Statue Turning to Life offers mystery; the naughty muscle dancers, at the Streets of Cairo, with their hoochee coochy gyrations attract eager crowds—principally men; of a similar order are the Paris by Gaslight, the Congress of Dancing Girls, etc.

As for those who could not afford admission to the Midway, the "outside crowds," as the *Enterprise* referred to them, could look through the cracks in the fence at the wonders within, enjoy the electric fountain, watch Thompson's high dive and be amazed by Philion's aerobatics on the spiral tower. They also could partake in the attractions outside the Midway fence, including free musical performances, or just roam about seeing who and what there was to be seen.

On Monday evening, two thousand visitors, including common council members, enjoyed the Midway's offerings. Though it was still early in the week, the executive committee's hope for a moral carnival was being fulfilled, according to the *Tribune*: "The absence of gambling in the city is a marked feature of the carnival thus far and the law and order league and officers are being congratulated on every hand for the order prevailing and lack of criminalities in the city despite the size of the crowds visiting Mishawaka."

Tuesday, Interurban Day, brought visitors from South Bend, Elkhart, Goshen, Michigan City, LaPorte and Niles. Many people from Goshen and Elkhart arrived in Mishawaka on Tuesday morning, only to be disappointed that the Midway did not open until 1:00 p.m. "By 1 o'clock in the afternoon a throng awaited the opening of the gates to the Midway," reported the *Tribune*. The afternoon crowd on the Midway equaled Monday evening's admission totals. Thousands more arrived before 7:00 p.m. on packed railroad and interurban cars. By the time the last visitor departed the Midway at 11:30 p.m., through its gates had passed four thousand people for the day. The *Tribune* estimated another two thousand people were strolling through the streets of downtown.

One of Tuesday afternoon's highlights was Dana Thompson's high dive. The *Tribune* described Thompson's death-defying act:

> *As he begins to ascend the iron ladder silence reigns. He reaches the top smiling and carefully cleans his moccasins. Thompson sizes up the tanks far below and then deliberately drops turning a complete somersault alighting in the tank in a doubled up position. The water splashes and he comes up smiling. The feat is the most daring and dangerous ever seen in this city.*

Tuesday was the carnival employees' pay night, and several thousand dollars was paid out to them. "It was an odd sight to witness," noted the *Tribune*. "Turks, Arabians, French, Germans and other nationalities walked away satisfied with the money earned either by feats of daring, dancing, mystery or in the more common employment about the Midway."

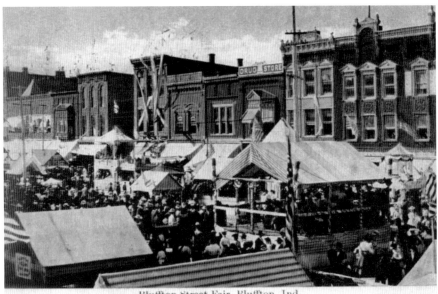

This postcard image of the 1910 street fair in Bluffton, Indiana, suggests what South Main Street would have looked like during Mishawaka's carnival. *Author's collection.*

Wednesday's crowds exceeded those of Tuesday. Carnival goers were entertained on Second Street by the Third Regiment Band in the morning and by the St. Stanislaus Band in the evening. So many people came from Goshen and Elkhart that hundreds were left behind in their hometowns because the interurban cars had no room to bring them to Mishawaka. Five thousand people paid admission to the Midway. Adding to Wednesday evening's excitement, two snakes escaped from the Midway, and one of them was later killed on North Main. The whereabouts of the other reptile were undetermined.

Wednesday also saw the debut of a remarkable new act: Master Reese, the fifteen-year-old "slack wire" performer from Benton Harbor. Several times per day, Master Reese, also known as the Boy Blondin, walked on a tightrope from the top of the three-story Phoenix Building across Second Street to the Tromp Block. In the evenings, Master Reese's balancing pole had red lights at each end and fireworks erupted around him when he reached the middle of the street. The performer also did a variety of tricks on the highwire, including walking blindfolded. On Wednesday evening, Achille Philion added a new feature to his spiral tower act. Below the cable on which he ran his ball were cascading sparks of fireworks representing Niagara Falls.

Thursday—South Bend Day—brought even larger crowds to the carnival: two thousand Midway admissions in the afternoon and more than five thousand in the evening. The huge number of visitors strained the capacity of the streetcar line from South Bend. "By 7 o'clock the streets in the business district were almost impassable," described the *Tribune*. "There was a perfect crush and it was with great difficulty that the crowds were handled." The *Enterprise* marveled at Thursday's crowds: "Mishawaka never before had so many people within her borders at one time." Two thousand patrons viewed the Burmese midgets during the evening, and a similar number attended the Streets of India. Others had to be turned away because of the limited space in some attractions. The St. Stanislaus Band, the Third Regiment Band and a South Bend drum corps helped entertain crowds throughout the day.

Several thousand people watched Philion's act with its shower of sparks and fireworks from the top of the tower as he descended. Philion and his assistants had warned the crowd to stay clear of the tower during the fireworks, "but the great mass of people was unmanageable," the *Tribune* observed. As the sparks started falling, the crowd began to panic, pushing against the fence, which was not sturdy enough to resist their weight. About forty feet of fence fell to the ground and with it many adults and children. "It was a miracle that no one was killed," the account marveled. About twenty people suffered minor injuries, and several women fainted after being injured or seeing people trampled by the panicked crowd. One man received a deep laceration to his head after being stepped on, and a child was saved from being crushed to death. The *Tribune* declared, "The men were worse than the women and used less judgment." One man tried pushing aside others to escape, and he received a blow to the face from another man trying to calm the crowd. The panic was unnecessary because no spectators were ever in any danger from the fireworks display.

This accident, fortunately, caused no serious harm, but a fatal injury did occur nearby a couple hours later. Charles Wilson, known also as Harry Blair, was a thirty-one-year-old balloonist from Hastings, Michigan, who had been following the carnival, hoping to assist Professor Gilmartin's balloon ascents. When Gilmartin did not secure a contract, Wilson stayed to sell confetti and operate a cane rack and knife stand. While crossing the Lake Shore tracks to return to his lodgings, he was struck by an eastbound freight train east of Spring Street. Wilson may have gotten confused as two trains approached. He stepped on the wrong track and was struck by the train and thrown seventy-five feet. Wilson was partially decapitated across the face, his arm and leg were cut off, several of his ribs and his shoulder blade were

The *Mishawaka Enterprise* offered this imagined view of the Midway in its August 16, 1901 edition. *Author's collection.*

broken and numerous other injuries resulted from the accident. "His body presented a sickening sight," described the *Tribune*. "His face was mashed to a pulp and was beyond recognition." The mutilated remains were taken to Ellis & Sandilands, the undertakers, where hundreds of people came to view the deceased and pay their respects.

Friday was LaPorte Day. The afternoon crowds were not huge, "but at night a magnificent crowd was present in Midway and on the streets," the *Tribune* reported. The Midway had five thousand paid admissions that day. Among Friday's highlights was the Boy Blondin's 8:00 p.m. high-wire performance, including fireworks.

For Saturday's Mishawaka and Old Settlers Day, enormous crowds again flocked to downtown and the Midway. The weather had been favorable all week until a rain shower on Saturday evening; nonetheless, almost five thousand people purchased admission to the Midway on the final day. Most Mishawaka factories closed Saturday afternoon so workers could attend the carnival.

Not all of Saturday's events were as lighthearted and joyful as the carnival. Charles Wilson was buried in Mishawaka City Cemetery that afternoon. Efforts to contact Charles's family in Michigan had been unsuccessful, so carnival workers took up a collection to cover the burial expenses.

Late Saturday evening, the Canton Carnival Company packed up, and its train departed at two o'clock on Sunday morning for Alton, Illinois, where it would be putting on a similar event that week.

The consensus of the local newspapers and the public opinion they sampled was that Mishawaka's carnival had been a stunning success. The *Tribune* referred to the event as "a most satisfactory and successful week from every standpoint" and added, "Thousands of people have visited the city and were impressed with its beauty and natural advantages as a manufacturing center and residence place. The principal object of the carnival that of booming the city has been attained....It seems nothing is impossible in Mishawaka. Its resources are unlimited." In an editorial, the *Tribune* also praised how Mishawakans came together for the carnival, including businessmen volunteering to take tickets at the Midway and "prominent ladies" working at the Country Store: "The unity of interests for one common object was marked and is one of the secrets of Mishawaka's rapid development and constant progress." The *Tribune* asserted that leading Mishawakans agreed it would be several years before another carnival should be held in town. "The success of this first effort, however, is a source of deep gratification. Mishawaka is congratulated upon having citizens who work shoulder to

shoulder for the success of any great enterprise. Other cities should profit by her example." The *Enterprise* proudly proclaimed,

> *It is the greatest experience Mishawaka has ever enjoyed, and nothing to excel it has ever before been produced in Northern Indiana. Great credit is due the energetic joint committee of the Business Men's association and the Twentieth Century club for the perfect arrangements and the business like manner in which the great carnival and jubilee has been conducted.*

According to early estimates, the Business Men's Association and the Twentieth Century Club would share a profit of around $1,400.

The *Tribune*'s August 19 issue included quotes from fifteen notable citizens who were asked their opinions about the carnival. Among them was Frank Eberhart, who replied, "Just what we had predicted, a great success and a good show. A great advertisement for the city. The object desired, to bring thousands of people to the city, attained. Perfectly satisfied with the result." Vincent Brunner responded, "A financial success in every way. Everything satisfactory. The lack of grafters and the suppression of gambling were features of the carnival."

Others had mixed reactions. Postmaster Albert Gaylor said, "It was a great success and may be of benefit to the city. The management of the company were gentlemen and as good business men as one would care to find. The fakirs, shooting galleries, etc. were disagreeable features, with their monotonous music and noise." G.A. Schellinger commented, "Glad it is over. It was a good thing." A.A. Synwolt replied, "It was all right. The next carnival could be conducted to better advantage. The entertainments should have been scattered about the city." Dr. C.W. Slick remarked, "For a week of fun and excitement it was a grand success. Its moral effect cannot be told at present."

The carnival's numbers were amazing. The Midway alone recorded 25,500 admissions for the week, and thousands more came to the downtown to enjoy the carnival's other offerings. The biggest day of the carnival was South Bend Day, on which an estimated 12,000 people were in town. On the Midway, the Streets of India had 14,000 admissions for the week, the most of any attraction. The *Tribune* noted that the Animal Show sold thousands of tickets, despite its admission price being twice that of any other show.

Although the Canton Carnival Company had never operated in a city of Mishawaka's relatively small size, Colonel Frank Gaskill, the owner, had decided to take a chance, based on Mishawaka's renown and the large

communities nearby. Gaskill was "well pleased with Mishawaka and the treatment accorded the management and the show," the *Tribune* reported. "He greatly admired the progressiveness of the city and the business spirit of its citizens."

While carnival organizers generally succeeded at putting on a clean and moral event, the week was not spotless in this regard. Gambling was not available on the streets or the Midway, "but the tiger is said to have several lairs in more retired but convenient places," acknowledged the *Enterprise*. On Wednesday and Thursday, "gambling in every form was being practiced in a number of establishments," the *Tribune* stated, until Marshal Needham "suppressed it."

Both newspapers published articles about a variety of petty crimes and some disorderly behavior during the carnival. Several examples of carnival goers being pickpocketed were reported. On Tuesday night, a carnival worker was walking to his accommodations on North Mill when he was targeted in an attempted holdup, but the man scared off his attackers by brandishing a pair of revolvers. A young woman who worked at Mishawaka Woolen had a large amount of her long hair cut off by a thief at the carnival on Wednesday. A fourteen-year-old Polish boy from South Bend was injured on Thursday afternoon as he was trying to look or sneak inside the Midway. A man hit him with a pop bottle across the forehead, exposing several inches of bare skull and causing a pool of blood to flow from the wound. A pickpocket tried to rob carnival treasurer D.A. Shaw, but the intended victim caught him, punched him in the face and told him to leave town. The worst of these incidents occurred around seven o'clock on Saturday evening. As Marshal Needham attempted to arrest several men fighting on North Main, they turned on him, pushed him into a merry-go-round and hit him in the face. Four other police officers soon arrived and were able to apprehend two of the attackers, one of whom they had to beat with their clubs.

These incidents were exceptions to the rule; overall, the carnival was an orderly, safe and enjoyable event. "Considering the enormous crowds in town this week and all the grafters present," the *Enterprise* declared, "the city has been remarkably free from crime and trouble, and Marshal Needham and the police force under him deserve much credit for their vigilance and the excellent order maintained."

In the *Mishawaka Enterprise*'s August 23 edition, an editorial took exception to the "moralizing" of South Bend and Elkhart newspapers "over the alleged distressing effects" of the carnival. A paragraph reprinted from the *Elkhart Truth* stated,

> *It will take the city fully a month to rid itself of the element brought by the carnival and to make it the same little city with a high standard of social and moral character it was before the Carnival. The city may have gained a little lucre, also a little advertising of the right kind, but these advantages are completely outweighed by the evil and damage wrought by the street carnival.*

The *Enterprise* responded, "How sad!" and proceeded to accuse Elkhart of bringing its immorality to Mishawaka: "The evil wrought was but temporary and was mainly wrought by obstreperous and bibulous individuals from neighboring towns. The worst trouble the police forces encountered was with Elkhart toughs and the greatest number of arrests were from the same place." The paper added that a "weekly spree" of dissoluteness in Mishawaka from the carnival contrasted with the "continuous performance" of neighboring cities. For example, an Elkhart saloon had been raided and eighteen gamblers arrested during the same week as the carnival, and a drunken South Bend mob had beaten three police officers: one was shot, and at least one bystander was wounded. "Still, such little every day occurrences in our neighboring cities appear to cause no such qualms of moral solicitude as has the Mishawaka frolic," concluded the editorial.

After the carnival departed, Mishawaka began returning to normal. Residents went to church on Sunday morning, perhaps adding a few extra prayers for any moral lapses they may have committed during the previous week. The saddest sign that carnival week was, indeed, over came on Monday as the Midway fence was taken down. Dodge Manufacturing purchased all the used lumber.

Under the headline "After the Ball," the *Enterprise* captured eloquently the melancholy felt in Mishawaka as the carnival slipped into memory:

> *After a week of hilarious fun and excitement, of vast crowds, a conglomeration of music, good, bad and indifferent, of strange sights and sounds of all sorts, Mishawaka has once more returned to the peaceful tenor of her ways and life has resumed its daily and uneventful round. The gay Midway with its varied attractions has passed like a dream and Main street is once again open to public traffic. The special police force is no longer needed and everybody is recuperating from the unusual strain of continuous excitement.*

Occurring in a city of six thousand people, Mishawaka's 1901 street carnival is, per capita, the best attended event—and most exciting week—

in the city's history. Over the years since, though, other days and one week have rivaled it in spectacle and enthusiasm. On July 5, 1909, Mishawaka held a Historical Pageant and Fourth of July Celebration with a parade that was twice the size of the July 4, 1901 parade and a full day of activities, including the grand opening of the Hotel Mishawaka and turning on the downtown's new electric streetlight system. From May 15 to 21, 1932, Mishawaka celebrated its one hundredth anniversary with Centennial Week, which featured a street carnival, a parade with over one hundred floats viewed by twenty-five thousand people, a Princess Mishawaka contest, a historical pageant performed twice in Lincoln Park for crowds of six to ten thousand and other events throughout the city. Centennial Week had performers on a tightrope stretched between the rooftops of the First National Bank and the Phoenix Building, reminiscent of the Boy Blondin from 1901. The closest parallel to the 1901 carnival in the living memory of Mishawakans today would be Sidewalk Day, the beloved tradition that began in 1958. For one day, downtown streets were closed to vehicular traffic, carnival rides operated and merchants sold food and wares in front of their establishments, much like their forebears did along Second Street in 1901. Sidewalk Day was a fun highlight of the summer, but it was only one day, much tamer and far less attended than carnival week. Events in Ironworks Plaza today may bring a few thousand people for a few hours, and the annual July 4 fireworks show attracts large crowds to the riverfront for one evening. Mishawaka's population in 1932 was more than four times what it was in 1901, though, which made Centennial Week, relatively speaking, smaller than the crowds packing downtown for the August 1901 carnival. Today, Mishawaka has more than eight times its 1901 population, which means events would need to bring forty to fifty thousand people to equate with the carnival—and they would have to do so night after night for almost a week.

Mishawaka will never again see a spectacle like the 1901 street carnival. High-dive artists, tightrope walkers and live animal acts are today exclusive to circuses, and the only midway is at the county fair. Attractions like the Streets of Cairo and the Streets of India would be seen as culturally insensitive or racist. Gawking at the 742-pound man and the Burmese "midgets" would be disapproved of as dehumanizing people for entertainment's sake. Modern-day motorists and downtown businesses would never tolerate closing several blocks of Main Street and part of Lincolnway for six days. Liability concerns would prohibit tightrope walking between First Source Bank and the Phoenix Building.

The 1901 street carnival happened in an area Mishawakans today know well and traverse daily. The 100, 200 and 300 blocks of South Main, the site of the spectacular Midway, are much quieter now than during that momentous week. The crowds are gone, and every performer, vendor and carnival goer is long since deceased. Only a few structures still standing, such as the Phoenix Building, witnessed the carnival's excitement. Must such a wondrous event entirely end, though? Late at night, when South Main is empty and quiet, perhaps phantom crowds again pass through an illuminated arch and fill the Midway, mesmerized by an electric fountain, a high-dive act, acrobats, performers from exotic lands and fireworks brilliantly illuminating the sky before fading away.

Chapter 5

THIS MISHAWAKA PICTURE IS WORTH A THOUSAND WORDS

Among the thousands of photos in the Mishawaka Historical Museum's collection is an aerial view of downtown Mishawaka, seen from the southeast. For some, the photo is a reminder of their childhood Mishawaka. For others, it depicts a place that only faintly resembles today's downtown.

The photograph was taken in the late spring or early summer of 1952. How do we know this? The best clue can be found in Mishawaka Rubber & Woolen's smokestack and power plant, under construction in the photo. The 250-foot-tall smokestack was completed in November 1951, and the six-story power plant was ready a year later. Fully leafed trees and a power plant without exterior brick walls suggest May or June.

At the photo's center is the intersection of Main and Lincolnway.

The block northeast of the intersection looked mostly like it does today. One building facing North Church has since been removed to enlarge the municipal parking lot, and the building at 114–116 North Main was lost after a 1974 fire. Today, the property is used for parking and Doc Pierce's outdoor dining area.

The southeast block has more buildings in the photo than in 2024. East of the Mills Building, a structure on Lincolnway East is visible, and commercial buildings lined South Church. The phone company was on East Third, and the Major-Laing Building, with several storefront spaces, faced South Main. Mishawaka Savings & Loan completed its office at 121 South Church in 1961, and First National Bank tore down the Major-Laing Building in 1967.

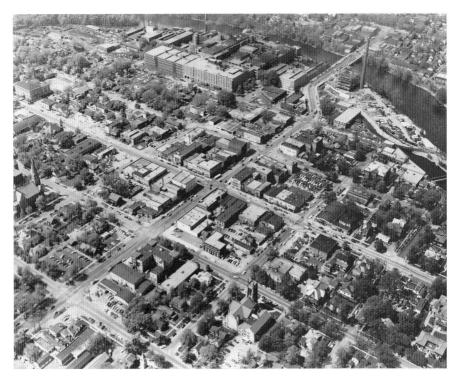

A 1952 aerial photo of Mishawaka's downtown shows many buildings that were demolished over the ensuing decades. *Mishawaka Historical Museum.*

In the photo, twenty buildings occupy the northwest block. This block and the one to the west were razed during 1970s urban renewal. In 1982, Liberty Mutual bought these vacant blocks to build its Midwest underwriting office.

The southwest block had seventeen structures, most of which survive. The gas station at Mill and Third was removed, and a law office now occupies the site. The 1873 building that stood just south of the Phoenix Building succumbed to fire in 1984.

Other areas of 1952's downtown Mishawaka are a who's who of lost landmarks. Mishawaka Rubber & Woolen occupied everything north of Front Street on both sides of Main. All those structures were later removed. South of Front and east of Main, the Tivoli Theater's stagehouse appears prominently. One block east were city hall and Central Fire Station. No historic building on either block stands today. The most beloved downtown landmark of all, the Hotel Mishawaka, occupied part of the 200 block of South Main. It fell to the wrecking ball in 1968, and today the block is filled by the post office and its parking lots. The block bounded by Spring,

Mill, Third and Lincolnway had a mix of commercial and residential buildings, but they were removed for the People's First Federal Savings & Loan office, which opened in 1976, and the County Services Building, completed in 1980.

One of the photo's striking features is the many houses downtown. For example, the block where the library now stands had five houses in 1952. The old U.S. Post Office is the only historic building remaining there today. Across Lincolnway East to the north, several houses are visible, including the Roper House with its distinctive turret. The utilities office at Church and First and the former gas station at Race and Lincolnway are the only extant structures on this block. East of the First Methodist Church, several houses stood where a municipal parking lot is today. East of the Hotel Mishawaka, houses lined Church. Houses also occupied the west half of the block east of St. Joseph Church, including the former nurses' residence for the St. Joseph Hospital School of Nursing. The Eagles Club would build its aerie at Fourth and Main in 1954, but every other structure on that block has been torn down.

Where most of these lost homes once stood are now parking lots, highlighting a vicious cycle. In an era when people lived in proximity to downtown businesses, they could walk to their destinations, so fewer parking lots were needed. As the number of downtown residences diminished, customers began to live farther away and felt compelled to drive, thus increasing demand for downtown parking.

Other features of the photo are also noteworthy. Parallel parking was available on the Main Street Bridge, an indication that the lots adjacent to Ball-Band's factory were inadequate for the size of its workforce. Church Street was only four blocks long, running from Fourth Street to Front Street. Today, it is part of the Princess City Parkway, an urban thoroughfare running the city's full north–south distance. North of the river, many commercial buildings surrounded the intersection of Main Street and Mishawaka Avenue, making a satellite downtown. Only a few of those structures endure. The 100 block of North Mill and the 100 block of East Front appear in this photo but were erased from the downtown map by the Liberty Mutual redevelopment and the Church-Main realignment of 1983, respectively.

So was the downtown Mishawaka of 1952 better than the downtown of 2024? That is a difficult question. A factory occupying riverfront property would be undesirable today, but the thousands of industrial jobs at Ball-Band would be highly coveted. Many of the stores within a block or two of the Four Corners were owned by community-minded local entrepreneurs, but

that element of downtown is much diminished in 2024. The several dozen single-family homes in the downtown of 1952 are a sad loss. If similar houses can and do survive on North and South Race today, then many of these demolished residences might still be attractive, livable landmarks had they not been razed. Single-family houses may never again be built downtown, but new apartments will enhance the city center's residential character. While it is easy to mourn the irrecoverable loss of so many buildings, one should also acknowledge that the downtown of seventy years ago had neither parks nor the Riverwalk.

This photo hangs in the museum's Historic Landmarks exhibit, where it teaches visitors about what downtown Mishawaka once was and inspires thoughts of what it may one day become.

Chapter 6

CENTER POINT TOWER

The Mishawaka Landmark That Never Was

MISHAWAKA (October 2020)—Local leaders, including the mayor and several city council members, were on hand yesterday to celebrate the 50th anniversary of the groundbreaking for what was formerly the tallest building in northern Indiana, downtown Mishawaka's Center Point Tower…

That fictional paragraph could have been the lede for an actual news article if architect Paul Jernegan had been able to build the most remarkable structure ever planned for downtown Mishawaka. The story of Center Point Tower and Jernegan's ambitious effort to revive Mishawaka's city center evokes both amazement and thoughts of what might have been.

Paul Frank Jernegan was born in Mishawaka on April 17, 1908, the oldest of Ralph and Estella Jernegan's three children. The Jernegans were one of Mishawaka's most prominent families. Ralph was an attorney, and his family resided at 115 South Race Street, just around the corner from Ralph's father, Edward, who lived at 221 Lincolnway East and was the editor and owner of the *Mishawaka Enterprise* from 1872 to 1920.

Paul was a member of Mishawaka High School's class of 1925 and graduated from the University of Michigan, where he also earned an advanced degree from the College of Architecture and Design. For sixty-two years, Jernegan operated an architecture firm with offices in Mishawaka, Goshen and Chicago. In recognition of his distinguished career, the American Institute of Architects honored Jernegan with the rank of fellow in 1964.

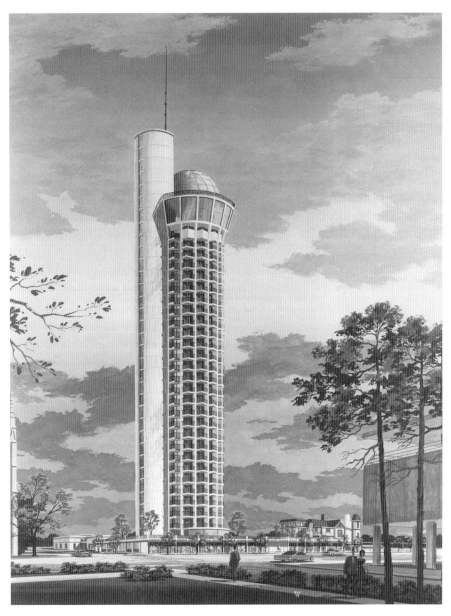

Worthington Associates of Kansas City, Kansas, prepared this artist's rendering of Paul Jernegan's proposed Center Point Tower. *Mishawaka Historical Museum.*

After Edward's death in 1922, his home remained in the family; it was later converted into offices and apartments and became known as the Jernegan Building. Paul's office was there, and his mother continued to reside at 115 South Race. After Estella passed away in 1960, her house sat vacant but stayed in Paul's ownership.

Jernegan was in the prime of his career in the mid-1960s, just as downtown Mishawaka was facing its most significant challenges since the Great Mishawaka Fire of 1872 destroyed nearly three-quarters of the central business district. Aging commercial buildings, growing demand for modern facilities and urban renewal mania imperiled numerous historic structures, while competition from suburban shopping centers threatened downtown merchants. The Mishawaka Redevelopment Commission was looking to demolish several buildings to make way for a "civic center," which would include a new post office and public library. As both an architect and a lifelong Mishawakan, Jernegan was keenly aware of both the plight of and opportunities offered by the downtown and felt compelled to act on its behalf.

Plans for the civic center led to the need for more municipal parking. To this end, the redevelopment commission set its sights on the property south of the Jernegan Building and north of Third Street, land Jernegan owned. On April 25, 1966, Jernegan and commission members met to discuss where each side stood. Hillis Hans, the commission's president, stated that the commission had no intention of including the Jernegan Building in urban renewal. The frame house at 115 South Race, though, would enjoy no such protection because it was incompatible with the masonry facades of the post office at Church and Third Streets and the new library planned for Lincolnway and Church. The commission preferred that the house be moved or demolished but said it could be retained if a "fire-resistant exterior veneer" were applied. The commission and Jernegan agreed that if he would construct offices and apartments or significantly alter the building at 115 South Race, Jernegan could maintain ownership of that land and the lot at the corner of Third and Race for use as off-street parking. If no improvements were made or planned for 115 South Race, the redevelopment commission would acquire it and the corner property for public parking. Jernegan could remove the house and use the land as a parking lot for the Jernegan Building's tenants, but he would lose the corner parcel. The commission gave Jernegan a year to dispose of or alter the existing structures or to initiate new construction, and it requested a written proposal of intent before it next convened on May 16.

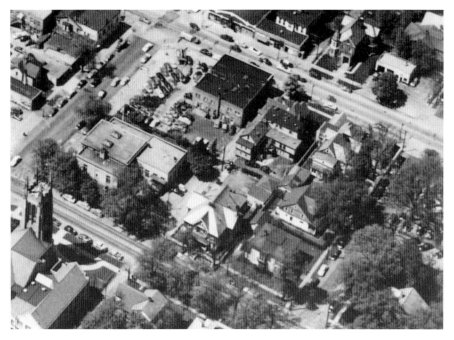

The east half of the block bounded by Third, Race, Church and Lincolnway, shown here in 1952, was the proposed site for Center Point Tower. *Mishawaka Historical Museum.*

The April 25 meeting left Jernegan with a choice: either make plans to redevelop some or all of the land along Race or lose it all to urban renewal. If Jernegan wanted to retain the entire parcel, he must construct a new office or apartment building or substantially modify the house that stood there. Other than cost, it came down to how much Jernegan wanted the property and, if he chose to build, how big he was willing to go.

Jernegan soon made it clear that he refused to give up his land and would go *really* big to keep it. He realized that his architectural career's greatest masterpiece could be painted on the blank canvas that lay just outside his back door.

On May 12, 1966, Jernegan submitted a "private redevelopment proposal" for the property along the west side of Race. He planned to move the house at 115 South Race to another location and to either demolish the two garages on the site or raze one and veneer the other with masonry to make it both fire-resistant and aesthetically compatible with a nearby fieldstone wall. Most importantly, Jernegan proposed "structural surveys, market analyses, and zoning variance investigation" to ascertain the feasibility of "a high rise office-apartment structure." These studies would be completed within

a year, and if they proved favorable, he would draw up designs and seek construction bids.

Jernegan then offered a brief but tantalizing description of the high-rise he planned. "This concept visualizes a slender tower structure, the tallest in northern Indiana," Jernegan began dramatically. A second-floor plaza would cover parking on the ground floor and underground. The lower floors of the tower would have professional offices, a lawyers' library and retail facilities. The upper floors would consist of "high class apartments," and at the top of the tower would be a "prestige restaurant" and swimming pool "with emphasis on a view which would encompass a large part of the entire St. Joseph Valley."

Jernegan's proposal also asserted the tower's benefits, which included combining the appeal of high-rise residences with Mishawaka's small-city attributes, supporting economic development and promoting plans for a county sub-courthouse in the former post office:

> *This proposed development would offer the attractions of the large city high rise living but here adding the further advantages of the small community. Local industrial, residential, professional, commercial, and retail amenities would be given a vital boost. A lawyers pool in close proximity to the proposed sub-courthouse would add support to the establishment of full-fledged courtroom facilities at that location.*

A greater priority in Jernegan's thinking, though, was the transformative effect his tower would have on the downtown's renewal and skyline:

> *Architecturally and planning-wise, such a tower structure would immediately become a community landmark, serve as an esthetic "punch-line" and vertical accent for the whole proposed civic center complex, particularly in relation to the basically horizontal emphasis of the existing post office (proposed courthouse) and the planned new one-story public library. And it could very well serve as the much needed stimulus and down-town anchor for a revitalized central business district.*

Jernegan would later also develop ideas for remaking downtown Mishawaka into the region's retail leader. The high-rise would be its most visible feature but only the beginning of the central business district's renaissance.

Jernegan acknowledged that the tower might prove "impractical" to build, so he identified "two alternate actions." The first would be to erect

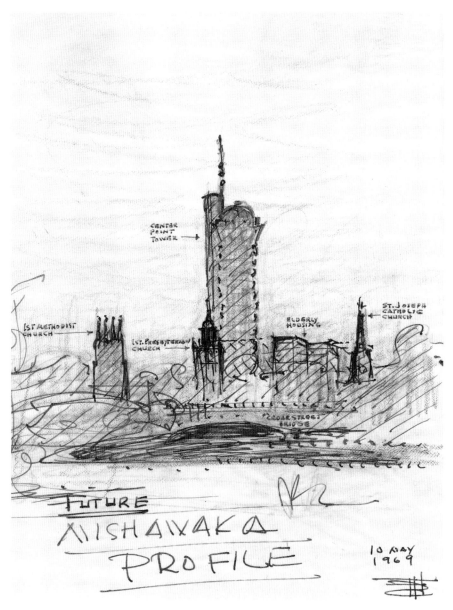

Center Point Tower would have radically altered Mishawaka's skyline, as shown in this sketch by Paul Jernegan, dated May 10, 1969. *Mishawaka Historical Museum.*

a professional building with four to eight offices in a style compatible with the existing Jernegan Building. The other option: construct no new building, cede the property at Third and Race to the redevelopment commission and retain the vacated land at 115 South Race to serve as parking for the Jernegan Building.

The commission acknowledged receipt of the plan on May 26 and directed Jernegan to offer more details, in both written and visual form. Over the next year, he carried out extensive investigations and was able to submit his findings in a report dated July 1, 1967. Jernegan stated that his research "confirmed the advantages and general superiority for our purposes of a tall high-rise structure." The tower would offer significant rewards and pose extraordinary challenges: "Such a project has the greatest potential for helping up-grade Mishawaka's central area; it is also fraught with the greatest difficulties and problems of execution, all, however, fully anticipated."

Jernegan added a cautionary note about the need to reconsider the future of the entire downtown, not just half a square block. His studies had identified that "one overriding contingency remains to cloud the entire undertaking. Without a concurrent major re-evaluation and reorientation of our central business district [CBD], present and future, no project of the type we envision is feasible." If the high-rise were to be built, it could only happen as part of a larger downtown revitalization. In a separate section, Jernegan included suggestions to address "this integrally related problem of Mishawaka's CBD." He also warned that if the tower project were not approved or if "vital CBD developments not be forthcoming," it would diminish the downtown's prospects and "discourage even lesser undertakings." Jernegan ended his letter by offering a general prescription for downtown's maladies: "A further decline in our historic business center can be reversed only if Mishawaka's 'heart' area responds to treatment, not governmental alone, important as that obviously is, but through a greater participation by the private sector of our economy."

Jernegan's document then introduced the name "Center Point Tower" for the project, selected to emphasize the "central location of Mishawaka's downtown business district in relation to the total St. Joseph Valley metropolitan area."

Center Point Tower would rise from the southern half of a "one-story arcaded structure topped by a terrace-plaza" covering a site with 181 feet of frontage along Race Street and 78 feet along Third Street. To the north, the Jernegan Building would remain.

The main tower would consist of thirty-three floors: a ground floor; nine floors of offices, including a legal library at the midpoint of the floors occupied by law offices; eighteen floors of apartments; a restaurant on the twenty-ninth through thirty-first floors; and a swimming pool on the thirty-second and thirty-third floors, topped by a "55-foot diameter hemispheric dome of tinted acrylic plastic." Each floor would have an inside diameter of fifty feet and feature several balconies.

Adjacent and to the south of the main tower, a utility tower would include three high-speed elevators (two for passengers and one for both passengers and freight) and two emergency stairs. The roof of the utility tower would be 340 feet above street level, slightly taller than the top of the dome. A 76-foot pole crowning the utility tower could be used for broadcasting television signals and would bring the structure's total height to an astounding 416 feet.

The proposal gave other details about the Center Point Tower project. The total gross area of the development would be 142,454 square feet, the ground floor area would be 14,118 square feet and the net rental area for each tower floor would be 1,963 square feet. Off-street parking would allow for forty-three cars on two levels. Retail or office space on the ground floor could be configured for four units, two fronting Race and two facing Third, ranging from 600 to 1,000 square feet each.

As a landscaped base for the tower, a terrace would be on the second floor, above the ground floor parking and offices or shops. Plans included trees, other plantings, stone benches and "an ornamental pool with fountain jet."

Jernegan then described the tower's interior and provided drawings of different floor configurations. He noted that the floors were "so designed, structurally and mechanically, that there is complete freedom of usage within the limits of the clear 50-foot diameter circular area." This flexibility meant the nine floors of offices could have one to three offices per floor, and each of the eighteen residential floors could accommodate one to three apartments, varying from one to three bedrooms each. The twenty-ninth floor would be occupied by the restaurant's kitchen. Diners would enter the restaurant on the thirty-first floor, which would also include restrooms, mezzanine dining and a bar. The main restaurant, which would feature a revolving floor, would occupy the thirtieth floor. Two-story windows would offer fantastic views of Mishawaka and the surrounding area. The restaurant's seating capacity would be 224 persons. Crowning the structure would be the "sky-high" swimming pool and "observation promenade."

Jernegan went on to explain the utility tower and other features of the building. The utility tower would be a "self-contained, reinforced,

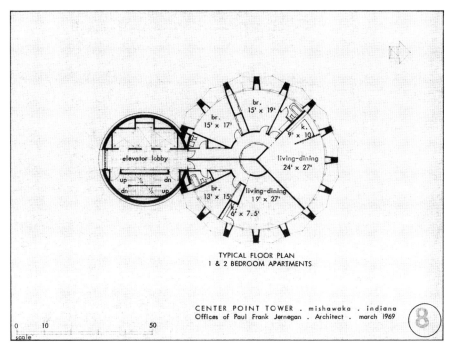

Center Point Tower's apartments had different floor plan options. Here, two apartments occupied a floor and were served by elevators in the adjoining utility tower. *Mishawaka Historical Museum.*

continuous slip-form pour, slightly tapered circular concrete structure" with all the elevators, stairs, mechanicals and trunk lines for the main tower, thus allowing each floor to be a wide-open space. The structural frame of the entire building would be "cast-on-site and pre-cast prestressed concrete." Any "ornamental and exposed metal" would be made of "rust inhibiting steel." The glass would be tinted bronze.

The use of "pre-cast and on-site prestressed concrete elements" would allow the tower to be built one story at a time, "stopping at any point floor level temporarily or as long as desired." Jernegan noted that finishing the structure to its "full height would be mandatory for both economic and esthetic reasons," but doing construction in phases was an option, if it helped the project's financing.

Not wanting the utility tower to be a giant shaft of featureless concrete, Jernegan chose to decorate it with a 320-foot-tall window featuring "pierced masonry grilles with stained glass inserts" representing scenes from the history of Mishawaka and St. Joseph County. The thirty-five panels would start on the third floor and extend to the top of the utility tower, forming a

"continuous screen" over each floor's south-facing elevator lobby windows. Those windows would enable the panels to be seen up-close from each floor during the day and would backlight the panels at night. The panels would represent historical events to be determined by a "jury of historically qualified Mishawaka citizens" and competitions open to local grade school, high school and college students. The grilles would be created and installed in stages, allowing the community to have a "full public discussion and analysis" of their content. The stained-glass panorama would be the region's largest work of art.

The booklet containing Jernegan's proposal also featured fold-out designs for the floor plans of the basement, ground floor and second floor, as well as eleven pages of other floor plans, including office and apartment layouts, the three restaurant levels and the swimming pool. Thirty-four-inch-long drawings of the structure's full height, showing both the south and east elevations, were also part of the publication. Most extraordinary of all, though, was an eight-by-ten-inch, full-color artist's rendering of Center Point Tower, prepared by Worthington Associates of Kansas City, Kansas. Looking from the southeast, it also showed the Jernegan Building, the post office, a sliver of the First Methodist Church and part of a new building at the northeast corner of Race and Third.

Jernegan's vision for Center Point Tower had its public unveiling on August 1, 1967, at a meeting attended by redevelopment commission members and representatives from banks, industries, businesses and the legal profession.

Three days later, the rest of Mishawaka read about Jernegan's plans in the *South Bend Tribune*. Under the banner headline "Skyscraper Proposed for Downtown," the article included a summary of details from the proposal, comments by Jernegan and redevelopment director Leonard Gherardi and a large black-and-white reproduction of the Worthington Associates illustration.

Jernegan addressed the project's cost but declined to give a specific price tag until working drawings were done. He believed that Center Point Tower would not be especially expensive to build, though, and that financing would depend on the construction cost and advance leasing. Jernegan said that the head of one local financial institution had offered him encouragement. "If I can line up the tenants, he'll make sure that the money is available," the architect explained. Potential occupants' interest would ultimately determine whether the tower could be built. Jernegan, a critic of urban renewal in downtown Mishawaka, promised to cooperate with the redevelopment commission in its objectives as he pursued his project.

Center Point Tower was greeted favorably by Gherardi, who believed that larger plans for revitalization would be favorably impacted by Jernegan's tower. Gherardi noted that development done by the private sector, such as Center Point Tower, was the most effective way to rejuvenate the downtown. A goal of Mishawaka's urban renewal efforts was to encourage private investment, he added. The redevelopment commission's plans for downtown were adaptable, according to Gherardi, and could accommodate Jernegan's proposal and whatever ways it might be modified. Gherardi's department would be ready to assist the project, he said, but needed a detailed construction timetable so the remainder of the redevelopment plan could be altered accordingly.

The possibility of a thirty-three-story building in Mishawaka provoked many thoughtful discussions around the city in the following weeks. The prospect of the downtown's first large apartment project was an exciting glimpse into the future. The height of the tower stirred the imagination and elicited the most commentary. A 416-foot building was on a scale far exceeding the city center's two tallest structures: the 250-foot Uniroyal smokestack and the 180-foot spire of St. Joseph Church. Just the 340-foot height of the tower itself, apart from the antenna, would be nearly three times that of the 119-foot, four-pinnacled steeple of the First Methodist Church across the street.

The community's oldest voice, the *Mishawaka Enterprise*, offered its opinion in the August 10 edition. "What do you think of the Mishawaka skyscraper?" it asked. "This is the question that has been flying about the valley this week. The answer: Yes, of course, why not?" The *Enterprise* endorsed Center Point Tower as a "bold, creative concept. It should be given very serious consideration by everyone who sincerely wants to see the progress of Northern Indiana and especially the City of Mishawaka."

Though Center Point Tower was daring and futuristic, Paul Jernegan did not stop there. As mentioned in the cover letter of his July 1 document, he then offered several pages of proposals for the central business district. Jernegan began with the problem of Mishawaka's small downtown, which he said was due, historically, to the proximity of South Bend and, more recently, to the retail options of Town & Country Shopping Center and McKinley Avenue. Jernegan was unwilling to accept either the decline of downtown Mishawaka or "second city" status. "Actually, Mishawaka with its many natural advantages—its geographically central location, sound economy, inherent stability, varied population and numerous other plus factors—*should* and *could* have not only a good but even *the* outstanding

central business district in the entire St. Joseph Valley area," he asserted. Jernegan then went deeper into the downtown's flaws: the lack of both "a main north-south traffic artery extending into the community near the axial center of the city" and a large department store, which would be, as he put it, a "traffic generator."

Based on these assumptions, Jernegan advanced proposals for turning the downtown into a "true regional center" for the entire "St. Joseph Valley urban complex." Without such "major revitalization," he warned that Mishawaka could "anticipate nothing beyond a limited specialty shop-governmental-institutional enclave in the metropolitan fabric." Jernegan added that such a prospect would also "doom to failure" his own plans for Center Point Tower. He acknowledged that his vision would be seen as "shooting for the moon"; however, it was no mere flight of fancy but rather "a hard core necessity for survival." Jernegan wanted to instill a "sense of urgency" in the community to act on his ideas, yet he advised optimistically, based on years of research, that "there is every reason to believe that Mishawaka's CBD can be saved and developed into a true major shopping center, seemingly in contradiction to current thinking, which appears to be reconciled to a district of limited scope."

Jernegan then provided a twenty-two-point outline of the downtown. The plan included three large department stores, either one or two floors, ranging from 110,000 to 362,000 square feet. Jernegan's drawing of the reimagined downtown showed Store A straddling Lincolnway West and filling the blocks bounded by Mill, Spring, First and Third Streets. Store B would occupy part of the block east of Center Point Tower and all of the block north of Lincolnway. Store C would be north of the river, covering the south side of the 100 blocks of both East and West Mishawaka Avenue. Connecting Stores A and B along Lincolnway would be a pedestrian mall, covered by all-weather plastic or concrete canopies. A north–south pedestrian way would link the downtown with Store C. Jernegan described it as a "two-level pedestrian structure which will permit street vehicular traffic at grade level." The walkways would feature movable sidewalks using conveyer belts. Where Main Street crosses the St. Joseph River, he proposed "an American Ponte Vecchio or bridge of shops," inspired by the famous bridge in Florence, Italy. Shops would be built perpendicular to the bridge, and shoppers would enter from the bridge's sidewalks.

In addition to the retail development, Jernegan planned other amenities and infrastructure improvements. Among them was the architect's thirty-year-old dream of a civic auditorium, which would adjoin city hall to the

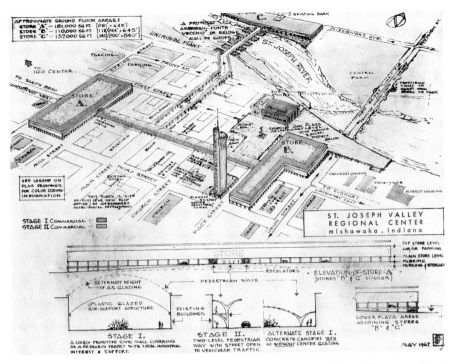

The St. Joseph Valley Regional Center that Paul Jernegan envisioned would have revitalized downtown with department stores, a civic auditorium and plaza and a new bridge over the St. Joseph River, shown in this 1967 drawing. *Mishawaka Historical Museum.*

east and be surrounded by a civic plaza facing Store B and stretching east along the river and south toward Lincolnway. To address the lack of a north–south artery, Union Street would be turned into such a road. A new bridge would cross the river just north of Lincolnway, traverse Central Park and then follow Division Street. He noted that the highway could be extended north to "make practical the much-needed Mishawaka Northern Indiana Toll Road interchange" and to facilitate access to downtown from Michigan. Jernegan also proposed an east–west "inner by-pass" using land along the north side of the New York Central Railroad right of way. The road would divert "strangling and disrupting" traffic around the southern edge of the central business district.

Jernegan's proposal referred to Center Point Tower and other projects in development: the public library, Valley Bank and Trust's office, First National Bank's drive-through, a post office, an addition to St. Joseph Hospital, a downtown hotel or motel, a housing project for the elderly and the adaptive reuse of the old post office. Jernegan still hoped to save the Hotel Mishawaka,

which occupied the site at the southeast corner of Main and Third that was slated for the new post office. He suggested that a better location for the post office would be on the south side of Fourth Street, between Church and Union. Jernegan would expand and modernize the hotel, making it into "a first-class, well-located and attractive hotel-motel facility."

Jernegan's final point addressed "existing buildings and preservation." To allay concerns that his plans would mean clear-cutting downtown landmarks, Jernegan stated, "All structurally sound, architecturally worthy, or historically valuable existing structures which can be saved within the framework of the various new planning proposals should be retained, maintained, rehabilitated where necessary, and altered where required." This included integrating historic buildings into the stores, walkway and plaza and "taking every precaution to prevent or at least minimize any defacement or loss of their architectural or historical character." As shown by Jernegan's aerial illustration of what he called "St. Joseph Valley Regional Center," this would leave intact the four blocks surrounding the Lincolnway-Main intersection and landmarks such as St. Joseph Church, First Methodist Church, the Beiger Home and the Dodge Old People's Home. The First National Bank branch on East Mishawaka Avenue would be incorporated into Store C. Lost due to Jernegan's vision of progress, though, would be the Eberhart-Kamm House at 400 Lincolnway East and the Eberhart House at the northeast corner of Third and Race.

Jernegan also shared his proposal with the community through a full-page ad in the *Tribune* on September 10. Under the headline "Regional Center of the Valley" and subheading "Why Perpetuate Our Limitations and Plan an Obscure Future?…Some Specific Private Proposals for a Greater Downtown Mishawaka," the ad included much of Jernegan's July 1 text and proposed a "Center-City Development Corporation" to facilitate plans for the department stores, civic plaza, pedestrian walkways and new highways. The page also featured Jernegan's illustration of downtown with the new buildings and the drawing of Center Point Tower.

Jernegan had articulated his ideas in detail along with compelling visuals and shared them with stakeholders. Now he sought to fan the sparks of interest into a blaze of enthusiasm for Center Point Tower and the St. Joseph Valley Regional Center concept. In the spring of 1968, he began running an ad in the *Tribune* for Center Point Tower, including a drawing of the building and the text, "Center Point Tower in St. Joseph Valley's developing new center" and "Downtown Mishawaka providing this area with some of the finest offices and apartments anywhere." Several bullet points highlighted

the building's apartments, offices, retail spaces, parking and other attributes. At the bottom was the phrase, "Contingent leasing now for 1971 occupancy."

Jernegan was doing everything he could to sign up tenants for the building, which would be the prerequisite for financing and construction. It was not easy, though. Jernegan's files for Center Point Tower include a handwritten note taped to the back of a copy of the leasing ad: "This was mounted on office entrance door—facing public entrance to building—from: March 1968 to: 1 January 1971 without *one* single inquiry resulting!! Oh, Mishawaka!"

While trying to keep Center Point Tower on track, Jernegan also sought support for St. Joseph Valley Regional Center. This, too, was an uphill struggle. Jernegan's records indicate that even prominent local residents were skeptical or dismissive. Elmer Jensen, co-owner of Winey's Dress Shop, told him, "Forget it. Mishawaka will never be any different than it is right now and always has been. Downtown South Bend is the big center and will continue to be. So just forget trying to make a bigger center here. You are only wasting my time and yours to even talk about it." Dr. Kenneth Kintner, a redevelopment commission member, urged Jernegan to be "reconciled" to downtown as a "limited service-specialty shop district," adding, "The McKinley shopping complex and others like it have all the retail commercial business and there is nothing we can do about it." Jernegan also approached major department store chains, hoping to attract them to downtown. R.J. Kelly, a Sears, Roebuck expert, stated the retailer had "little or no interest" in opening a Mishawaka location and was "well satisfied" with its South Bend and Elkhart stores. A Carson Pirie Scott representative familiar with Mishawaka dismissed it as "too far afield." Jernegan also reported that he had been approached by a national insurance company seeking space for a district office. Jernegan met all their major criteria for a site, and the company was strongly interested—"until the moment that they realized the location was downtown Mishawaka, when they immediately withdrew all consideration."

A year after publishing the details of both Center Point Tower and St. Joseph Valley Regional Center, Jernegan was still planning and advocating on behalf of his ideas. On August 10, 1968, he submitted to the redevelopment commission a revised plan for Center Point Tower, what he identified as his "final development proposals." Jernegan admitted with disappointment that he had been unsuccessful in building support for his ideas: "It would be less than frank not to admit that the net results of efforts to promote the Center Point Tower project, along with what are considered to be essential collateral developments, have up to now been anything but encouraging." Nonetheless,

he retained "confidence in the long term potential for downtown Mishawaka and the surrounding urban community" and intended to move forward with the development.

To that effect, he specified a "more deliberate time schedule" to be carried out in five stages. Stage 1, scheduled for completion in January 1969, involved removing the house at 115 South Race and developing all the property between Lincolnway and Third Street for parking. Jernegan noted that this would accomplish the commission's goal of increasing parking for the civic center and keeping the land on the tax rolls. Stage 2, to be finished by July 1969, consisted of additions and renovations to the Jernegan Building, including "structural and architectural design interconnections" with the tower to the south. During Stage 3, slated for completion by October 1970, the tower's foundations, subbasement, basement and first floor would be constructed. Stage 4, to be finished by October 1971, involved building to the tenth floor and developing the plaza and gardens on the roof of the ground floor retail or office structure. Stage 5, to be constructed by January 1973, would extend the tower to its full height.

Jernegan ended the letter by reiterating his belief in "the truly great promise this Tower project offers Mishawaka" and vowing that "its total completion…remains our ultimate objective."

Despite Jernegan's optimism, Center Point Tower never advanced beyond words and drawings. He was unable to sign up tenants, which meant no financing was available for construction. As a result, the redevelopment commission bought the property south of the Jernegan Building for a municipal parking lot that was used primarily by patrons of the Mishawaka Public Library, which opened in 1969.

Instead of a sub-courthouse, the Mishawaka Police Department moved into the former post office in 1974 and remained there until a new police station opened in 1995. The building was then acquired by the library as part of an expansion project that also included demolishing the Jernegan Building for additional parking. Where Center Point Tower would have stood is now the south half of the Mishawaka-Penn-Harris Public Library's parking lot.

The closest that downtown Mishawaka came to a skyscraper was the 500 Lincolnway East Apartments. The eight-story building, opened in 1970, offers housing for low-income elderly people.

Jernegan's dream of an upscale apartment building soaring into the Mishawaka sky never came to be. In 2019, though, the Mill apartments opened near Beutter Park. The sprawling complex occupies two city blocks, almost as impressive horizontally as Center Point Tower would have been vertically.

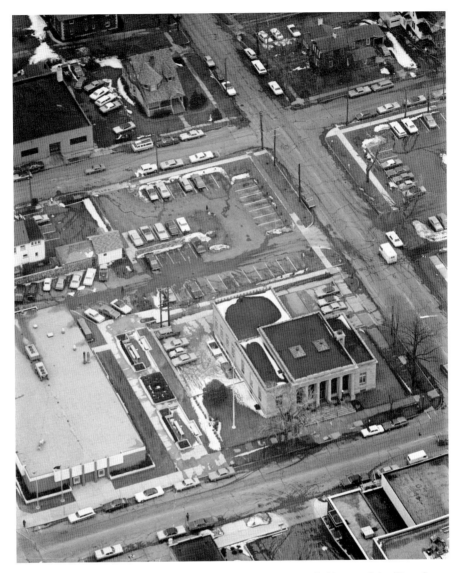

Paul Jernegan's plans for Center Point Tower failed to come to fruition, and the City of Mishawaka turned part of the site into a municipal parking lot, shown here circa 1973. *Mishawaka-Penn-Harris Public Library.*

St. Joseph Valley Regional Center also did not materialize. Between 1974 and 1982, the redevelopment commission cleared all buildings from the two blocks north and west of Lincolnway and Main. The store that Jernegan planned was never built in that vicinity; instead, the property was eventually sold to Liberty Mutual, which opened its new Midwest underwriting office

on the site in 1985. Meanwhile, the rest of downtown died a slow death as, one by one, most of the remaining stores closed their doors over the following decades. Restaurants, bars, antique stores and several service-related businesses keep storefronts occupied and bring people downtown today. The City of Mishawaka bought and renovated the former Liberty Mutual building and moved city hall, Mishawaka Utilities and the police department there in 2022. Mishawaka did create the north–south traffic artery that Jernegan called for, though not by extending Union Street to Division Street. Instead, Bremen Highway and Union, Church and Main Streets became Princess City Parkway, which runs the full north–south length of the city, almost to the Indiana Toll Road entrance that Jernegan foresaw.

The department store chains that dismissed Jernegan's entreaties to invest in Mishawaka's central business district did eventually find their way to the city. Instead of three downtown stores connected by a covered pedestrian mall and walkways, University Park Mall, which opened in 1979, put four anchor stores and one hundred other businesses under one roof. The mall and commercial development on the city's far north side transformed Mishawaka from a Rust Belt factory town into the region's shopping destination, far exceeding what Jernegan imagined in the 1960s.

What if Center Point Tower and St. Joseph Valley Regional Center had been built?

Mishawakans might still be debating the aesthetic merits of the tower, whether it is an eyesore or a beloved icon that, like the Seattle Space Needle, is both futuristic and retro in its appearance. Jernegan did not envision the growth of the library, which put on additions in 1984 and 1998. Having the library, a major retail/office/apartment project, the Jernegan Building and the former post office so close together would have made for crowded conditions. Eventually, the library would have needed to move to a new site, or one or more of the other buildings would have had to come down, the block not being big enough for them all. As long as Center Point Tower stood, the restaurant and observation deck's stunning vistas would have made it a regional tourist attraction, and the building's distinctive shape would have become the downtown's symbol, even more so than Will's Clock.

If Jernegan's plan for St. Joseph Valley Regional Center had come to fruition, downtown Mishawaka would have become the area's retail hub, eliminating the incentive to build University Park Mall a few years later. Grape Road might still be a two-lane country road, and shoppers would be complaining about the traffic and parking problems of the bustling central business district. In the 1970s, South Bend and other cities made the

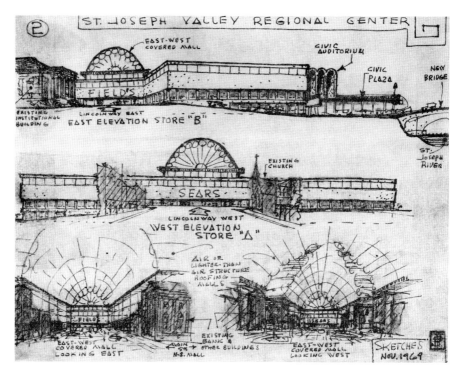

Paul Jernegan's plans for downtown included department stores connected by a covered mall, as depicted in this 1969 sketch. *Mishawaka Historical Museum.*

mistake of turning downtown streets into pedestrian plazas that disrupted traffic, raising doubts about whether this would have worked any better in Mishawaka. The long-term success of Jernegan's downtown redesign would have been determined largely by the staying power of the three department stores. Had they prospered, downtown Mishawaka would truly have become the center of the St. Joseph Valley. The alternative, though, would have been the city's worst nightmare: three massive, vacant stores needing demolition and redevelopment. If Jernegan had achieved another of his aspirations, saving the Hotel Mishawaka, city officials would not still be trying to attract a new downtown hotel fifty-five years later.

Paul Jernegan died in Mishawaka on February 18, 1993. He is buried with his wife and other family members in Mishawaka City Cemetery. Even years after Center Point Tower and St. Joseph Valley Regional Center's fates had been decided, Jernegan held on to documents and drawings about the projects. He also saved articles about similar developments in other cities, perhaps as a private act of vindication proving it *could* have been done in Mishawaka, too.

Jernegan's work is carried on today by a new generation of civic leaders. Mishawaka may never have a skyscraper, but the new city hall and ongoing efforts to redevelop the former Uniroyal property and nearby parcels of land continue his attempt to rejuvenate the central business district. Such projects will go far toward fulfilling Paul Jernegan's dream of making downtown Mishawaka the "true regional center" of the St. Joseph Valley.

PART II
BUSINESSES

Chapter 1

KUSS HOUSE EVOKES MEMORIES OF FREDERICK KUSS AND KUSS BAKERY

Mishawaka has numerous landmark houses identified with the businessmen who built or owned them, such as the Beiger, Robinson-Dodge, Merrifield-Cass and Schellinger houses. To this list can be added the home of Frederick Kuss, located at 512 Lincolnway West. The two-story, Queen Anne–style house, built circa 1890, was rated "Outstanding" in the *City of Mishawaka Summary Report*, a historic sites and structures inventory published in 1995.

Fred Kuss was one of Mishawaka's most prominent business owners in the late nineteenth and early twentieth centuries, and he started a family business that endured for a century. Fred was born in Prussia on February 27, 1845. When he was fifteen years old, he left school and trained as a baker's apprentice for three years. He emigrated to the United States in 1868 and settled in Chicago. Fred worked in a bakery/grocery business for three years until the Great Chicago Fire of 1871 destroyed the establishment. He then moved to South Bend, where he ran a bakery for two years.

In 1873, Kuss came to Mishawaka and started a bakery with Mr. Rohleder, a grocer. Kuss & Rohleder, a grocery store with a bakery department, was located at the corner of East Second and Church Streets. Rohleder left the partnership in 1879, and Kuss continued as a sole proprietor. He later relocated the business to 201 North Main Street. In 1905, Kuss Bakery moved around the corner to 119 West First Street, a location that is today the police station's parking lot.

Frederick Kuss built this house at 512 Lincolnway East in the 1890s. It is shown in 2022. *Author's collection.*

Kuss married Mary Ann Weiss in 1874, and they had six children. Mary Ann died in 1905.

Fred Kuss was involved in local politics, representing the sixth ward on the city council for six years and serving multiple terms as councilman at large. He was vice president and a director of the First National Bank and First Trust & Savings Company and was a director of the North Side Trust & Savings Company. Kuss was also a member of the Independent Order of Odd Fellows.

Fred Kuss ran the bakery until an illness forced him to step away from the business in 1922. He died in his home on December 22, 1924, and is buried in Mishawaka City Cemetery.

After Kuss's passing, his sons Charles and Edward operated the bakery. Charles's sons, William and Robert, ran Kuss Bakery until it finally ceased operations in February 1974. William's son, Fred, was also working for the

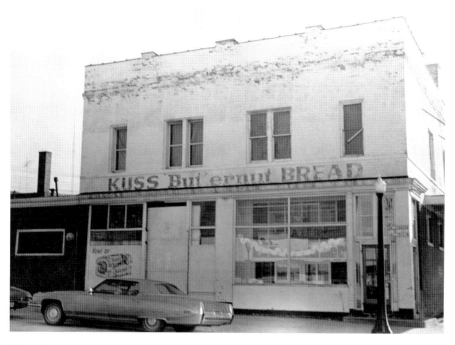

When Kuss Bakery (seen here circa 1974) ceased operation in February 1974, the business was located at 119 West First Street. *Mishawaka Historical Museum.*

bakery at the time, the fourth generation of the Kuss family to participate in the business. The building where the bakery had been for three-quarters of a century was badly damaged by fire in November 1974. The weakened structure was immediately demolished, part of the urban renewal that would eventually raze the entire Northwest Block.

Mishawakans old enough to remember Kuss Bakery speak with nostalgia of its tasty baked goods, especially bread and pecan rolls, and the aromas that wafted from Kuss's ovens and filled the downtown.

Kuss Bakery is only a memory now, but the Kuss House, which was built with profits from Fred's business, still stands. The home, which was on the market for some time and finally sold in August 2022, will now be the setting for another Mishawaka family to write their own history.

Chapter 2

IN SEARCH OF MISHAWAKA'S INTERURBAN STREETCAR LINES

In Mishawaka's East End are remnants and legacies of one of the area's significant transportation advances.

East of Byrkit Avenue, a road parallels the Norfolk Southern tracks and extends beyond the city limits to Osceola. It is paved in some areas and dirt in others. East of Capital Avenue, signage identifies the road as East Third Street. A side street at best or more like an alley elsewhere, it was once part of Indiana Railway Company's twenty-six-mile interurban line that connected South Bend, Mishawaka, Elkhart and Goshen.

Streetcar service in Mishawaka and South Bend predates this interurban line. Horse-drawn cars operated in and between the cities as early as 1885, and electric streetcars replaced them in 1890. Linking multiple towns over greater distances was the interurbans' achievement.

The new electric interurban line opened to passengers on Sunday, July 30, 1899. The first car left the South Bend station, located at Washington and Michigan Streets, at six o'clock in the morning and departed from Elkhart one hour later. On this first day of service, streetcars left South Bend every half hour until midnight, and three thousand people—mostly from Mishawaka and South Bend—rode the rails between the cities. Afterward, regular service included departures from both South Bend and Elkhart on the even hours and trains from Elkhart to Goshen every half hour.

The railway's route from South Bend followed the St. Joseph River along today's Lincolnway and then through Mishawaka on Second Street. East of the city limits, the streetcars turned south at what is now Byrkit Avenue, into

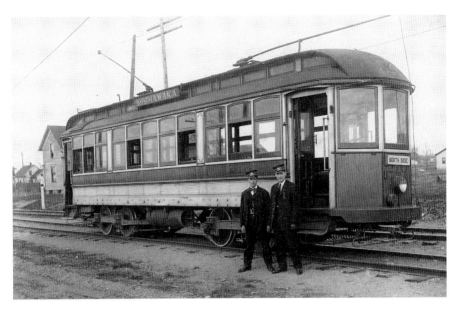

An interurban car is shown on Mishawaka's North Side line, circa 1910–20. *Mishawaka Historical Museum.*

a private right of way on the George Byrkit farm. From there, the line went east, paralleling the north side of the Lake Shore & Michigan Southern Railway tracks for five miles, including a stop in Twin Branch, before entering the property of Indiana Railway Company's power plant and car storage barn on the western edge of Osceola. The route continued east through Whittaker and into Elkhart before going to Yellow Creek, Dunlap, Keely and Goshen.

"The big cars of the Indiana Railway Company went back and forth every half hour loaded to their utmost capacity with citizens of the four newly linked sister cities, South Bend, Mishawaka, Elkhart and Goshen," the *Mishawaka Enterprise* reported. "It was a bonanza for the lucky street car company. The line is in fine shape and the trips were made with regularity and fair speed."

Fare for a round trip to the eastern end of the line was forty cents from South Bend and thirty cents from Mishawaka. One-way tickets were twenty-five cents and twenty cents, respectively.

The interurban's electricity came from South Bend Electric Company, the powerhouse in Osceola and a similar generating facility in Dunlap. The car storage barn in Osceola had seven hundred feet of track and accommodated fifteen to twenty cars. Dunlap and South Bend also had car barns.

Initially, the company's trackage totaled fifty miles, and its rolling stock was comprised of fifty cars, including twenty-three open summer cars and twelve closed winter cars.

The opening of the new electric interurban line "connecting in one commercial and social circuit the prosperous cities of South Bend, Mishawaka, Elkhart and Goshen and the pretty villages along the line marks an important epoch in the history of northern Indiana," stated the *South Bend Tribune*.

> *It brings these points nearer together in every sense than ever before. It holds out a promise of closer union commercially with a resulting benefit to each. It offers the opportunity for the social elements in each to mingle with a more friendly and a much nearer acquaintanceship than has heretofore existed.*

In the following decades, Indiana Railway Company went through various name changes and acquisitions of competing lines. It also expanded to Michigan City, LaPorte, Niles and St. Joseph before a series of receiverships and competition from cars and buses led to its later contraction, and interurban service in the area ceased altogether on June 1, 1934. Streetcars in Mishawaka and South Bend ran until June 16, 1940, and then buses took over their old routes. Most of the track was abandoned and salvaged for scrap metal, but some of it is still uncovered periodically in downtown Mishawaka during street projects. Transpo is the direct descendant of Indiana Railway Company.

Today, you can see the path of Indiana Railway Company's interurban line in Twin Branch by following the road that runs north of the Norfolk Southern tracks. Two bridges in this area remain from the interurban line. One is at Laing Creek, south of Laing Park. The other is half a mile east at Woodward Ditch near Lawndale Avenue. Both bridges are about twenty feet wide. The Woodward bridge is sixty feet long, and the Laing bridge is forty feet long.

These old, forgotten interurban bridges and the roadbed connecting them are authentic vestiges of the earliest efforts to connect cities in northern Indiana with regular local passenger rail service. Another echo, albeit not historic, of Indiana Railway Company is the "Interurban Trolley," the green buses decorated to look like old-style trolleys. The Interurban Trolley yellow line connects Transpo's Mishawaka Transfer Center with downtown Elkhart and the red line to Goshen. Between downtown Mishawaka and Byrkit Avenue, the green buses run on the precise route of the interurban. In Twin

A bridge over Laing Creek, as seen in 2023, is a vestige of the Indiana Railway Company, which connected Mishawaka and South Bend to Elkhart and Goshen. *Author's collection.*

Branch, they operate within sight of the old roadbed near the Lake Shore. Wherever these nostalgic buses drive, though, they ride, in spirit, on tracks first traveled long ago by Indiana Railway Company's interurban trains.

Another reminder of the interurban line that connected Mishawaka to Elkhart and Goshen can also be seen in nearby Osceola. George Bradley's book *Northern Indiana Railway* states that the Osceola power plant and car barn shared a forty-by-three-hundred-foot building. After the railway began purchasing its electricity from Indiana and Michigan Electric Company in 1908, the Osceola power plant was shut down and replaced with an electric substation.

Modern aerial images show that East Third Street, part of the interurban's route through Twin Branch, continues into Osceola, running parallel to and north of the Norfolk Southern tracks. East Third Street ends south of the Beech and Lincolnway West intersection.

A 1911 map of Osceola in the Ball State University archives indicates where Indiana Railway Company trains diverged from the track that ran alongside Lake Shore & Michigan Southern Railway and where the property with the

power plant and car barn was. The map shows that Osceola then consisted of several dozen platted lots on Washington Street, Chestnut Street, Union Street (today's Apple Road) and Vistula Road (Lincolnway). Half a mile west of Union Street, another north–south road crossed the railroad tracks: modern-day Beech Road. The 1911 map shows a trapezoidal property east of this road and south of Vistula labeled "Indiana Ry Power Plant." A rail line cut diagonally through the parcel before continuing east on Vistula. Today, this property is the large gravel parking lot west of Osceola Hardware and across the street from the Osceola Town Hall.

At that site, there is a sign for one of the Interurban Trolley's yellow line stops at the southeast corner of Lincolnway and Beech. Given the site's past, the sign's location is wonderfully appropriate.

Another chapter in Mishawaka's interurban history was written in the East End during this era. Chicago, South Bend & Northern Indiana Railway Company (as Indiana Railway Company came to be known) used to operate a spur line from its main track north on Virgil Street and across Lincolnway East to the Mishawaka Water & Electric Department's pumping station, a distance of a third of a mile.

In March 1913, the City of Mishawaka reached an agreement with the railway for it to build the spur, which would be used to bring coal and building supplies to the station. The pumping station, which opened later that year, needed coal for its two boilers and massive Corliss engine. At the time, the North Virgil pumping station was the city's primary source of drinking water.

The Virgil Street spur line continued bringing coal to the pumping station until 1953. After the interurban line ceased operations in 1934, New York Central, which ran the main line, brought coal cars to the siding. The railroad's locomotives were unable to make the sharp turn onto the siding, so trucks were used to tow the coal cars along Virgil Street to the pumping station. Imagine the unusual sight that Beiger School students enjoyed as giant coal cars moved slowly past their classroom windows!

When larger trucks became available, it was just as affordable to unload the coal at the railroad switching point and deliver it by truck. What finally settled the matter was the potential danger caused by railcars crossing Lincolnway. In August 1955, the rails were removed from the unpaved stretch of South Virgil between Lincolnway and East Third during a street project.

It is unknown when the other rails were taken out. Today, no rails are visible anywhere between the Norfolk Southern tracks and the entrance to the pumping station. As late as twenty years ago, though, two mysterious

BUSINESSES

Chicago, South Bend & Northern Indiana Railway Company and, later, New York Central delivered coal on a spur line along North Virgil Street to the city's pumping station. The tracks were removed in 1955. The street is shown here in 2023. *Author's collection.*

rails could be seen just north of the Lincolnway-Virgil intersection. Perhaps they, too, were removed, or maybe they were paved over and wait to be exposed again when the asphalt deteriorates. Were that day to come, the rails would be the last vestige of the Virgil Street interurban line.

Indiana Railway Company and the Virgil Street spur line are long-lost features of Mishawaka's transportation history. A century and more ago, these railroads met the ever-present need to move people and freight. Today, that need is met through other means that are easy to take for granted. Instead of grumbling next time the crossing gates go down, pause and remember the interurbans, which contributed much to the area's growth, prosperity and interconnectedness.

Chapter 3

ACHILLE ALLY 1923

Standing at 429 West Eighth Street in Mishawaka is a two-story, dark brick structure that was the home of Case Printing for many years. It is now a private residence.

This former commercial building is one of the best surviving examples of the neighborhood "corner store" type of architecture in all of Mishawaka, not just the West End. Some of these commercial structures have had their exteriors significantly modified, but the venerable landmark at 429 West Eighth retains its original appearance.

A distinguishing feature of this building is the limestone plaque between the upstairs windows and the roofline. It says, "Achille Ally 1923." This plaque evokes the era when the West End teemed with Flemish immigrants, some of whom became entrepreneurs.

"The west side business district has had added to its business center a new brick business block in the completion of the Achille Ally two-story building at West and Eighth streets," reported the *South Bend Tribune* on Friday, September 14, 1923. The building was "equipped with a vestibule front and display windows," and Ally and his family resided in the upstairs apartment. The building measured twenty-four feet along its frontage on Eighth and forty-five feet deep along West Street. Achille's "dry goods and notions" store opened for business on Saturday, September 15.

Achille Ally was born in Ruyselede, Belgium, in 1883 and immigrated to the United States in 1910. He married Elodie Mesta Mestdagh, who also immigrated from Ruyselede in 1910, at St. Bavo Church on February 7,

In 1923, Achille Ally constructed this building at 429 West Eighth Street for his dry goods store. *Author's collection.*

1911. The Allys had one son, Cyriel, born in 1911. Achille operated Ally's Dry Goods Store until he retired in 1943.

Achille and Elodie were living at 430 West Eighth, directly across from their former business, when Achille died on February 20, 1953. Elodie continued to reside in their home until she passed away on May 30, 1965. The Allys are buried in Fairview Cemetery.

The Ally Dry Goods building may seem ordinary, but it is significant in multiple ways. The "Achille Ally 1923" plaque on top suggests the great pride that the Allys felt in their venture. Just thirteen years after emigrating from Belgium, Achille and Elodie had been able to raise the capital to erect a substantial building that would be the family's livelihood and home. They were living the American dream.

The Allys worked in a time when locally owned "mom-and-pops" proliferated throughout Mishawaka. These small business owners staked everything on their ability to provide quality products and services to their neighbors and friends. Many stores and other businesses bore the owner's name, and these Mishawaka families' good names were literally invested

in the success of their business. Some of those family-named and run businesses remain in Mishawaka today, such as Hahn Funeral Home, Vic Trippel Plumbing & Heating and Powell the Florist, but they are far fewer in number today than a century ago. It is a commonly expressed sentiment that Mishawaka should have more family-owned enterprises, some of which might include their name in the business title. Achille went one better, etching his name in limestone. Long after Ally died and even longer since he closed his business, this building, including the sign, still bears witness to his family's dream and entrepreneurship.

The Ally building and several other West End commercial buildings merit designation as historic sites by the Mishawaka Historic Preservation Commission. This would ensure the buildings' survival and architectural integrity for another century so they can continue to evoke the stories of immigrants who came to Mishawaka for a better life and found success.

Chapter 4

"FOR YOUR DINING PLEASURE"

Garrett's White Spot Restaurant

The Mishawaka Historical Museum has several artifacts from restaurants and hotels that have operated in Mishawaka, including a menu from Garrett's White Spot Restaurant, located at 2219 Liberty Drive. Garrett's White Spot prospered for a time, was known by everyone in town and then closed its doors. As the years passed, the restaurant faded from Mishawakans' memory. What is the history behind this lost Mishawaka business?

John Garrett was born in Lakeville in 1910 and was a lifelong area resident. He married Helen Burggraf in 1936 in South Bend. John left his job as a supervisor at Oliver Corporation in 1947 to develop land that he purchased earlier that year at the southwest corner of Liberty Drive and West McKinley Avenue. This property was at the city limits and may have seemed like it was on the edge of the frontier. "At the time, it was nothing but an open field," Helen Garrett later recalled. "The only other thing in the entire area was the Magrane Animal Hospital on the opposite corner." Some of the surroundings included swampland. The Garretts' property had been a place where children played and dug tunnels.

The Liberty/McKinley intersection seemed rural, but it would not remain so for long. Later that year, Bethel College opened its doors five blocks to the west, and construction of homes began at Normain Heights half a mile east.

The Garretts lived at 2105 Liberty, one block away, and they later resided at 509 West McKinley. John and Helen had two daughters, Christine and Diane.

Garrett's White Spot, shown here in the mid-1960s, was located at the southwest corner of Liberty Drive and McKinley Avenue. *Mishawaka Historical Museum.*

The White Spot Lunch opened in 1947 as a drive-in that could accommodate thirty patrons, and it specialized in frozen custard. The restaurant was the Mishawaka area's first to offer "remote drive-in ordering" (ordering by intercom from a call station). The White Spot later added broasted chicken to its menu, another first in the area.

In 1951, the Garretts expanded the White Spot to include indoor seating, bringing the restaurant's capacity to seventy-six patrons. Two years later, they opened the twelve-unit Garrett Motel at 423 West McKinley. To do so, the Garretts acquired the remainder of the block bounded by Liberty, McKinley, Russ Avenue and Charlotte Street.

In 1963, John and Helen again enlarged the White Spot, turning the drive-in into a coffee shop and constructing a 7-room addition with both lower-level and ground-floor eating areas. Garrett's White Spot Restaurant & Lounge had its grand opening on Saturday, December 21, 1963. The coffee shop could seat 14 customers at the counter and 64 more in the booths and tables. The main dining room, known as the Gold Room, seated 84, and adjacent to it was the Royal Room, which had seating for 76. The basement had a large banquet room with two smaller adjoining rooms. The lower-level areas could be combined into one room with a capacity of 250 persons. The restaurant also featured the L-20 Lounge

BUSINESSES

The Garrett Motel, shown circa 1960s, stood to the west of the White Spot. *Author's collection.*

and a modern 30' × 60' kitchen. The entire building measured 163' × 80' and had a 200-space parking lot.

Garrett's White Spot operated seven days a week. The coffee shop opened at six thirty in the morning, and the dining rooms began serving at ten thirty. The lounge was open from ten thirty in the morning to midnight. The restaurant advertised its availability for business meetings and social gatherings, including afternoon card parties and wedding dinners and receptions. Garrett's White Spot also featured a "freezer fresh carry out department."

John Garrett died in 1967, and Helen continued to operate Garrett's White Spot and the Garrett Motel. The restaurant closed on June 21, 1974, and the entire property was sold to Mishawaka Federal Savings, which demolished the structures to make way for its first branch office. That building opened in 1975 and was used by Mishawaka Federal and its successors, most recently Northwest Bank, until the office closed in April 2022.

Helen Garrett died in 2005, and she and John are buried in Fairview Cemetery, a few blocks from where their restaurant stood.

Today, restaurants and hotels are everywhere on Mishawaka's north side, but it was a much different landscape in the 1950s and '60s. Mishawaka had only a handful of small motels then and limited options for sit-down dining.

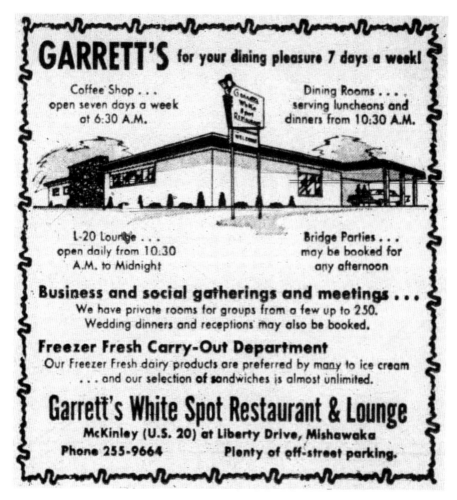

Garrett's White Spot placed this ad in the September 18, 1964 *South Bend Tribune*. *Author's collection.*

Long after Garrett's White Spot and the Garrett Motel were razed, John and Helen Garrett should be remembered as pioneers of the commercial development that would sprawl along McKinley Avenue and, later, Grape Road and North Main Street.

Chapter 5

GHOST SIGNS

In Search of Mishawaka's Historic Painted Advertisements

Outdoor commercial advertising today comes in many forms: billboards, digital signs, neon lights, vehicles wrapped in corporate logos, letters mounted on buildings. Likely none of these methods will match the longevity of the advertisements painted on brick buildings and wooden barns in the early and middle twentieth century. For decades, these displays weathered both the elements and the vicissitudes of an endlessly transforming economy, often far outlasting the products and companies they were created to publicize. Known by the evocative term *ghost signs* because of their fading paint and archaic subject matter, such ads can be found throughout the United States and internationally. Mishawaka, too, has daily sightings of these commercial specters—if one knows where to look.

Unfettered by zoning and signage ordinances, advertisers could not resist painting their message on any prominent wall, wherever the greatest number of potential customers could see it. Ads for bread or Coca-Cola commonly embellished urban commercial buildings, and CHEW MAIL POUCH TOBACCO messages proliferated on barns throughout rural America. These signs "evoke the exuberant period of American capitalism," asserts Kathleen Hulser of the New York Historical Society. "Consumer cultures were really getting going and there weren't many rules yet, no landmarks preservation commission or organized community saying, 'Isn't this awful? There's a picture of a man chewing tobacco on the corner of my street.'"

Artists called wall dogs created these ads using lead-based paint, which helped the signs stick to the masonry, kept out water and protected against

sunlight better than modern paint does. Some paint even seems to have seeped into the brick, forever staining it the intended color. Because restoring or painting over ghost signs was often cost-prohibitive, some remained in the open for decades, neglected, gradually flaking and fading. Others survived because they were hidden by the walls of newer, adjacent buildings. When the later structures were demolished, the long-forgotten signs were exposed, emissaries from a bygone era of business.

Interest in ghost signs has grown in recent years. Part of their appeal suggests a reaction against modern billboards' mass-produced, ephemeral slogans and images. By contrast, these hand-painted signs from long ago have endured, becoming landmarks of the streetscape or countryside. "With the advent of perfection of digital, you can lose sight of the human touch," asserts Sam Roberts, who leads ghost sign tours in London, England. "Signwriting has minor imperfections, but through the medium you have a connection with the person who produced it." One former wall dog noted that the signs were "painted to the signperson's skill and came out beautiful.…There's a human factor there that will never be seen again."

Even more compelling, ghost signs are tangible links to the past that have somehow lasted into our own time, yet their faded condition speaks to the decay and loss that inevitably claim all things. Ghost signs also contribute to a place's distinctiveness. The *Guardian*'s Nick Gadd writes,

> *I think of ghost signs as fragmentary urban memories. A humble ghost sign can teach you something about a place's history that a great public building cannot.…In a world where many cities feel increasingly the same, a ghost sign can offer a unique and particular experience of place.…Sometimes illegible or obscured, they tease us with fragments of meaning. Even when the sign is clear, the story behind it is not, which opens up a space for the imagination. Ghost signs add mystery to cities, which might be the profoundest part of their appeal.*

Where can these apparitions of advertising be found in Mishawaka?

The most famous and prominent ghost sign in Mishawaka—or the county, for that matter—is on the south wall of Doc Pierce's Restaurant, located at 118–120 North Main Street. An Italianate structure dating to 1873, the building is one of the oldest in downtown Mishawaka. After the Great Mishawaka Fire of 1872 devastated this block and its neighbors to the west and southwest, brick structures such as this quickly arose from the smoldering ashes and marked the town's rapid recovery from its worst disaster.

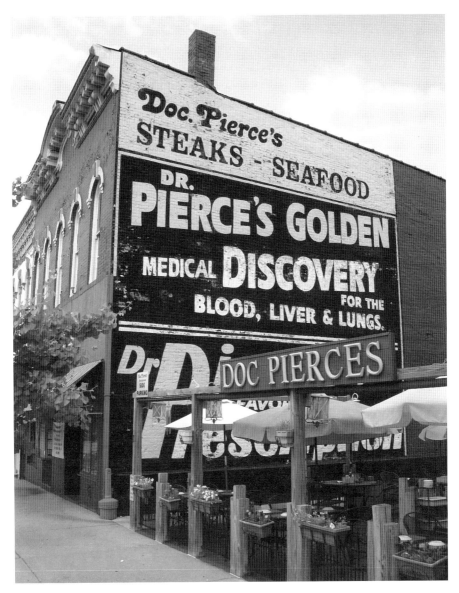

The Doc Pierce's sign at 118 North Main Street is a downtown landmark. *Author's collection.*

This building was erected in the aftermath of a great fire, and fire also played a role in a later chapter of its history. In January 1974, a massive blaze destroyed the Larimer Bros. Furniture Store at 114–116 North Main, which stood in what is now the restaurant's outdoor dining area. Removing the debris exposed a large, two-panel advertisement for Dr. Pierce's Golden

Medical Discovery and Favorite Prescription products. The sign was painted sometime before 1900, when a building was constructed at 116 North Main.

Who was Dr. Pierce? Dr. Ray Vaughn Pierce was born in 1840 and graduated from a medical college in Cincinnati. He practiced medicine in Titusville, Pennsylvania, for four years before moving to Buffalo, New York, where he established the Invalids' Hotel and Surgical Institute and began the World's Dispensary Medical Association. Pierce manufactured and sold patent medicines, which were advertised extensively throughout the United States, including on signs such as this. Two of Dr. Pierce's most famous products were his Golden Medical Discovery, said to improve digestion and relieve gas pains, and Favorite Prescription, a remedy for pains and nervousness suffered by girls, women and expectant and nursing mothers. The bottom of the Mishawaka sign originally included the phrase CURES WEAK WOMEN, which was later covered over. Pierce also briefly ventured into politics, serving two years in the New York State Senate and a term in the U.S. House of Representatives. He died in 1914.

Even before the fire, plans were underway to turn the old Reno Bar at 120 North Main into a new restaurant. Bruce Tassell; his wife, Pat; and their business partners Coy Jankowski and Tom Wilson carried out the interior remodeling, constructed a new lower-level facade and hired C. Smith Signs to restore the faded Dr. Pierce's sign to its original black background and bright yellow letters. Following the suggestion of a Mishawaka physician, the establishment was named Doc Pierce's Saloon when it opened in July 1976 and advertised itself as "good for what ales ya." Above the two panels of the original sign was later added a third panel that said, "Doc. Pierce's STEAK-SEAFOOD," using black letters on a yellow background.

Doc Pierce's Restaurant and its restored ghost sign are icons of downtown Mishawaka. More than a century after Dr. Ray Vaughn Pierce died, one of his ubiquitous ads survives in the Princess City, evoking a different era of both marketing and medicine.

The Doc Pierce's sign was restored again in the summer of 2022, giving a fresh coat of paint to the existing design and making the fading, flaking yellow and black more vibrant.

Purists such as ghost sign photographer Dr. Ken Jones assert that historic brick signs such as Doc Pierce's "should not be restored or recreated" because such efforts often obscure or substantially alter the original artwork. New paint will also eventually peel, detracting from the sign's aesthetics and necessitating yet another restoration effort. Some signs have instead been conserved to retain their actual, albeit faded, appearance, or

The faded remnants of Dill Camera Shop's sign are still visible at 119 South Main Street. *Author's collection.*

missing letters or sections have been carefully repainted to match the rest of the advertisement.

One block from Doc Pierce's, another ghost sign haunts the second-story south wall of the building at 119 South Main Street. Unlike the advertisement for Dr. Pierce's products, this sign has never been covered up by a neighboring building, and its paint has significantly deteriorated, effacing much of the message.

The building was constructed in the 1890s and saw numerous tenants until Dill Camera Shop relocated there from 118 West Mishawaka Avenue around 1944. The origin of Dill's goes back to 1912, when Earl Dill came to Mishawaka from Frankfort, Indiana, to do photo processing for Hook's Drug Stores. Dill's daughters and their families continued the enterprise as two separate businesses: a camera shop in the front and a photo lab in the back. Ken Atkinson married Dorothy Dill and ran the camera shop until he was succeeded by his son-in-law, Jeff McWhirt, who was co-owner with Chuck Perry until 1991. McWhirt sold the business to Gene's Camera Store of South Bend in 1996 and remained as manager of the Mishawaka location until it closed in 2019.

A 1959 photo partially shows a sign for Dill Camera Shop painted on the building's exposed brick wall. Ideally located, the sign was visible to any driver approaching downtown from the south. The photo includes the right half of the ad, with a large DILL to the left of CAMERA and SHOP, which appear on two lines, and SUPPLIES on a third line above the image of a movie camera.

The Dill Camera sign had changed by the mid-1960s. A color home movie depicting various downtown buildings shows an eight-second glimpse of the corner of Third and South Main and the full sign. Also, several black-and-white photos from the 1960s and '70s show partial or distant views of the sign. Together, these sources reveal most of its content. Across the top third of the sign is DILL CAMERA SHOP in large blue letters against a white background. Large red letters read PHOTO FINISHERS in the right two-thirds of a yellow horizontal band that crosses through the middle of the sign. Smaller letters to the left appear to say YOUR ONLY QUALITY, and along the bottom of the band is OF BLACK AND WHITE AND COLOR FILM. The lower third of the sign includes, in blue letters on a white background,

RECOMMENDS SYLVANIA BLUE DOT
FLASHBULBS AND PROJECTION LAMPS

A 1970s photo showing only the bottom of the ad shows the same text. Jeff McWhirt notes that the sign was partly underwritten by Sylvania as advertising for its product line.

The Dill Camera sign was altered more than once, according to McWhirt, and the last repainting was done by C. Smith Signs in the 1980s. A three-dimensional painted plywood cutout of a Nikon camera was added, but it was removed when the building's masonry was later tuck-pointed.

Today, so much fading has occurred that only a few words are identifiable, yet enough visual evidence exists to prove that the sign's content is different than it was in the 1960s and '70s. The clearest lettering is along the bottom of the ad:

SYLVANIA
BLUE DOT FLASHBULBS AND PROJECTION LAMPS

This wording is apparently the same as before, but SYLVANIA and BLUE DOT have moved to the lower left corner of the ad. The yellow band with its fading red PHOTO FINISHERS is also still visible, and the faint remnants

of large letters across the top of the sign seem to include DILL in the upper left. What survives is mainly a white rectangular background—with some bricks entirely devoid of paint—that suggests the ad's dimensions. The sign is now mostly just a memory for those Mishawakans old enough to recall its message and vibrant colors.

Also contrasting with Doc Pierce's, the Dill Camera sign is unlikely to be restored. The business no longer exists in downtown Mishawaka, and the building's current occupant, DoJo Creative, is a marketing and website design firm—entirely unrelated to the subject matter of the ghost sign. Jeff McWhirt also explains that the tuck-pointing contractor cautioned that having paint on the building interferes with the brick's ability to breathe and could hasten the masonry's deterioration. Some vestiges of the Dill Camera sign could last for decades, a spirit slowly fading away until it disappears entirely. Doug Elder, the new owner, has expressed interest in mounting a new sign on the side of his building, which would completely cover but potentially preserve the remnants of the old Dill sign.

The third historic ghost sign in downtown Mishawaka can be sighted on the north wall of the two-story commercial building that includes 221, 223 and 225 North Main Street. This structure was erected around 1911. Daily, thousands of drivers used to see more recently painted signs, such as one for Lighthouse Autism Center, on the first floor's brick wall-for-hire, but the current occupant of the building, Popular Smoke & Vape, has mounted its own advertisement on the painted brick. To the right of the new sign, an eagle and American flag with the words UNITED WE STAND above it remain painted on the brick. What passersby rarely notice, though, are the other two signs on the wall. In a band that runs the full length of the building, just below the roofline and above a row of boarded-up windows, is a sign that begins with a faint white MISHAWAKA, followed by mostly bare, dark-red brick and just a vapor of other letters in a second word—perhaps AN and ING—followed by a more discernible CO. The sign is surrounded by faint hints of a white border. Below the S and H and between the first two windows of the second story is a smaller sign, its white letters partly gone but still readable from a short distance away:

BATTERIES
CHARGED
-AND-
REBUILT.

The Mishawaka Vulcanizing ghost sign had almost entirely faded away by 2017. *Author's collection.*

What phantoms haunt the wall of this nondescript building that anchors the north end of the central business district? The mysterious disappearing sign along the top advertises the Mishawaka Vulcanizing Company, which first appears in the 1919 city directory at 221 North Main, the storefront on the building's south side. An ad in the directory reveals that Mishawaka Vulcanizing was a tire repair shop that specialized in "sand boils, blow outs, rim cuts and re-treading." Vulcanization is a process that uses heat and pressure to bond rubber components into a finished automobile tire. By 1920, Mishawaka Vulcanizing had moved to 225 North Main, the other end of the building. Clyde K. Bosse and Louis Goss were the business's owners in 1919, but Bernard J. Myers replaced Goss as partner the next year. Mishawaka Vulcanizing appears in the city directory until 1925, by which time Myers was listed as sole proprietor of the business. The next year's book identifies the establishment as "Bernard J. Myers auto sups [supplies]," and the name Mishawaka Vulcanizing Company was never again used. The faded sign atop the building thus dates from a narrow range of years, 1919 to 1925. Afterward, because the business's name changed, there was no reason to refresh the paint on the sign, which was left to gradually fade away. A photo of North Main Street taken in 1950 shows the left half of the Mishawaka

Vulcanizing sign, which was already deteriorating. The batteries ad, which had a black rectangular background and a white border, is likely from the days of the auto supplies store in the 1920s or '30s. Myers purchased the building in 1928. His business had evolved into a tire dealership, Myers Tire Shop, by 1932, and he continued as the proprietor until 1945 or 1946. Raymond Eberhardt owned the tire store by 1947. Later also called Eberhardt Auto Supply, the business remained at 225 North Main until about 1955, after which it moved three doors south to 217 North Main.

Each of the three storefronts comprising this building is owned separately, and 225 North Main Street remained in the Myers family. After Bernard Myers's death in 1956, his daughter inherited the building. His grandson, Buzz Nicholas, next owned the property and operated Buzz's Used Furniture there from 1997 until his death in 2021. Nicholas explained that Myers ran the "equivalent of a Firestone store" and changed customers' tires on a concrete pad outside the northwest corner of the building, along Front Street. He also sold auto parts and supplies, including batteries. In the building's earlier days, there were apartments above all three storefronts, but none of these spaces is used today. Beginning in the early 1990s, Buzz rented the sign space on the north side of the building to political candidates, businesses and

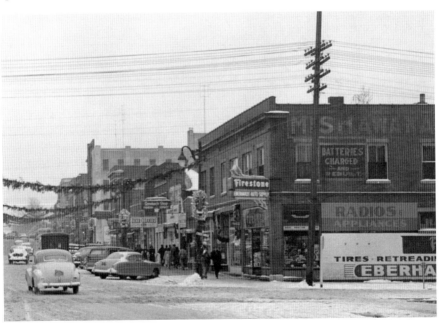

Mishawaka Vulcanizing Company's painted sign is one of several seen at 225 North Main Street in this 1950 photo. *Mishawaka Historical Museum.*

other advertisers. He noted that painted signs within one hundred feet of the Main Street corridor must conform to strict Mishawaka zoning ordinances and be approved by city officials.

The city's fourth historic ghost sign is located at 501 East Lawrence Street, half a mile northeast of downtown. Constructed sometime between 1923 and 1925 in the north side's Italian community, this two-story building was first Michael From's grocery store, according to the 1925 city directory; several different grocers followed him during the next two decades. The Horvath & Forte Grocery operated there in 1945, and John Forte became sole proprietor by 1947. Forte's Grocery remained at the corner of Lawrence and Locust until 1975. After it closed, two other grocery stores briefly occupied the space before Shirley's Pet Salon settled in from 1978 to 2001.

Howard R. Kirk and his daughters Sheila Leal and Glenda Goins acquired the building in 2005 and opened Candy Apple Corner, a store that sold antiques and both new and vintage furnishings, including repainted children's furniture. "I always had aspirations of having a shop," explains Glenda. "My sister and I thought it would be awesome to have something in here. It was close to my house. You just walked by and fell in love with this building."

When Kirk and his daughters began their business, the lower level of the east side of the building featured a fading painted advertisement for Mason's Root Beer. The design included the words OLD FASHIONED and TOPS FOR TASTE to the left of a large bottle cap that said MASON'S OLD FASHIONED ROOT BEER. Mason's Root Beer began production in 1947, and one longtime neighborhood resident states that the ad was already there in 1958. Helping preserve the sign from the elements was a line of huge pine trees that were removed to make the adjacent lot available for possible use by Candy Apple Corner. Glenda recalls using the ghost sign as a landmark when directing customers to the store.

In the summer of 2008, Leal and Goins began restoring the Mason's Root Beer sign, carefully repainting the existing letters, bottle cap and tan background. "We thought it would help bring in business. Besides, we thought it was just cool," remembers Sheila. "The sign was bringing to life something from years and years ago. It was important to keep the vintage." As the sisters began the project, they discovered that the original Mason's sign appeared to have been more "crudely" restored once before, and a darker band across the top of the ad had been painted over earlier wording.

When their father died in August 2008, Glenda and Sheila stopped restoring the sign, and they closed the business shortly after. The storefront space remained vacant for years but later was renovated into an apartment.

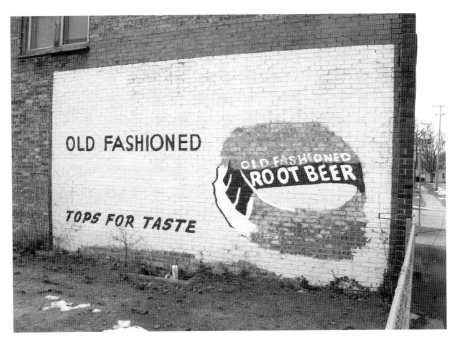

A partially restored Mason's Root Beer sign appears on the side of the former commercial building at 501 East Lawrence Street. *Author's collection.*

The upstairs apartments also are being rented. The new paint on the Mason's sign retains its vibrant colors, and close observation of the unrestored sections reveals the nearly vanished letters MAS on the bottle cap. The sisters have considered completing the sign in the future.

In Mishawaka, these four classic ghost signs survive, and the artistic practice of painting advertisements on buildings continues into the present. The former Merrill Pharmacy at 606 North Main Street features a painted sign on the lower level of the brick building's north side, west of the drive-through. The sign features the pharmacy's name in large blue script on a white background and has been updated in recent years to include smaller logos for the business's new Hometown Pharmacy chain affiliation and a hair salon formerly located one door south. The BK Root Beer stand at 1020 North Logan Street displays a mural on its cinder-block west wall showing a frosty mug of root beer connected by a chain leash to a hot dog and the words DOG'S BEST FRIEND. Parkway Lanes East bowling alley at 1504 Chestnut Street features on its cinder block west wall a mural that includes the name of the business, the word *pizza* and images of a pizza slice, a beer mug, five bowling pins and two bowling balls. The largest painted-brick sign

in Mishawaka is at the Town & Country Shopping Center. The entire west wall of the Mishawaka Furniture store—approximately 150 feet long—is an advertisement for the shopping center. On a tan background, small red letters at the top say TOWN & COUNTRY. Below in large blue letters is the slogan "Convenient & Friendly Shopping" in script, and an interlocked T and C emblem is at either end of the enormous sign.

The most artistic of the city's modern painted signs is on the cinder-block north wall of the Ozark Pawn Shop at 1006 South Merrifield Avenue. On the right half of the mural is the business's name and phone number and the slogan WE PAY CASH FOR ALMOST ANYTHING. To the left are images of a car, a guitar, a diamond ring and a drill emerging from several $50 and $100 bills and the traditional symbol of pawnshops, three balls suspended from a bar. The colorful design is one that even the most skilled wall dog of years gone by would admire.

Unless they are painted over or their buildings are demolished, these advertisements may eventually become ghost signs, joining many venerable painted-brick displays throughout the country. One other local painted ad of recent vintage is already doing just that. On the cinder-block east wall of the former Woody's Paint Spot building at 602 East Mishawaka Avenue is a sign advertising the business. Interestingly, C. Smith Signs, which worked on the Doc Pierce's and Dill Camera signs and painted the Autism Lighthouse Center sign, was in this building until about 1991. The city directory shows that Woody's Paint Spot, which later came to include a NAPA Auto Parts store, moved here by 1994 and remained until around 2014. In recent years, the building has been the home of the Actors Ensemble, a local dramatic group that rehearses and performs there. The advertisement, which also was painted by C. Smith Signs, features cans of Valspar and Sherwin Williams paint being poured out behind the logo that reads "WOODY'S PAINT SPOT" and, in smaller letters, "INDUSTRIAL AND AUTOMOTIVE PAINT SUPPLIES." The sign is fully readable but has begun to fade. Though not a historic design painted on brick, the Woody's Paint Spot ad is still a modern ghost sign, promoting a business that no longer exists.

Chasing ghost signs teaches lessons about past products and businesses, the people associated with them and changes in marketing and the economy. Awareness of these ads also encourages local residents to be more observant of their community and the details of its landmark buildings. Mishawaka is fortunate to have four visible historic ghost signs, and removing layers of paint, aluminum siding or neighboring buildings may someday bring about nostalgic hauntings by more of these visions from yesteryear.

Chapter 6

"THE MOST BEAUTIFUL WAY OF LIFE"

Mishawaka Artist Melvin Johnson

Mishawaka's Melvin C. Johnson turned his passion for oil painting into a career that spanned more than a quarter of a century and captured on canvas the beauty of scenery and buildings throughout the eastern half of the country. Johnson's studio on West Thirteenth Street was also a gallery where customers came to acquire beloved works of art for their homes.

Melvin Clarence Johnson was born in Chicago on September 26, 1923. After his parents divorced, Melvin and his brother moved to southern Marshall County, and they were raised by their grandmother. Melvin attended Tippecanoe High School, where he demonstrated a talent for art. He took first place in a statewide pen-and-ink drawing competition, and he made all the school's posters and advertising art. Melvin had so much work to do for the school that he lost interest in art and decided not to attend art school despite art teacher Virginia Holt's efforts to convince him to go. She even offered to pay his tuition.

In 1943, Johnson moved to Mishawaka and made boots at Ball-Band. Melvin did not enjoy the job, but his brief time at the factory led him to meet Loretta Verstraete, who worked in the nurse's office at the plant. "The women that saw my dad would swoon," his daughter, Linda Bobson, explains. "He came in and asked her out, and six months later [on June 30, 1945] they were married." The newlyweds made their home at 426 West Thirteenth Street, where they raised Linda, who was born in 1949. The Johnsons were members of St. Bavo Church.

After leaving Ball-Band, Melvin owned a gas station at the corner of Lincolnway East and Indiana Avenue and then worked a Tip-Top bread route for Ward Bakery. Johnson, a car lover, next began selling cars, first for O'Neil Ford, then L.O. Gates and finally Jordan. "He was a terrific salesman," adds his son-in-law, Dennis Bobson. "He won the Ford Top Hat award three or four years in a row."

Melvin was a strong believer in goal-setting, hard work and striving to meet personal challenges. "I always quit a job when I was making the most money," he told Suzanne Kamm for a 1976 article in the *Indianapolis Star*. "I never looked for a job in my life. I sat down and decided where I wanted to work. That's where I worked."

Given Johnson's later prolificacy as an artist, it is perhaps surprising that for twenty years, the ability he had shown as a teenager lay dormant. As far as his family knows, Melvin made no artwork of any kind during those decades.

While Johnson pursued a career in auto sales, his latent talent and interest in art eventually began calling to him. During a trip to New Hampshire in 1963, Melvin purchased a still life, *Country Dance*, by Richard Packer, a college-trained artist. "And one night when I couldn't stop thinking about painting, I decided to call Mr. Packer," Johnson remembered in 1972. "And that's just what I did. I asked if he could help me. Before I called, I had bought an oil painting set, but everything came out mud." For three or four years, Melvin traveled to North Conway, New Hampshire, and studied under Packer several weeks at a time, the only formal training he had had since high school. Johnson and Packer became good friends and later went on a painting trip to Maine together. "He taught my dad a lot. [Dad] really admired him," notes Linda.

Melvin continued selling cars while painting in his free time until he "became addicted to it," in his words. Linda remembers, "He's sitting at the kitchen table with this tiny little easel that he made and a piece of tempered Masonite. He would sit there and he would paint every night and work really hard at it. Next month, you'd see, *Boy, he's improving*. He got better and better."

Loretta encouraged Melvin to make art a full-time career and persuaded him that her job as a bookkeeper at Office Engineers would support them and allow him to pursue his artwork.

In 1965, Melvin and Loretta made the first of numerous trips to the East Coast, where he painted scenes from Newfoundland to Florida.

The next year, Melvin opened the art gallery behind their home, and he began selling his paintings. Grandson Aaron Bobson explains, "He

Melvin Johnson, shown with his wife, Loretta, painting at York, Maine, in 1973. *Bobson Family.*

primarily called it the gallery, but he did have an easel in there. He did all of the still lifes and flower paintings in there." The gallery could hold upward of 180 paintings. It also became a social hub. Linda recalls, "He knew a lot of nice people, and they'd come to visit, not just because they were going to buy a painting." Aaron adds, "There was always somebody in the gallery or always somebody in their big room." Among his frequent visitors was Jordan Kapson, Melvin's former boss at the Jordan dealership. In 1970, Johnson decided to leave his sales job and make a living by painting full time.

Melvin typically painted landscapes and buildings, usually on 24" × 36" canvases, and sold them for $400 or more, both in exhibitions at his gallery and to patrons who saw him at work in scenic locations. He always signed his paintings "M.C. Johnson" near the lower right corner of the canvas. Every other year, Johnson had an exhibition, where he expected to sell 140 paintings or more. "Everybody who dealt with him loved him," Linda states. "So when he opened the gallery, all the people that he sold cars to, they came and bought paintings."

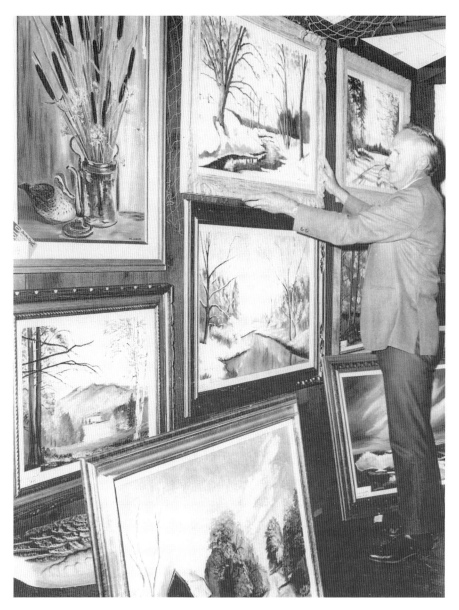
Melvin Johnson positions a painting in his gallery on Thirteenth Street, September 1972. *Author's collection.*

Johnson would even sell paintings in installments, an idea he may have gotten from Packer's gallery. Dennis recalls,

> *Melvin did not believe in credit cards. He would never do a Visa business. If they wanted a painting and couldn't pay for it, a small one was ten dollars a month, and a large one was twenty dollars a month. What he told me is, "It works great. Every time I go to the mailbox, there's a paycheck in there." There might be ten envelopes in there, ten bucks apiece or twenty apiece. It worked for him.*

Loretta was the art gallery's bookkeeper and meticulously kept track of the money and customers' payments. Linda recalls Melvin saying to his wife, "I don't know what I would do without you."

In several newspaper articles from the 1970s and '80s, Johnson reflected on his purpose, preferred subject matter and approach to each painting. In 1972, the *Tribune*'s Larry Williams asked Melvin about the origins of his talent. The artist answered,

> *It's a love of nature. The simplest things are best. The cattails and Queen Anne's lace. People see just 25 percent of what they're looking at. They're oriented to material possessions. You leave that all behind when you walk in the woods enjoying nature. I want to share my life and experiences with other people.*

Johnson's favorite subjects for paintings were seascapes, including lighthouses and boats, and rural landscapes, such as barns, silos, covered bridges and Amish buggies. Many scenes conveyed the theme of what Melvin described as "fading America in a state of majestic decline." Aaron adds, "He said he wanted to paint pictures of things that were not going to be around very much longer."

Melvin and Loretta's travels often took them to the Northeast and the South. In 1975, they traveled twenty-five thousand miles in search of compelling scenes to represent on canvas. Loretta, who never learned to drive, accompanied her husband on all these painting trips.

Johnson's work also depicted places in Mishawaka, such as several of the city's landmark churches, and scenes at Indiana University (IU), Purdue and Notre Dame. "He would do quite a few Notre Dame [paintings]," Dennis explains. "People would come in for a Notre Dame game, and their friends

Melvin Johnson was painting near Parke County's McAllister Covered Bridge when this photo was taken on May 12, 1982. *Bobson Family.*

would bring them over to the studio. A week later, he'd get a call, 'Can you ship that painting we were looking at to Texas?' He would."

Melvin spent three weeks in May 1988 and several weekends afterward in Bloomington, painting scenery and buildings on the IU campus, where Aaron was a sophomore. The *Indiana Daily Student*'s Judy Cebula profiled Melvin in an article that included this description:

> *His easel, standing five feet high, made of strong, plain pine, was a natural magnet for passers-by. Assorted brushes and squeezed tubes of paint cluttered the shelves of the easel. People stopped and smiled at the work in progress and at the silver-haired man in a fishing cap, a red bandana scarf hanging from his back pocket.*

During Johnson's weeks at IU, he painted twenty works. Among his subjects were Woodburn Hall, the Lilly Library and the Indiana Memorial Union.

Melvin told Kamm,

> *I love it outside. If you want the real truth to life, go stand in the woods. Nature will give you the answer to life. You'll see one tree limb grow out of the way of another. Trees have more respect for one another than people have. You'll see it all in the woods, the living and the dead, the young and the old.*

Johnson would only paint what he had personally seen, and his work realistically represented the subject he was depicting—no abstract art or impressionism. "I'm not a postcard painter. If I couldn't stand outside and paint, I might as well take the brushes and throw them in that river," he explained to Cebula, pointing to the Jordan River, which flows through the campus.

Melvin noted that he did not try to make "pretty" paintings. Instead, he wanted to represent the natural beauty he saw. "Nature will tell you anything you want to know, if you observe it," was the fundamental lesson the artist had learned from his work.

"Painting is seeing," Johnson also asserted. Even that which is unattractive, he said, could bring out beauty in a scene. "Ugliness in the right light is beautiful," he added.

Being an artist also required patience. For a painting of St. Joseph Church, Melvin studied the building and its surroundings for two years before choosing to paint it in the spring to capture the most beautiful shades of green in the leaves.

"My ambition is to paint a painting so beautiful, my soul will pour through my fingers," Johnson told the *Tribune*'s Mary Collins in 1980. "It will be so beautiful, it will bring tears to my eyes. Every day, I try for that goal. Every day, I fall short. You always fall short. A painter is never satisfied with his work."

Melvin always said a brief prayer before starting to paint. He typically worked on a painting for a day or two, painting quickly and spontaneously. First, he would paint the sky or other background elements and then the basic form of the primary subject. Next, Johnson would add details to those forms—but not every detail, as he said he wanted to "let people do a certain amount of looking, of supplying details for themselves." Dennis adds, "When he was on the road, he would paint a big one on scene, and then in the evening he would do something else to work on it." Johnson painted every day.

Melvin Johnson painting at the Quarryville Railroad Station in Pennsylvania in October 1982. *Bobson Family.*

Johnson was pleased to have customers spend money on something he had created, but he was also aware that he was selling his experience of creating the artwork:

> *I don't sell a painting. I help people buy a living experience. Good, bad, or otherwise, what I paint is an honest statement of what I thought I saw. When I sell a painting, I'm selling a day out of my life. I sell the thoughts and emotions of that day. I lose a memory when I sell a painting. It's like tearing a page out of my diary to walk out the door.*

Selling a painting involved establishing a relationship between the artist, the scene and the customer. "People who buy my paintings relate in some way with what they see," Melvin explained. "A scene will remind them of something in their lives. They see what I saw. I have succeeded in establishing a rapport with that viewer. Otherwise, they wouldn't buy the painting."

To describe his work as a traveling artist, Johnson said, "This is the most beautiful way of life a human can have."

Linda observes, "I think he was driven. He was not happy unless he was painting. He was happiest on location."

With reporters, Melvin shared some of the memorable experiences he had as an artist. "I meet some of the greatest people in the world while I'm painting," Johnson told Kamm. In West Virginia, he met a man who said he admired a certain painting but regretted that he had no money with him to purchase it. Johnson let him have the painting and said he trusted the man to send the money to him in Mishawaka. The money did soon arrive along with a note expressing amazement that Melvin would be so trusting of someone he did not know. When Johnson was painting a scene, bystanders would often engage him in conversation, even offering him food and housing. One time, Melvin set his easel in the middle of a quiet state highway. When a policeman came by, the officer expressed his support for Johnson's efforts and kept the road clear for the artist to do his work. At Mabry Mill, Virginia, Melvin met a couple who returned to the mill each year to have their photo taken in front of it because they first visited there on their honeymoon. The man and woman were captivated by Johnson's painting of the mill and bought it on the spot.

According to Linda, Mabry Mill was her father's favorite painting location:

> *He loved to go there. That was on the Blue Ridge Parkway. They knew a lot of people in the area. They stayed with people that owned a printing business. He drew such a crowd there that the ranger came along and told him he couldn't paint there anymore because he was causing a traffic jam. He was despondent after that. It was awful.*

Sometimes, Melvin would have to go to great lengths to get the desired vantage point for his subject. He painted in driving rain and intense heat. Johnson once endured eight hours outside in temperatures near zero to capture a wintry forest scene. On more than one occasion, he was bitten by insects he was allergic to, including bees, yet he kept painting even as his hand swelled so much that he could no longer hold the brush. To gain his ideal view of Maine's Portland Head lighthouse, Johnson climbed down sixty feet of precarious cliffside with his painting equipment. He even had to fasten himself to a tree during heavy winds along the seashore. During a North Carolina storm, Melvin tied rocks to the legs of his easel to keep it from blowing away, and he got drenched while completing the painting.

Linda asserts,

> I think at the end of the day, he was totally exhausted. Because when you stand there that long and you don't move and you're concentrating on this, it was hard work. Harder than most people would realize. He stood the whole time. He would take a break once in a while. Mom sat there all day and watched him. She was a trooper.

Collins noted that Johnson had sold paintings to customers in thirty-nine states and three foreign countries. His goal was to have his paintings in all fifty states. Some of Melvin's customers enjoyed his art so much that they purchased many paintings. Dennis remembers Johnson saying that Gloria and Dan Scott "had bought seventy paintings from him. They had so many paintings they put an addition on the back of their house as a studio for his paintings."

Accompanied by their dog Andrew, Melvin and Loretta traveled in an Airstream that had enough space for beds and cooking gear. In the early years, they had a station wagon pulling the trailer. Atop the station wagon was a carrier that Melvin and his brother, a sheet metal worker, made to carry up to thirty-six paintings as they dried. Such an arrangement was better than keeping the paintings in the Airstream, filling it with unhealthy fumes from the drying paint. Later, Melvin and Loretta replaced the station wagon with a small truck that had room in the rear for the drying artwork.

The Johnsons typically were away from Mishawaka for about five months a year, usually on trips that lasted six weeks. Melvin hoped to return with a cache of paintings that could later be sold at his exhibitions. Often, though, customers bought the paintings even before they dried, especially at Mabry Mill or at campgrounds where the Johnsons stayed. "He would be upset because he was trying to get new paintings for his studio, and he only came back with half of what he intended to come back with," Dennis recalls.

Collins noted that Loretta "shares his appreciation for hot coffee, conversation and natural beauty." The *Indiana Daily Student* article explained her role in Melvin's artwork. "She's the boss. She keeps me going," he stated. Loretta oversaw shows at the gallery, scheduling them around when she and Melvin would be traveling to favorite locations, such as the Great Smoky Mountains in the spring and New England in the summer and fall. She also kept a journal of whom they met and where Melvin painted. "I write down all the names of the people that stick in my mind," Loretta said. "He paints and I write a little bit about the people we meet."

The Johnsons traveled with their truck and trailer, shown in Maine in 1990. *Bobson Family.*

In late 1991, Melvin was diagnosed with cancer and given only a few months to live. He continued to paint, though, and his final painting was of a farm scene, which the Scotts later gave to Loretta.

Melvin Johnson died in his Mishawaka home on April 19, 1992, and he was buried in Fairview Cemetery. A small artist's palette is etched on his gravestone, a simple symbol of the artwork he created and sold to patrons.

With Melvin's death, the wonderful way of life—traveling and painting—that he and Loretta enjoyed also passed away. Loretta went on some trips with Dennis and Linda, such as to their cabin in New Hampshire and to North Carolina and Branson, Missouri, but she did not travel much.

Loretta was the faithful custodian of her husband's art, continuing to operate the gallery behind their house. "She did keep the studio open for quite a few years," Dennis recalls, "a good ten or fifteen years, where she actually had customers coming back. Then it kind of slowed up."

Loretta died in South Bend on October 25, 2019, and she rests beside Melvin in Fairview Cemetery.

The legacy of Johnson's artwork lives on more than thirty years after he died. The Bobsons figure that Johnson made at least 200 paintings a year for twenty-three years, resulting in 4,600 paintings. This estimate, they assume, is conservative. Melvin likely made over 5,000 paintings during his career. One wonders where all these paintings are today. Perhaps through subsequent sales and people migrating from one state to another, Johnson reached his goal of having at least one painting in every state. Likely, tens of thousands of people have owned or personally seen a Melvin Johnson painting. Bobson family members retain hundreds of his paintings, many of which hang in their homes. Johnson's works are on public display in Mishawaka, including at the Mishawaka Historical Museum, the Mishawaka-Penn-Harris Public Library and St. Peter Lutheran Church. Other paintings are in city hall.

Melvin's artistic talent also lives on in his family. Linda is an accomplished woodcarver, specializing in birds, and she creates beautiful stained-glass windows. Dennis and Linda's daughter, Heidi, also inherited the family gift, which she demonstrated by painting murals on her bedroom walls.

As an artist, Melvin Johnson created beauty each day, which is something few people can say about their work. A century after his birth, those who knew and loved Melvin's paintings remember and celebrate this Mishawakan whose art has touched so many lives.

PART III
INDUSTRIES

Chapter 1

"FOR GOD'S GREATER HONOR AND GLORY"

Mishawaka's Famed Organ Builder Louis Van Dinter

Mishawaka never gets listed with Nashville, Detroit or Los Angeles as a music capital. Some Mishawakans, though, have used opportunities provided by their hometown to achieve international fame in the music world, including jazz trumpeters Pete and Conte Candoli and drummer turned entrepreneur Remo Belli, whose synthetic drumheads transformed modern music.

Another Mishawakan, all but forgotten today, contributed substantially to the popularization of music throughout the Midwest in the late nineteenth and early twentieth centuries: organ builder Louis Van Dinter.

Louis Hubert Van Dinter was born in Weert, the Netherlands, on February 20, 1851, the oldest of Mathieu and Elisabeth Van Dinter's six children. Weert is in the province of Limburg, located in southeast Holland, just fifteen miles from the German border.

In retrospect, it seems that Louis was destined to be an organ builder, for his ancestors had engaged in this trade for more than a century before Louis's birth. In his article "The Van Dinter Organbuilders" from the Organ Historical Society's *Tracker* magazine, Michael Friesen notes that three families had been organ builders in Weert: the Beerens, the Vermeulens and the Van Dinters. The Vermeulens were the pioneers, their first organ work dating to 1730. Friesen states that the "lives and work of the three families were generally separate," but they were linked by two marriages. Maria Beerens, Louis's maternal great-great-grandmother, married Petrus Vermeulen, and Louis's mother, a Vermeulen, wed Mathieu in 1850.

Mathieu's father, Petrus Franciscus, was the first Van Dinter to build organs. Petrus was a nobleman with the title Baron Peter Van Dinter and owned a castle, DeMunt (the Mint), in Tegelen, Limburg. The baron lost his entire fortune when the State Bank of Austria went bankrupt in 1811. Petrus then sold his castle, bought land and was able to make a livelihood from building and repairing organs, a skill he had developed as a childhood hobby. A *South Bend Tribune* article from 1933 explains,

> *As a child he had always been interested in the intricate workings of watches and music boxes, so while yet very young, an organ-master was engaged for him to explain how organs were made. Thus, the trade that he learned as a pleasure was later to be the means of his livelihood. He rode about his little Holland provinces repairing and making the organs that were a common instrument there.*

From the adversity of Petrus's financial disaster arose an opportunity that would benefit generations of his family as they became highly regarded organ builders in Holland and the United States.

Louis believed that his grandfather's first venture in organ building was making an instrument for Petrus's own home, aided by his sons and a German organ builder whose name is lost to history. Friesen adds that the number of organs built by Petrus Van Dinter is unknown and that he may have primarily done organ tuning and repairs.

Petrus was married twice. His union with Theresia Bijl resulted in four children, including Petrus Adamas, who followed in his father's professional footsteps and took up organ building. After Theresia died in 1817, Petrus's second marriage, to Theresia Houba, resulted in five sons and a daughter. Four of these boys became organ builders, most prominently Mathieu.

Mathieu learned organ building from Petrus and from Louis's maternal grandfather, Lambertus Vermeulen, whom Mathieu began working for in Weert around 1844. Friesen points out that Vermeulen was a fifth-generation organ builder whose two sons had died. Having no male offspring to whom he could pass on the family trade, Lambertus "appears to have taken Mathieu under his wing" and taught him organ building. A few years later, Mathieu married Vermeulen's daughter, Elisabeth.

Louis was thus the beneficiary of two families' organ building traditions, which he acknowledged in a 1930 letter to his cousin Joseph Vermeulen in Holland: "So you see that I am the duplex [an organ component] of both organ families, and, thank God, am not quite crazy yet."

Mathieu and Lambertus collaborated for several years and then worked independently. After his father-in-law retired, Mathieu continued building organs.

Louis spent his childhood and adolescence in Weert, where he learned the family craft under his father's tutelage. Louis also attended a technical school and studied "draftsmanship and design," according to a *Tribune* article from 1927. The book *Pictorial and Biographical Memoirs of Indiana: Elkhart & St. Joseph Counties* (1893) says Louis spoke four languages: Dutch, German, French and English. One source refers to him as a musician, though it does not identify his instrument.

Louis later stated that he immigrated to the United States in 1870 and his father followed the next year. Various sources, though, show Mathieu arriving in 1869, 1871 or 1872. Another source suggests that Louis and Mathieu both emigrated in 1870. What prompted Mathieu to leave Holland in the middle of a successful career remains uncertain. One possible explanation is that Mathieu and Lambertus had lost a substantial sum of money in a failed effort to build a perpetual motion machine.

Louis briefly lived in New York City, where he worked for Henry Erben, a highly respected manufacturer who taught him different methods for building organs. Friesen suggests that Van Dinter's time in New York was valuable for learning about the American market and its organ-building styles.

Louis remained in New York for about six months before moving to Detroit, where Mathieu had settled directly after coming to the United States. The Van Dinters may have chosen Detroit to resume their business because the city provided a less competitive market for organ builders.

"Mathias H. Van Dinter" first appears in the 1871–72 Detroit city directory as an organ builder, is not listed in the 1872–73 directory and reappears in 1873–74. Friesen explains that it is not known when Mathias's sons started working for his business, but the 1874–75 directory includes a listing for Mathew H. Van Dinter & Sons, with Frank, John and Louis identified as the sons. Mathew used that title for his business in the 1875–76 directory. Louis had moved to a different location and was operating his own enterprise, and Frank and John were thereafter listed as the only sons working with Mathew. Subsequently, Louis always identified 1870 as the founding year of his organ business.

On November 10, 1874, Louis married Mary Plets in Jackson, Michigan. A year older than Louis, Mary was born in Belgium and came to the United States with her parents, Francis and Virginia, in 1856. Mary's father was a "merchant tailor and successful businessman," according to *Pictorial*, and

the family lived at 334 East Fort Street in downtown Detroit, just next door to the organ factory that Louis later opened at 332 East Fort. Beginning in 1877, the Van Dinters lived with the Plets. Louis and Mary had eight children, all born between 1875 and 1889.

Friesen notes that Louis may have formed a temporary partnership with Frederick J. Simmons, a Detroit organ builder. In April 1875, the First Baptist Church of Detroit celebrated the installation of its new organ, which, according to a program from the event, was made by "Simmons & Van Dinter, Builders, Detroit." No other documentation of Simmons & Van Dinter exists, and they do not appear in the 1875–76 city directory.

Louis was listed as an "organ tuner" in the 1876–77 directory, and he maintained a business presence in Port Huron, Michigan, located fifty-four miles northeast of Detroit. An advertisement for "piano & organ tuning by Louis Van Dinter" appeared in the *Port Huron Times Herald* from February through April 1876.

The next year's edition of the Detroit city directory included "Louis Van Dinter & Co., manufacturers, church pipe organs." The 1879 directory featured a half-page ad for "Louis Van Dinter & Co., pipe organ builders. Tuning and repairing done to order." Van Dinter's business on East Fort Street occupied a two-story building, measuring twenty by fifty feet, with modern equipment. In *Industries of Michigan: City of Detroit* (1880), Richard Edwards stated,

> He makes an exclusive specialty of manufacturing pipe organs for church purposes, employing among other devices a peculiar process for voicing metal pipes, which is in use by no other house and is his own invention. The instruments turned out by him are noted for purity and sweetness of tone, excellence of workmanship, and superiority of finish. They range in price from $700.00 to $5,000.00 and are not excelled by those manufactured by the leading establishments of the East.

In the following years, Van Dinter's business prospered, as indicated by this 1880 reference in the *Musical Courier*, a New York City publication:

> Louis Van Dinter & Co., Detroit, Mich., are quite full of work. One of the last instruments they erected was a two-manual organ for St. Albert's Church, Detroit. Considering that this firm only started in this country in 1870, it has made quite a number of organs. Even during the last three years, which were considered dull times, the factory was run on full time.

An advertisement for Louis Van Dinter & Co. in the 1879 Detroit city directory. *Author's collection.*

By 1886, Louis needed more capital to expand his factory but was unable to acquire the funding unless he joined the Freemasons, which, as a Catholic, he could not do. He explains, "I became known as a competent church organbuilder, and it became necessary to enlarge my factory building. As I was in need of financial assistance at that time, I was offered all the money necessary on the condition that I join the order of Freemasons." The situation "disgusted" Van Dinter, to use his word, and he sought a more favorable environment to grow his business. Two years earlier, Louis had installed two organs in Mishawaka: one for St. Joseph Church and the other for the First Presbyterian Church. According to Friesen, he "had already been favorably impressed with the community… and decided to resettle there." Van Dinter bought a parcel of land along the south half of the west side of the 200 block of South Spring Street, across from what was then St. Joseph Church's rectory. The land included a house at the corner of Fourth and Spring, and he planned to immediately build a medium-sized factory adjacent to it and to the north.

The home, located at 223 South Spring, was built around 1853 as a farmhouse on the edge of town. The house was large enough to accommodate Louis and Mary's six children (Mamie, George, Charlotte, Rose, Theophilus

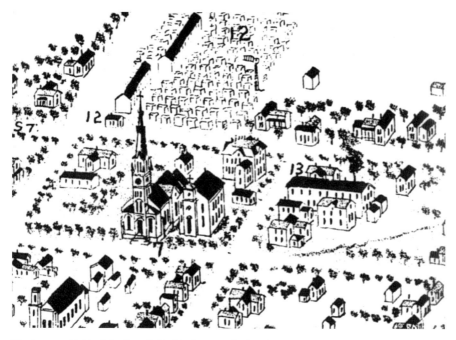

To the west (*right*) of St. Joseph Parish Square, depicted in this 1890 aerial illustration, stood Louis Van Dinter's organ factory, marked "13." *Author's collection.*

and Josephine) and Mary's parents, who lived with the Van Dinters. Two more children were soon added to the household: Elizabeth in 1887 and John in 1889.

On April 23, 1886, the *Mishawaka Enterprise* proudly reported on Van Dinter's plans to move his factory to Mishawaka. Under the headline "A New Business Enterprise in Prospect," it explained,

> *Mr. Van Dinter, of Detroit, who constructed the fine organs in the Catholic and Presbyterian churches of this city, has long had a desire to move his business to Mishawaka, and last week was here to negotiate for a suitable location as well as to form a co-partnership with Mr. Erb, who constructs the elaborate church altars and furniture of which frequent mention has been made in the Enterprise. Both gentlemen are highly skilled in their respective trades, and the two businesses would work admirably together. We hope by next week to chronicle the consummation of the plans mentioned, and to eventually see the business grow into a large and thriving manufactory.*

The "Mr. Erb" mentioned was August J. Erb, who was born in Fulda, Germany, in 1838. His father had manufactured cabinets and church furniture. August immigrated to the United States around 1866 and worked in Pittsburgh, Pennsylvania, and Freeburg, Illinois, before coming to Mishawaka in 1871. He was employed at the Montgomery Furniture Factory for three years before going into business as a cabinetmaker and church furniture manufacturer. An *Enterprise* article from May 9, 1884, reported on some of Erb's recent projects and stated that he "has the reputation of making the most elaborate and elegant altar pieces and other church carvings of any firm in the northwest." When St. Joseph parish completed a magnificent new Gothic church in 1893, Erb crafted the exquisite communion railing, pulpit and altar.

Van Dinter and Erb became acquainted in 1884. Local cabinetmakers or furniture manufacturers were often enlisted to make organ cases, and Louis hired Erb to build the case for the First Presbyterian Church's organ. Earlier that year, Van Dinter had had to install the organ for St. Joseph Church without its case. The dedicatory event for the organ occurred with its inner mechanisms still exposed, and Friesen suggests Van Dinter contracted with Erb to ensure such an awkward circumstance would not be repeated. The two men recognized the synergy that could come from a partnership.

Van Dinter and Erb's collaboration was formally announced in the May 28, 1886 edition of the *Enterprise* under the headline "A New Manufacturing Firm" and subheading "The Erb & Van Dinter Organ and Altar Factory." The article offered this description of the factory's development:

> *The two-story building occupied by Mr. Erb as a shop for manufacturing altars, etc. was this week moved to the lot purchased by Mr. Van Dinter, on Spring Street, between 3rd and 4th, and placed in position on the foundation prepared for it. Additions will be built to it in front and rear, making a factory, when finished, 24 ft. wide by 90 in length, two stories high. The front addition will be without upper floor, for the purpose of facilitating the building of high altars, organs, etc. The balance of the building will be in two floors, the rear addition below being used for the machinery room, the machinery mostly band and jig saws, etc. The power will be a ten-horse power engine, which, it is thought, will be sufficient at present.*

The *Enterprise* also explained that the factory was expected to employ fifteen men when it was fully operational. Van Dinter's factory, at 213 South Spring, was expanded over the years and eventually had a length of 110 feet.

Erb resided at 209 South Spring, making him a neighbor to the north of the factory just as Van Dinter was to the south. Both were members of St. Joseph Church, then the only Catholic parish in Mishawaka.

Friesen notes that there is no evidence beyond the newspaper article that Van Dinter and Erb's business arrangement was ever formally known as an "altar and organ factory," and it is unclear how long the partnership, whatever its nature, lasted. When the first city directory was published in 1898, the two businesses were listed separately, and no "Erb & Van Dinter" organs are known to survive.

Moving his organ-building business to Mishawaka worked out well for Louis, and orders came steadily his way. By 1893, the Van Dinter Pipe Organ Factory, as it was called, was one of only three organ factories in Indiana. *Pictorial* noted that Van Dinter was held in high esteem in his profession and had constructed "some of the largest organs in the West." The writer continued,

> Mr. Van Dinter gives every organ his personal attention, especially the voicing being all done by himself, and his long experience, his skillful and artistic work enable him to command a good price. He has a fine record, having built more than fifty large organs....His work is in a great measure for the Catholic churches, but he does much also in Protestant Churches, his contracts being as many as he is able to fill. He manufactures every part of an organ except the metal pipes, using the best of material.

Louis typically used Michigan white pine for wood pipes, bellows and other inner workings because it was superior for handling heat and moisture. When the white pine supply was running out after the turn of the century, he bought the last carload and then turned to California sugar pine. Organ cases were made using oak or other hardwoods.

Van Dinter seems to have been especially gifted at "voicing" organs. This sophisticated process, as much art as science, determines, according to Friesen, "whether the instrument will delight musicians with its tone character or emit mere sounds." In a 1927 interview with the *South Bend Tribune*, Louis offered his perspective on voicing:

> When I hear an organ, I know by its character of tone the character of the one who voiced it. If the voice is sharp or rough, or mellow and soulful, I can be certain that the soul of the man who worked on it will correspond. Of course, the tone is never perfect, and when I am engaged in voicing an

organ I must force myself to leave it. Otherwise, in the quest for absolute perfection, I should never finish.

When the new St. Joseph Church opened in 1893, Van Dinter was hired to enlarge and relocate his 1884 organ. He also remodeled the organ in 1916 and kept a close eye—and ear—on its care and use over the years.

Another Mishawaka church that enjoyed a Van Dinter organ was the First Baptist Church, originally located on the 100 block of West Joseph Street (Mishawaka Avenue). The Baptists' organ was originally intended for the new home of Martin Beiger, the president of Mishawaka Woolen Manufacturing Company, also known as Ball-Band. Martin and his wife, Susie, began construction of their palatial edifice in 1903, but Martin died unexpectedly soon after. Susie delayed finishing the mansion until 1909. Martin had planned for his good friend Van Dinter to install an instrument in the Beiger home, but construction of the organ did not begin until two years later. Mrs. Beiger decided to sell the organ to the First Baptist Church for the generous price of $1,200, approximately 40 percent of its value. In

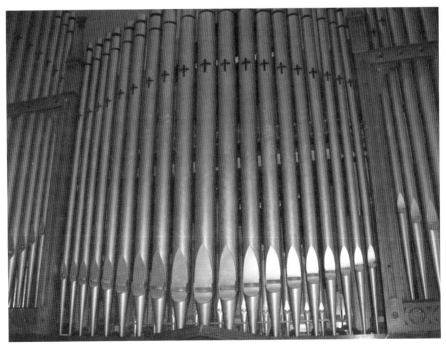

St. Joseph Church in Mishawaka has a Van Dinter organ, parts of which date to the 1880s. *Author's collection.*

July 1909, the church dedicated the new organ with a recital by Charles Hansen, organist of the Second Presbyterian Church of Indianapolis. The organ stood ten feet wide, ten feet deep and fourteen feet high and included a rare Vienna flute stop and a saxophone stop. Hansen told the *Tribune* that "it was the finest organ of the size he had ever played upon."

Much like previous generations of his organ-building ancestors, Louis Van Dinter operated a family business. All three of Louis and Mary's sons were employed at the factory. George and Phil worked on a part-time basis, but their occupations as listed in city directories and census records indicate that they were primarily employed at Mishawaka Woolen. John was a full-time organ builder and later likely assumed most of the construction duties, leaving Louis to work on voicing. A 1900 example of letterhead identifies the business as "Louis H. Van Dinter & Co.," but a later letterhead refers to "Louis H. Van Dinter & Son." That son was John. However, Friesen reports that an organ built for Holy Trinity Polish Catholic Church in Chicago in 1909 was a collective effort by the family, "Louis H. Van Dinter Sons" being carved into the filigree above the center impost.

Van Dinter seemed content to keep his organ-building business small, later eschewing ads in the local newspapers or in the city directory. In a 1903 letter to Joseph Vermeulen, Louis explained, "I gave up building big instruments, and now I occupy myself with small organs....The reason for that is that I have too much trouble with workmen; every factory worker here wants to be a rich man." Described by Friesen as a "conservative organ builder in many ways," Van Dinter did make at least one exception to his rule about small organs when he built the Holy Trinity instrument, which was Louis's largest organ. It included three thousand pipes and took the Van Dinters two years to build. To Louis, quality of production was more important than quantity: "I would rather carry on a smaller business and continue to make the best organs possible."

The size of Van Dinter's business was also limited by his preference for building organs for Catholic churches. At the time of his retirement in 1930, Louis stated that only eight of his 180 organs were made for Protestant churches and that six of those were later returned to his possession for remodeling and installation in Catholic churches.

Van Dinter organs had a long-standing reputation for being of the highest quality. The *Tribune* stated in 1927 that they "are ranked with the largest and best instruments in the United States" and in 1933 added, "The workmanship and skill of the builders make them foremost in their trade throughout the country."

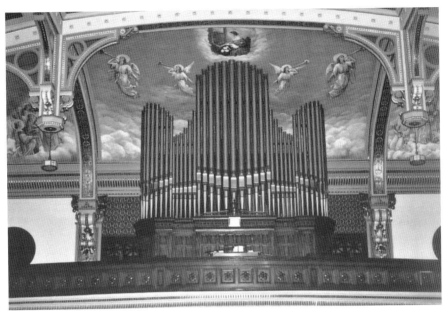

Chicago's Holy Trinity Polish Catholic Church features the largest of Louis Van Dinter's organs. *Holy Trinity Polish Catholic Church.*

After a year of declining health, Louis Van Dinter died on March 9, 1932, at St. Joseph Hospital in Mishawaka, just steps from his home. Articles in the *Cincinnati Enquirer* and the *Chicago Tribune* referred to him as "one of the oldest pipe organ builders in the United States," and the *South Bend Tribune* stated that he "was one of the best known men in Mishawaka and St. Joseph County." Two days after his death, Louis's funeral took place in his beloved St. Joseph Church, appropriately accompanied by music from the organ he had built and literally given voice to. Van Dinter was buried in St. Joseph Catholic Cemetery, Mishawaka.

Though Van Dinter was famous in his lifetime, the passage of time has faded memories of him as both an organ builder and a Mishawakan.

Following Louis's retirement in 1930, John continued the family business, in some form, until 1945. The large factory on Spring Street was no longer used after Louis retired. John likely sent orders for constructing organs to the A. Gottfried Company factory in Erie, Pennsylvania, and he would then assemble them. City directories list him as an "organ builder" through 1944, except for when he was identified as an "organist" in 1936 and a "piano repairman" in 1940. Friesen suggests John Van Dinter did "mostly tuning and repair" after 1931 and did not build any new organs. A 1938 article in

the *South Bend News-Times* stated that George and John "still have the ability to repair and tune organs but are not active in the work at present." In 1945, John was working with his brothers at Ball-Band, and Friesen identifies him as the last Van Dinter organ builder. John and Phil both died in 1954, and neither had children. George's son, Virgil, who also was employed at Ball-Band, died in 1977 and had no children. With him, the family name in the United States came to an end.

Several members of the extended Van Dinter family are at rest in St. Joseph Catholic Cemetery. Alongside Louis and Mary are their children Lottie, Phil and John. One row west are their daughter Josephine, her baby and Mary's parents. Elsewhere in the cemetery, their daughter Elizabeth and grandson Virgil and his wife are buried.

Other than on his gravestone, the one place where Louis Van Dinter's name can still be seen prominently in Mishawaka is in St. Joseph Church. Surprisingly, though, it is not on the organ he built. Van Dinter donated the eighth Station of the Cross, *Jesus Speaks to the Women of Jerusalem*, which hangs near the rear of the church just below the organ and choir loft, and "L. Van Dinter Donor" appears at the bottom of the elaborate wooden carving.

The building on South Spring where the Van Dinters manufactured organs for almost half a century was demolished in 1938, and the site became a playground for St. Joseph School. The house where Louis and Mary lived and raised their family stood until 1967. After repeated incidents of vandalism, the owners had it razed, and the property is now also part of the playground for Mishawaka Catholic School's St. Joseph campus.

Van Dinter's most tangible and enduring legacy has been the organs he produced and the music they have made. The actual number of these organs is in dispute, though. In 1927, he claimed to have built 150 organs, but that number was reported to be 180 just three years later. Friesen notes that Louis had built about 50 organs by 1893, which led him to believe "the 150 figure more plausible."

No complete list of Van Dinter organs exists, and only about 50 had been documented at the time of Friesen's article in 1989. All these known installations had occurred in Indiana, Michigan, Illinois, Kentucky and Wisconsin.

Most of Van Dinter's documented organs have been lost. A sampling includes those at First Presbyterian, First Baptist, First Methodist Episcopal, St. Paul Episcopal, St. Peter Lutheran and St. Andrew German Evangelical in Mishawaka; St. Patrick, St. Hedwig, St. Mary, St. Stanislaus and Swedish Lutheran in South Bend; St. Michael in Plymouth; St. Vincent in Elkhart;

St. Mary in Fort Wayne; St. John the Baptist in New Haven; St. Mary in Huntington; St. Peter and St. Joseph in LaPorte; Sacred Heart in Peru; St. John the Evangelist in Jackson, Michigan; Immaculate Conception in Niles, Michigan; Holy Cross in Marine City, Michigan; St. Peter Cathedral in Marquette, Michigan; St. Mary in Sault Ste. Marie, Michigan; Sacred Heart in Hudson, Michigan; St. Alphonsus, Sacred Heart, Our Lady of Help, St. Albert and First Baptist in Detroit; St. Catherine in New Haven, Kentucky; Immaculate Conception in Louisville, Kentucky; St. Francis in Hollandtown, Wisconsin; and St. Mary in Chicago.

Some of Louis's work survives, though. As of 2021, the Organ Historical Society's Pipe Organ Database listed the following extant Van Dinter organs, a few nearly original in their configuration and others radically altered over the years: St. Joseph, Ancilla Domini Convent in Donaldson, St. Mary's College (dormitory chapel) and St. Mary's Convent (assembly hall) in Notre Dame, SS. Peter & Paul in Huntington, St. Charles Borromeo in Peru, Trinity Lutheran in Crown Point, St. John the Baptist in Joliet, Holy Trinity Polish Catholic in Chicago and St. Frances of Rome in Louisville.

Online searches for these organs yield numerous photos and some historical commentary. St. Joseph Church acknowledges its organ's Van Dinter heritage with this statement on the parish website: "The Organ at St. Joseph's was originally built by local organ builder Louis Van Dinter, and the current organ still contains some of the original, beautiful pipework. The facade and some of the original pipework still exist in the current instrument."

The Center at Donaldson's website notes that the Ancilla Domini organ was built by Van Dinter in 1923 "as his last masterpiece."

The organ in St. Frances Church was originally installed by Louis in St. Mary's Church, also in Louisville. When St. Mary's was razed in 1937, its organ and stained-glass windows were moved to St. Frances as part of a renovation of the 1887 building. A Commonwealth of Kentucky historical marker in front of St. Frances Church includes the line, "Organ built in 1884 by Louis Van Dinter."

For SS. Peter & Paul Church's 175th anniversary in 2019, the parish ended its celebration with a concert that featured the Van Dinter organ. An article in the *Huntington County TAB* included this statement: "The instrument at SS. Peter and Paul—which is regularly maintained and is in constant use—is one of the few that remain playable today."

Near the end of his career, Van Dinter was thinking about his work, both the intrinsic compensation it gave him in this life and the eternal benefits he

hoped it would merit in the next. "It seems that there is a strong fascination, proud satisfaction in organ building," he wrote to his cousin Joseph Vermeulen in 1930.

> *This seems to be our earthly reward, combined with the blessing of long life, rather than monetary affluence, for I never heard of a rich Catholic organbuilder. In regard to myself, I have hope for a remuneration hereafter, for the organbuilder having produced something for God's greater Honor and Glory in His own "The Roman Catholic Church on earth."*

These words could serve as the epitaph for Louis Van Dinter, whose organ building has brought countless people closer to God through music that echoes the sounds of heaven.

Chapter 2

WHEN MISHAWAKA WAS "THE POWER CITY"

The Story of the Twin Branch Dam and Power Plant

Alanson Hurd, Mishawaka's founding father, was attracted to the St. Joseph Valley in the early 1830s because of bog iron deposits in the Twin Branch area and a natural fall in the river near present-day downtown. In an era before steam or electric power, Hurd knew that waterpower would be needed for his St. Joseph Iron Works and for other manufacturers he hoped would line the banks of the St. Joseph River. Hurd considered locating the ironworks and a dam in Twin Branch but decided on the site three and a half miles downriver.

Two generations after Hurd established St. Joseph Iron Works, other entrepreneurs would be drawn to the Twin Branch site's potential for electric power generation.

In January 1900, Martin Beiger, the president of Mishawaka Woolen Manufacturing Company, and James Du Shane, a patent attorney in South Bend, formed a new company with easterners who had invested in Elkhart Electric Company to build a dam and power facility near where Twin Branch Creek divided into two streams—the origin of the term *Twin Branch*—and emptied into the St. Joseph River. The purpose of this new business, St. Joseph & Elkhart Power Company, was to produce electricity for Mishawaka and the surrounding area, including South Bend and Elkhart.

What later became the Twin Branch Dam was first known as the Hen Island Dam, named for the low-lying wooded island that is still visible between the dam and the Capital Avenue Bridge.

The March 30, 1900 edition of the *Mishawaka Enterprise* reported that clearing the riverbank and preparing the construction site near Hen Island had started earlier that week. The article noted that Emmett Saunders, another Mishawaka Woolen executive, was president of St. Joseph & Elkhart Power Company and Martin Beiger was its vice president. The *Enterprise* explained that the dam would have a height of twenty-one feet from the water level above the dam (headwater) to the water level at the base of the structure (tailwater) and would supply the area's "commercial or manufacturing purposes. Thus will be furnished a cheap and convenient power which will prove of vast benefit to this great and constantly growing industrial center of the St. Joseph Valley." The paper also noted that St. Joseph & Elkhart Power Company had bought land or options to land along the river all the way to Elkhart, trying to prevent any other dam from being built in that area. When finished, the Hen Island Dam would create a lake eight miles long, submerge all islands upriver and widen the river in places from four hundred to one thousand feet. Nearly forgotten today is how radically the Hen Island Dam transformed the appearance of the St. Joseph River between Twin Branch and Elkhart.

Little progress was made on these plans during the remainder of 1900. This delay may have been due to litigation surrounding multiple companies' efforts to dam the St. Joseph River at different locations. Indiana Power Company, which incorporated in December 1899, was attempting to build a dam near the Elkhart/St. Joseph county line. Construction began in April 1900, which prompted St. Joseph & Elkhart Power Company to seek an injunction to stop work on the rival dam. The investors behind the Hen Island Dam had also organized South Bend Power Company in February 1900, planning to build a dam six miles downriver from South Bend and then sell the electricity to South Bend and Niles, Michigan. Their venture was in direct competition with Niles native and Chicago millionaire Charles Chapin's South Bend Electric Company, which James Du Shane, Thomas Stanfield and Andrew Anderson had founded in 1882. Chapin bought an interest in the company soon after and later became its president. South Bend Electric Company's steam plant provided electricity for streetlights, homes, stores and manufacturers in the city. Chapin knew that a hydroelectric dam could generate power at a lower price, and this motivated his efforts to thwart the construction of such a facility unless he was its owner.

The local dam controversy grew into an interstate conflict involving the federal government. To ensure that Michiganders determined which of several corporations would build a dam at Berrien Springs, Michigan's U.S.

senator James McMillan and U.S. congressman Edward Hamilton sought to have the federal government declare the river non-navigable, which would have allowed local authorities to grant permission to construct a dam. Indiana's Senator Charles Fairbanks and Congressman Jesse Overstreet retaliated by introducing legislation that declared the river non-navigable above Berrien Springs. The corporations wanting to construct the dam vowed to defeat elected officials who did not support their efforts.

Indiana Power Company brought suits in the circuit courts of both Elkhart and St. Joseph Counties, and both courts ruled in favor of St. Joseph & Elkhart Power Company. The Indiana Supreme Court affirmed those verdicts, but the case eventually went all the way to the United States Supreme Court. This dam mess was finally resolved on October 20, 1902, when the high court dismissed Indiana Power Company's claim "for want of jurisdiction," which meant the Indiana Supreme Court had the final authority to settle the intrastate dispute.

St. Joseph & Elkhart Power Company was confident enough that it would ultimately prevail in the litigation that it resumed work at Hen Island in April 1901. A workforce of sixteen men began clearing the banks on the north side of the river, and Lake Shore Railroad workers removed topsoil for a gravel pit nearby. As soon as high water levels reached normal, the *Enterprise* noted on April 19, more substantial work could resume.

Construction of the Hen Island Dam did not begin in earnest until mid-July 1901. Chief engineer W.H. Lang of Sanderson & Porter, a civil engineering firm from New York City, had come to "immediately and vigorously push the construction of the Hen Island dam," according to the *Enterprise* of July 19. Several train carloads of equipment had also arrived, and work began on building a siding from the Lake Shore Railroad tracks to the construction area. A sawmill was established to process timber cleared from the site, which had been felled by a dozen Canadian lumberjacks, and a wood-frame barracks was built to house one hundred Italian laborers who would construct the dam and powerhouse.

Despite the slow progress, *Enterprise* editor Edward Jernegan was still enthusiastic about the benefits that the Hen Island Dam would bring for local industries. "This will doubtless be the means of developing one of the greatest manufacturing centers in the west in this locality and means much for the interurban cities," he wrote.

This optimism was echoed by *Power and Transmission*, a periodical published by Dodge Manufacturing Company, in its January 1902 issue. An article about the "monstrous" Hen Island Dam suggested that the hydroelectric

plant would be such a boon for industry that it would add significantly to the area's population: "Already within a radius of ten miles of the dam there is a population of considerably over 65,000 people and with the addition of other factories it is hoped to increase this to at least 100,000 by 1907." The Hen Island Dam did, in fact, contribute to the growth of Mishawaka's population from 5,560 residents in the 1900 census to 11,864 ten years later.

Work on the dam and powerhouse proceeded with a combination of manual labor, horse-drawn equipment and steam power. The south side of the river was first obstructed with fill dirt, and lumber was used to build a channel that shifted the water flow toward the north. Construction of the powerhouse had already commenced by January, according to *Power and Transmission*, but the dam would not be started until the spring. Six-inch sheet piling was steam-driven twenty feet into the ground to prepare for excavating the powerhouse's foundation. Lumber for the pilings came from trees on property that St. Joseph & Elkhart Power Company had acquired between the dam and Elkhart. Logs were floated downstream to the dam site and gathered by a 270-foot boom across the river. Until they were needed, the logs remained in the water and then were pulled out "by a huge steam derrick which handles the timbers as though they were so many wisps of straw." The logs were transported to the sawmill to be cut to an exact size. The powerhouse was built parallel to and south of the dam and was 176 feet long and 112 feet wide. Made of steel and solid concrete blocks poured on-site, it rested on five thousand piles driven into bedrock. *Power and Transmission* explained, "There are nearly a dozen engines of various sizes and capacities on the grounds, and steam for all is generated in the large boiler and is distributed about the plant through a five-inch pipe, which to avoid freezing is wrapped in asbestos and buried in the ground."

To begin construction on the four-hundred-foot-long dam itself, two cofferdams composed of stones and dirt were made. After the water was pumped out, the riverbed was dredged until workers reached solid rock, thirty-five feet below the normal water level. Tree trunks, forty feet long and up to a foot in diameter, were pile-driven into holes that had been blasted in the bedrock. After a clay base was laid, the space was filled with concrete.

As work continued at Hen Island, St. Joseph & Elkhart Power Company had to fend off yet another lawsuit. In early January 1903, the Elkhart-based St. Joseph River Navigation Company sought a federal court order to stop the dam's completion. The company had proposed to make the river navigable from Elkhart to Lake Michigan by dredging and installing

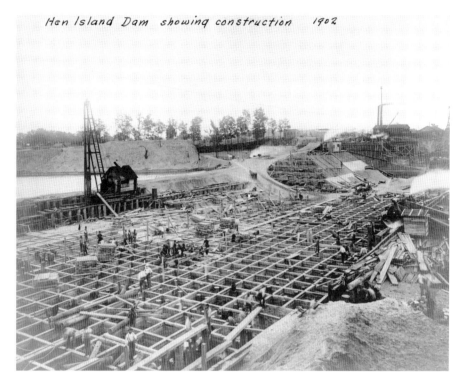

Construction of the Hen Island Dam and powerhouse is occurring in this extraordinary 1902 photo. *Mishawaka Historical Museum.*

a series of locks. The plan would have cost millions of dollars and interfered with the many industries that were located along the river. "It is not believed that the people or the manufacturers would permit any such destruction," wrote the *South Bend Tribune* on January 8, "and it is also felt that the returns to the company would be wholly inadequate." The judge heard both sides' arguments and immediately denied the injunction, much to the relief of the investors who had spent half a million dollars on the dam and recently ordered $120,000 worth of generating equipment for the powerhouse. With all legal obstacles now removed, the Hen Island Dam could be operational by year's end.

Transmitting electricity from Hen Island also required installation of new poles and power lines. According to the *Elkhart Review*, Sanderson & Porter subcontracted with Elkhart Electric Company, and fifteen linemen began this work in March 1903. Two three-phase circuits connected the dam to Elkhart along the north bank of the river, and four three-phase circuits carried power to Mishawaka along the south side of the river. Two

three-phase circuits then sent electricity from Mishawaka to South Bend for distribution by South Bend Power Company.

The *Enterprise*'s July 17, 1903 edition gave an update on the dam's progress, stating, "Work at the Hen Island dam has been going steadily forward this season, and it will not be many weeks now before the great structure will be practically completed." Although the project had cost "about three times as much as first estimated," Ed Jernegan was steadfastly confident that the dam "will be a credit to its builders and a source of future profit to its enterprising projectors. It will also add materially to the prosperity of Mishawaka and vicinity by attracting new industries."

By late October 1903, construction was finished and the water behind the dam was slowly rising. Elkhart officials cleared several acres of trees from Highland Park because it was to be partly inundated by the dam's backwater. On November 20, the *Enterprise* reported that the water had risen nearly to the top of the dam, which brought out many local residents who were eager to see the water start spilling over. Machinery would then finally begin generating electricity.

That milestone occurred on December 16. The next day's *Tribune* featured a short article with the extraordinary headline, "Mishawaka Electricity Lights Elkhart." It stated, "Elkhart was lighted last night by electricity generated at the St. Joseph & Elkhart Power company's station at the Hen Island dam." The article also mentioned that the dam would soon be powering Mishawaka industries, including Mishawaka Woolen Manufacturing Company, which was installing "an immense motor" that would run on electricity from Hen Island. Providing cheap, dependable and abundant power for Mishawaka Woolen had been Beiger and Saunders's motive for developing the dam. Before their vision could be fulfilled, though, Martin Beiger died on September 26, 1903, of complications from an appendectomy.

Below the distinctive castellated battlements of the powerhouse, four enormous Westinghouse turbines had been installed, and they produced enough electricity to meet most of the area's electric demand at the time. In the dam's early years, a crew of six to eight workers manned the hydroelectric plant twenty-four hours a day.

Hydroelectric power is such a mature energy source today that it is difficult to imagine when it was a new technology. The Hen Island Dam, though, was a pioneer in hydroelectricity, completed just twenty-one years after the world's first hydroelectric power plant opened in 1882 in Appleton, Wisconsin.

INDUSTRIES

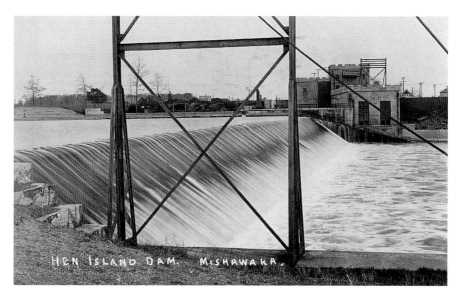

This postcard image of the Hen Island Dam, circa 1904, looks south toward the powerhouse. *Mishawaka Historical Museum.*

As the Hen Island Dam began humming dependably along, the legal wranglings of Charles Chapin and the area's competing power companies over the right to build a dam at Berrien Springs were soon settled. In 1904, St. Joseph & Elkhart Electric Power Company, South Bend Power Company and South Bend Electric Company were formed into Indiana and Michigan Company, a holding company based in New Jersey. The new company was co-owned by Chapin and the eastern investors who built the Hen Island Dam. Chapin bought the other parties' share of the business in 1907, the holding company was dissolved and Indiana and Michigan Electric Company of Indiana was created. That same year, Hen Island Dam was renamed Twin Branch Dam to fit in with the nearby residential development occurring in Mishawaka's east end.

When Chapin died in 1913, he was the principal owner, through Indiana and Michigan Electric Company, of several electric plants along the St. Joseph River, including Berrien Springs, Buchanan, Niles, South Bend, Twin Branch and Elkhart. His children inherited control of "I and M," and they sold it to American Gas & Electric Company (AGE), a New York–based holding company, in 1922. At the same time that AGE acquired I and M, it also purchased Benton Harbor and St. Joseph Railway and Light Company. As a result, according to a company history, "Customer demand for the power from Twin Branch was assured."

By 1922, the Twin Branch Dam needed repair, so Indiana and Michigan Electric made significant improvements, adding a new concrete structure on top of the dam and seven large steel Tainter gates that controlled the amount of water flowing over it. This modification enabled the power company to determine the level of the river downstream. As part of the modernization, two additional turbine generators were installed in the powerhouse, bringing the plant's total up to six. Under normal operating conditions, the renovated dam could pass 5,000–6,000 cubic feet of water per second and 27,500 cubic feet at peak times. After the water flowed through the gates at 2,400 feet per second, it deflected off a wall and surged into the air. Without the wall, the water would eventually have worn a hole in the concrete dam.

As local industry expanded and homes added electric devices like radios and washing machines, demand for electricity began to outpace what even the renovated Twin Branch Dam could supply. During the three-year period ending in October 1923, Indiana and Michigan Electric saw a 57 percent increase in customers and a 51.5 percent growth in power consumption. Over the decade preceding October 1923, the rise was even more dramatic: 400 percent more customers and a 300 percent boost in consumption.

Anticipating future growth, I and M sought to expand its power-generating capacity and began construction in 1924 of a coal-fired steam plant just north of the Twin Branch Dam. This site was chosen for two reasons. The first was

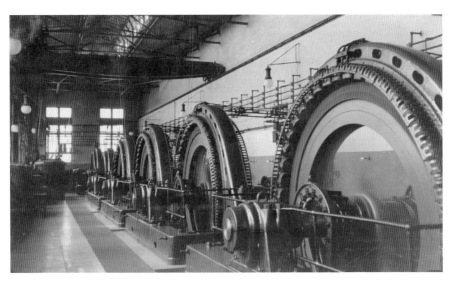

Inside the Twin Branch Dam's powerhouse, shown circa 1925, six turbines produced electricity. *Mishawaka Historical Museum.*

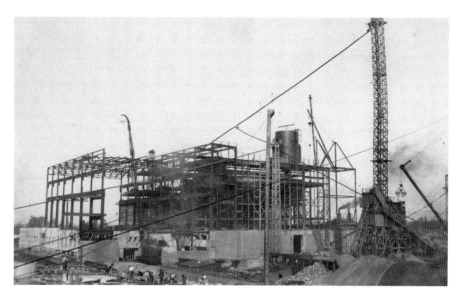

The Twin Branch steam plant under construction in 1924. *Mishawaka Historical Museum.*

stated by Eugene J. Galdabini in "A Detailed Description of the Twin Branch Power Plant," written in 1929: "From the electrical distribution standpoint, there is a great advantage in having the generation station located as nearly as possible in the center of the load area." The second was proximity to the St. Joseph River, which provided the abundant supply of water needed for a large steam plant.

In the spring of 1925, the first two generating units at Twin Branch became operational, and plans were made to add others as electricity need grew. The steam plant was designed by engineers Sargent and Lundy in cooperation with AGE engineers. Each of the two forty-thousand-kilowatt General Electric turbines had three standard boilers and a reheat boiler. A control room overlooked the turbine room and offered a view of the transformers and switchyard outside. Under the basement floor was a two-hundred-thousand-gallon supply of distilled water, and east of the plant were two one-hundred-thousand-gallon water tanks atop 100-foot-tall towers. The building also included eight concrete-lined bunkers, each able to hold 250 tons of coal. Two turbine generators from the hydroelectric plant supplied the steam plant with power and light. In its original configuration, the Twin Branch Power Plant stood approximately 60 feet tall with sides of 100 by 175 feet and was topped by two 50-foot smokestacks. Its facade consisted of brick, stone and tall vertical windows.

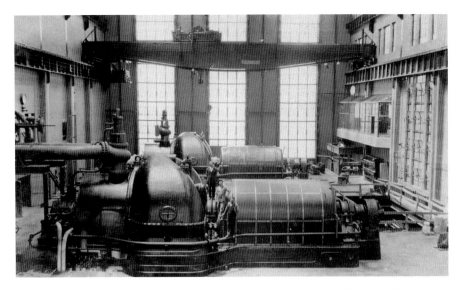

The Twin Branch Power Plant's turbine room, circa 1925. *Mishawaka Historical Museum.*

To satisfy the plant's 1,100-ton daily appetite for coal, a steady supply of fuel arrived via railroad. In fact, access to coal was so vital that American Gas & Electric formed its own railroad, the Twin Branch Railroad, to bring coal cars from the Elkhart & Western Railroad, which was part of the New York Central system and ran north of McKinley Highway about 1.3 miles from the power plant. The Twin Branch Railroad crossed Jefferson Road and entered the I and M property near where the Richard Bodine State Fish Hatchery is today. With 2 miles of main track and 1.6 miles of yard track and sidings, the Twin Branch Railroad was described as "the world's shortest railroad line." It was at first served by two steam engines purchased from the New York Central, and they were replaced with two Baldwin Westinghouse battery-electric locomotives in the 1930s.

The July 10, 1925 *Mishawaka Enterprise* reported that fifty members of the Mishawaka Lions Club had toured the new Twin Branch plant the previous afternoon. The Lions' memorable excursion began with a ride on the Twin Branch Railroad. A locomotive pulled a flat car carrying the visitors to the junction with the Elkhart & Western and through the extensive yard track east of the plant. The Lions then toured the building and "marvelled at the immensity of the plant and the intricate processes which are employed to produce electric energy at an exceptionally low cost." During their visit, club members were also invited onto the roof, where they stood between the two smokestacks and enjoyed a panoramic view of the river and the mostly

INDUSTRIES

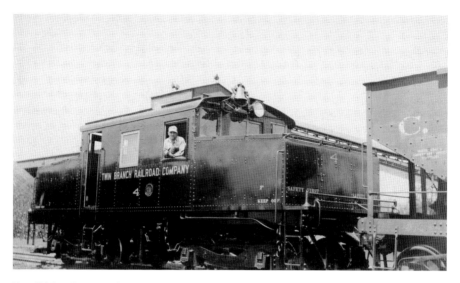

Burt Weiss, shown at the controls of a Twin Branch Railroad engine circa 1930s, was a locomotive operator at the Twin Branch plant from 1924 until his death in 1952. *Mishawaka Historical Museum.*

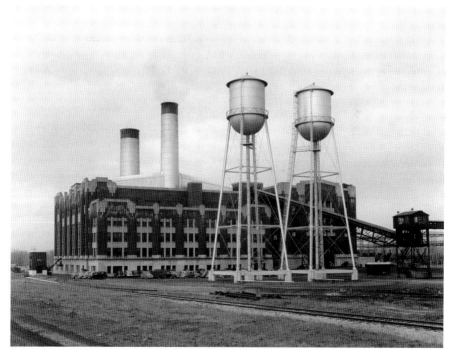

The Twin Branch steam plant and its reserve water tanks are seen in this circa 1940 photo, which looks west. *Author's collection.*

151

undeveloped countryside to the north and east. The *Enterprise* concluded by saying that the group of Mishawaka businessmen and community leaders "came away satisfied that the Twin Branch plant is one of the best assets for future growth that Mishawaka has."

Thanks to both the Twin Branch Dam and the Twin Branch Power Plant, Mishawaka became the region's electricity producer and even adopted the sobriquet "The Power City" in the 1920s. Through AGE's transmission network, Twin Branch brought power not just to local customers in Indiana and Michigan. I and M's connection to Calumet Gas and Electric Company meant that electricity from Mishawaka could also, if needed, supply Commonwealth Edison Company of Chicago. Lima and Fostoria, Ohio, also received power generated in Twin Branch. In a 1926 experiment, the Twin Branch steam plant successfully sent electricity to Boston. During the plant's early years of operation, it also proved capable of supplying customers in Florida.

The same year that the Twin Branch Power Plant began producing electricity, its parent company, Twin Branch Power Company, merged with Indiana and Michigan Electric Company to form a new operating company, Indiana & Michigan Electric Company (an ampersand replacing the *and*), its offices located in South Bend. When American Gas & Electric Company combined I&M with Indiana Service Corporation in 1948, the corporate headquarters moved to Fort Wayne. A decade later, AGE became American Electric Power (AEP); that name is still used today.

In 1940–41, the Twin Branch Power Plant added a third generating unit, which was, according to a company publication, "the world's first generating unit to utilize steam pressure as high as 2,400 pounds per square inch in the commercial production of electric power." Eventually, a total of five generating units were installed at Twin Branch, "each larger and more economical and more efficient than its predecessors." When Unit 5 came online in 1949, it "held the world's record for operating efficiency by a single unit," I&M later touted. It featured a turbogenerator unit with the highest pressure (2,500 pounds per square inch) and the highest temperature (950 degrees) in the world.

Over the years, the plant evolved into its final form, which consisted of a series of boxlike structures of different sizes that formed one enormous building, varying from 60 to 100 feet tall and roughly 400 feet long, running parallel to the riverbank. A quartet of smokestacks crowned the building and was visible from several miles away. The tops of the smokestacks were uniform, approximately 175 feet above the ground, but the irregular

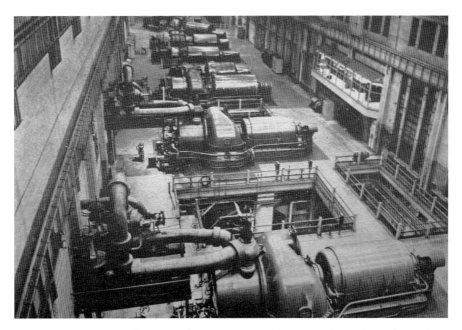

The Twin Branch Power Plant's turbine room included five generating units by the 1950s. *Author's collection.*

roofline meant that each smokestack was a different height. The easternmost smokestack sat atop the lowest end of the building, and as the height of the structure increased going west, the smokestacks became shorter.

In the late 1950s, the gross capacity of Twin Branch's five generating units was 420,000 kilowatts, far surpassing the 7,260 kilowatts produced by the adjacent hydroelectric dam.

The Twin Branch Power Plant was a technological marvel, the most significant and complex industrial building ever to operate in Mishawaka. The process that generated so much electricity involved coal from southern Indiana, railroads, water from the St. Joseph River, an elaborate series of stages that occurred on the grounds of and within the plant and transmission lines that distributed power from Mishawaka throughout the Indiana & Michigan system.

Bituminous, or soft, coal from mines in southern Indiana was transported to the plant via the New York Central, Elkhart & Western and Twin Branch Railroads. Because the Twin Branch Power Plant's five generating units could voraciously consume up to four thousand tons of coal daily, a procession of coal cars came to the facility, as many as 130 per day. On arrival, each car was clamped into a rotary car dumper, which rotated 180 degrees to turn the

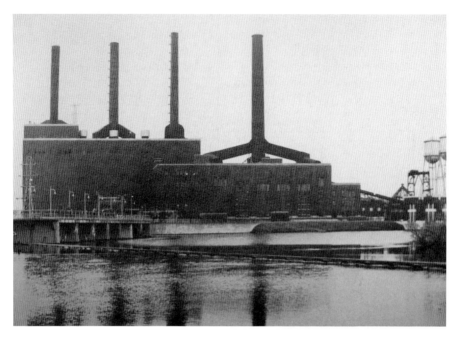

The enormous Twin Branch Power Plant had expanded to its final configuration by the time this photo was taken in the early 1950s. *Mishawaka Historical Museum.*

car upside down, pouring the coal into crushers. The car was then rotated the rest of the way around, completing a process that could be done in as little as six minutes per car. Coal was crushed into roughly one-and-a-half-inch pieces, placed on the outdoor storage pile east of the plant and then leveled by tractors to prevent spontaneous combustion. Upward of half a million tons of coal could be stockpiled outside the plant.

A gantry crane loaded the coal onto a conveyor belt, which took it into the bunkers at the upper level of the plant. From there, the coal fell into pulverizers that used giant steel ball bearings to grind it into powder. A blast of hot air blew the particles of pulverized coal into the furnace, where they exploded into flames. The furnace, at a temperature of 3,600 degrees Fahrenheit, heated twelve miles of tubing, filled with purified water, that lined the furnace. The heated water caused steam to rise in the tubes and collect at the top of the boiler in a steel drum that was spun to extract all moisture. The remaining dry steam was then superheated to as much as 1,050 degrees and left the boiler at a pressure of nearly 2,200 pounds per square inch. The high-pressure part of the generating unit conveyed the steam via a large steel pipe that glowed dark red as it fed into the turbine, where the steam was

INDUSTRIES

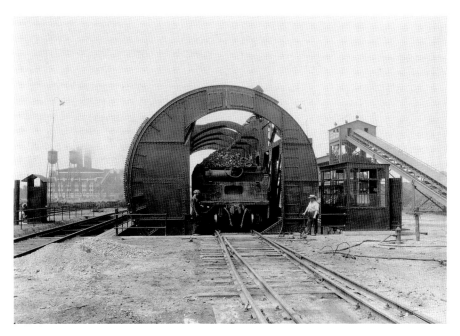

On arrival at the Twin Branch plant, each coal car was clamped into a rotary car dumper (pictured here circa 1925), which turned the car upside down and poured the coal into crushers below. *Author's collection.*

blasted at the rotor blades with such force that it functioned like a cyclonic wind, making the turbine spin at a high rate. The turbine powered an electric generator, which was a large cylindrical electromagnet that rotated inside an enclosure of copper bars.

The steam exhaust from the high-pressure half of the generating unit was sent back to the boiler's "reheat" section, and its temperature was increased to 1,000 degrees. Next, it was carried to the low-pressure half of the turbine, passed through more turbine blades, propelled another generator and produced additional power. Steam exiting the low-pressure turbine had a pressure of only half a pound per square inch. It was then sent through a condenser, where cool river water, circulating at thousands of gallons per minute, turned the steam back into water. This water was returned to the boiler and reheated to produce more steam for another cycle through the drum, turbine and condenser.

Generators for Units 1–4 of the Twin Branch Power Plant produced electricity at 11,000 volts, Unit 5 at 13,800 volts. Power from the generators was then sent through a large switchyard of transformers that "stepped up" the voltage to 132,000, which was required for transmission over long

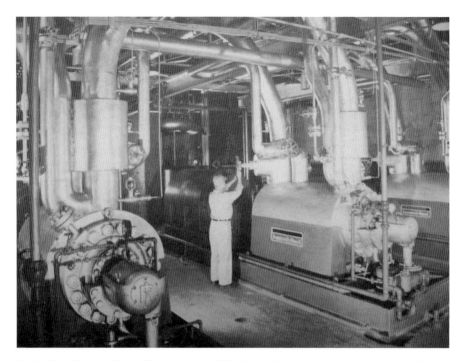

In the Twin Branch Power Plant, preheated feed water for producing steam was supplied to the boiler by these pumps, pictured circa 1950. *Author's collection.*

distances. Those lines and their towers emanated from the plant like tendrils, carrying electricity to load centers, where the voltage was "stepped down" at substations and distributed to I&M's residential, commercial, industrial and agricultural customers. Two small auxiliary transformers reduced voltage to 2,300 volts for use in the plant's equipment.

In the mid-1960s, when the Twin Branch Power Plant was still near peak production, a workforce of 250 employees kept the plant operating twenty-four hours a day. They included engineers, chemists, generating unit operators, maintenance and office workers and security guards. A large machine shop was used to repair or rebuild equipment of all shapes and sizes, and a laboratory tested coal, oil and water to help maintain top efficiency. In the control room, operators monitored and adjusted the plant's generation and transmission of electricity, depending on demand. The facility even maintained its own weather bureau to track storms and anticipate potential problems.

Just as the Twin Branch Power Plant could not have operated without a steady diet of coal, it also needed millions of gallons of water each day to

convert steam exhaust into water in the condensers. Inside a screen house that was a short distance from the main plant, screens prevented fish or objects from entering the large tunnels that brought water to the condensers. Typically, five hundred cubic feet of water per second passed through the plant. At peak times, though, the consumption of water was so great that the plant was using nearly the entire volume of the river as it flowed past the site. Water lost during the generating process was replenished from a reserve supply stored in the two large tanks outside the plant. The water was softened and purified so that it would not leave deposits in the tubes and turbines of the generating units. Water exiting the plant was about ten degrees warmer than before it entered, enough to keep the St. Joseph River downstream largely ice-free during the winter.

As late as 1957, the Twin Branch Power Plant was still the area's primary producer of electricity, but at peak demand levels, it had to be supplemented by other power plants in the AGE system, which included Indiana, Ohio, Kentucky, West Virginia, North Carolina, Virginia and Tennessee.

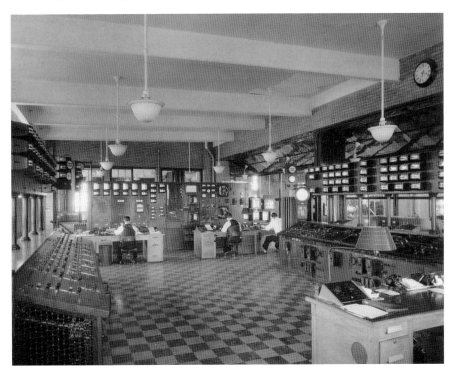

The complex operations of the Twin Branch Power Plant were monitored in the control room, seen here circa 1939. *Author's collection.*

In 1963, a *South Bend Tribune* article explained that Units 1 and 2 were so outdated that they were not being used. Daytime and nighttime demand varied enough that the plant shut down entirely at night, leaving the area's electricity needs to be met by American Electric Power's plants in southern Indiana and Ohio.

In the mid-1960s, I&M upgraded the long-distance transmission lines of its network. As part of this process, a 400,000-kilowatt transformer was installed at the Twin Branch Power Plant in April 1966. The transformer was then connected to the 345,000-volt power lines that were being installed southwest of the plant toward Wyatt, where they joined with other transmission lines of that voltage. The new lines were able to carry more electricity for longer distances at a lower cost per kilowatt hour.

By the early 1970s, the Twin Branch Power Plant was one of the three major plants contributing to I&M's total generating capability of 1.9 million kilowatts. Twin Branch's 375,000 kilowatts was surpassed by the 440,000-kilowatt Breed Plant near Sullivan, Indiana, and the 1.045-million-kilowatt Tanners Creek Plant on the Ohio River near Lawrenceburg, Indiana. I&M more than doubled its electricity production after Unit 1 of the Donald C. Cook Nuclear Plant in Bridgman, Michigan, opened in August 1975 and Unit 2 came online in July 1978.

Construction of the Cook Nuclear Plant was a reminder that the Twin Branch Power Plant was a dinosaur limping into its final years of service. Despite being more expensive and less efficient than newer coal-burning plants, Twin Branch stayed in operation because I&M faced steadily increasing demand for electricity. A milestone for the plant occurred on January 31, 1971, the last time all four of its smokestacks were using coal. That day, Units 1 and 2, which had returned to service, were shut down permanently. New air pollution laws were aimed at reducing both particulate matter—a cause of complaints by local residents—and sulfur dioxide emissions. These regulations prompted I&M to begin converting the Twin Branch Power Plant from coal to oil in mid-1973. Unit 3 was allowed to continue burning coal until April 1974, after which it would be used only on an emergency basis. Conversion of Units 4 and 5 to burning low-sulfur No. 2 fuel oil was completed by September 1973. A much-diminished 34,000-ton coal stockpile was maintained for Unit 3, and two 5-million-gallon oil tanks were installed northeast of the plant, connected by a six-inch pipeline to the Amoco Oil Co.'s tank farm in Granger. The Twin Branch Power Plant consumed 390,000 gallons of oil per day, more than 142 million gallons annually.

In retrospect, 1973 was the worst possible time to convert a coal-burning power plant to oil. That was the year in which the "energy crisis" became a topic of daily conversation and a cause of worry. Heavy demand for oil and a tight global supply were already raising prices, but the problem greatly worsened following the Yom Kippur War between Israel and Egypt and its ally Syria in October. The largest oil-producing Arab countries imposed a complete embargo on oil sales to the United States and other nations for supporting Israel in the war. By December, the Organization of Petroleum Exporting Countries (OPEC) had raised its crude oil prices 400 percent, from three dollars per barrel to twelve, and prices were even higher in the United States. Americans were introduced to steep increases in the cost of gasoline and heating oil, gas rationing and long lines at their local filling station. OPEC lifted the embargo in March 1974, but the "oil shock" had made it clear that access to an affordable, dependable supply of oil was a matter of national security. Higher oil prices had profound implications that reached all the way to the banks of the St. Joseph River in Twin Branch.

The combination of outdated equipment, strict antipollution regulations and the high cost of oil proved fatal to the Twin Branch Power Plant. According to I&M, the plant "was put into reserve in 1979," and an AEP history says Units 4 and 5 were "retired at the end of 1980." Demolition of the massive plant began in August 1983 when I&M contracted with a Florida company to remove the generating equipment, tanks, brick and steel structures and smokestacks. Not included in this arrangement were the hydroelectric units and related equipment, the transmission lines and transformers and the machine shop equipment. After various delays and accompanying lawsuits, the demolition work was ultimately carried out by Prompt Forwarding Systems of Mishawaka, a subcontractor for Dobie Corporation of Kentucky, and was largely complete by the fall of 1985.

I&M retained ownership of part of the Twin Branch site, but much of the land once used for the Twin Branch Power Plant's operations, including the sprawling rail and coal yards, became available for redevelopment.

This process had begun years before when two parcels of I&M land were repurposed for public use. In 1970, the utility and Mayor Margaret Prickett negotiated a deal that gave the City of Mishawaka fifteen acres at the far east end of the property in return for allowing I&M to put transmission towers and power lines through George Wilson Park. The parks department then developed the riverfront land into Marina Park (renamed Margaret Prickett Marina Park in 1980), which featured a boat launch. The practice of dedicating parts of the former steam-generating site to more environmentally

favorable uses continued in 1981 when I&M agreed to lease a 10.9-acre tract west of Marina Park to the Indiana Department of Natural Resources for forty years. The property became the Twin Branch State Fish Hatchery (renamed Richard C. Bodine State Fish Hatchery in 1991) and opened in 1983. The facility was designed to produce 225,000 seven-inch steelhead trout and 350,000 three-inch chinook salmon each year. The fish from Twin Branch were stocked in the St. Joseph River, migrated to Lake Michigan and then returned to spawn years later. Legislators voting to fund the project hoped it would make the St. Joseph River a magnet for fishermen, who would spend money in communities along the river.

After Marina Park and the Twin Branch State Fish Hatchery were completed, the adaptive reuse of the largest part of the former power plant site remained uncertain. While many neighbors hoped the property could have a residential use, consistent with the homes across the river in Twin Branch, that was not to be. In the late 1980s, Twin Branch Energy Park began to attract a mix of industrial and commercial firms that resulted in a much-changed landscape for drivers on Jefferson Road. Today, this industrial park is fully developed with approximately twenty buildings of various sizes along Twin Branch Drive, Magnetic Drive and Ferrettie Court. Steel Technologies has the most substantial presence, its three large structures anchoring the east end of the site.

Though dwarfed in size and electricity production by their steam-generating younger sibling to the north, the Twin Branch Hydroelectric Plant and Twin Branch Dam continued to operate reliably seventy years after they were constructed. The plant was run by remote control from across the river, and typically only one or two of its turbine generators were being used. All six were kept at the ready, and they could have been used to restart the Twin Branch Power Plant had it shut down.

Even after the steam-generating plant was demolished, the hydroelectric facility functioned in the manner for which it had been built, providing essentially free and environmentally friendly electricity for I&M customers. In 1989, the old plant underwent its first significant upgrade since the 1920s. Two new turbine generators were installed, replacing one original unit that had ceased functioning in 1980 due to a shaft failure and another that had been partly broken since 1979 and reduced to only 60 percent of its potential output. Remarkably, some of the generating units had been in continuous service since the presidency of Theodore Roosevelt.

Decades after the Twin Branch Power Plant closed, I&M is still producing electricity in the east end of Mishawaka.

As it has for more than a century, the Twin Branch Hydroelectric Plant continues feeding power into the grid through transmission lines that remain a prominent feature of the landscape along Capital Avenue. The Twin Branch Dam is one of six such facilities the utility operates on the St. Joseph River and is now among the oldest hydroelectric plants in the United States. I&M says eight turbine generators currently operate in the Twin Branch Hydroelectric Plant. None of the originals is in use, but two of them do remain in the powerhouse. That castle-like edifice remains a landmark of the Twin Branch neighborhood.

In August 2016, I&M began writing a new chapter in its legacy of power production in Mishawaka when it partnered with First Solar to open the Twin Branch Solar Power Plant, located on a nineteen-acre site in Bender Industrial Park, north of the AM General factory. In a remarkable historical coincidence, the entrance to the solar plant is less than one hundred feet from the former junction of the Elkhart & Western Railroad and the Twin Branch Railroad. Where untold millions of tons of dirty coal once passed now glisten the photovoltaic panels that make clean energy from the sun's rays.

The story of I&M's various Twin Branch plants suggests history's verdict on the technology, economics and environmental impact of electricity production. The complicated, resource-intensive, costly and environmentally unfriendly process of using coal to make power lasted for just 55 years at the Twin Branch site. The less ecologically impactful and much simpler and cheaper hydroelectric generation has been going on for 120 years, and prudent maintenance may keep the Twin Branch Hydroelectric Plant functioning into the twenty-second century. The future of the Twin Branch Solar Plant appears promising but is more difficult to discern. Cost and technology will determine whether I&M's pilot solar project proves viable on a larger scale. The St. Joseph River and the sun are inexhaustible sources of power, yet the skeptic will note that neither the dam nor the solar plant will ever come close to generating the amount of electricity that the coal-fired plant was able to.

Forty-five years after producing its last volt, the Twin Branch Power Plant is now just a memory. Newcomers to the Mishawaka area or others who are too young to have seen the plant's imposing outline and smokestacks might even have trouble believing that such a building once existed. Photographs of the massive structure and its accompanying coal yard, railroad and oil tanks would be needed to prove that the Twin Branch Power Plant was indeed real. While transformers, transmission lines and a few historic

outbuildings—including the screen house and the former coal-handling substation—remain on the I&M property, all evidence of the steam plant has been completely removed, and a couple acres of trees and undergrowth cover the exact site where it once stood.

No sign or monument in Mishawaka testifies to the existence of the Twin Branch Power Plant. Power Drive, on the south bank of the river between Lincolnway and the hydroelectric plant, is appropriately named, though, and suggests both the glory days of the steam plant and the present-day production of electricity from the dam. The most lasting and public memorial to the Twin Branch Power Plant is found in Columbus, Ohio. In front of American Electric Power's corporate headquarters stands a unique work of public art. One of two large pieces of industrial equipment on display is the turbine from Twin Branch Unit 4. An explanatory marker states the following, an epitaph of sorts:

> *This low-pressure turbine rotor came from the 85,000-kilowatt Unit 4 at the AEP System's historic Twin Branch Power Plant, Mishawaka, Indiana. It was the first of five identical generating units installed at AEP System power plants in three states during World War II and thus introduced the multiple-unit common-design concept to the System. This allowed for major economies in the engineering, design, construction, operation and maintenance of such facilities.*

The Twin Branch Railroad met a fate like that of the power plant it fed for so long. According to the U.S. Railroad Retirement Board, the Twin Branch Railroad ceased operations on June 1, 1978, and laid off the last of its employees on June 16, 1978. All the railroad's trackage is long gone, and no evidence of the railroad remains on the former I&M property where the coal yard, rotary dumper and yard track once were. The segment of the Elkhart & Western near the junction with the Twin Branch Railroad, once abandoned and heavily overgrown with weeds and even small trees, has recently returned to limited use. A switch and part of a siding indicate where the railroads once connected.

What about the engines that pulled countless coal cars in and out of the power plant's property? The 1930s battery-electric locomotives were replaced in the 1950s with two sixty-five-ton General Electric diesel engines. The electrics were stored for a while before they were retired. After the Twin Branch Railroad shut down, one of the diesels was used at AEP's Tanners Creek Power Plant and is now on display at the Railway Museum of Greater

Cincinnati in Covington, Kentucky. Twin Branch Railroad locomotive no. 4, a battery-electric, had been at the Indiana Transportation Museum in Noblesville. After that museum's collection was dissolved, the locomotive was rescued from the scrap heap by railroad preservationists. In October 2018, it was transported by flatbed truck to its new home at Ironhorse Railroad Park in Chisago City, Minnesota, thirty-five miles northeast of Minneapolis.

The Twin Branch Power Plant was an exquisite mechanism designed solely to make enormous amounts of power. The historical record offers details about how it transformed coal into electricity, but what was that power then used for? Most importantly, Twin Branch electricity—both from the hydroelectric plant and later, even more so, from the steam plant—enabled the rise of local industry and the growth of the area's population. Ball-Band, Dodge Manufacturing, Wheelabrator, Bendix and other area factories' machinery was connected to the turbines and transformers at Twin Branch. Everything else—including hospitals, schools, homes and streetlights—ran on this electricity, too. The first light that newborns saw at St. Joseph Hospital, the lights that illuminated football games at Tupper Field and the current that brought the first radio broadcasts in the 1920s and flickered televisions to life in the '50s—most of it came from the coal, heat and steam of the Twin Branch Power Plant and the turbine generators across the river.

The steam plant's demise parallels that of Mishawaka's large historic industries, which, one by one, closed their doors before the end of the twentieth century. Just as Mishawaka now must get its electricity from distant sources, the city has also had to diversify its employment base with smaller manufacturers and reinvent itself as the region's retail center and health care provider. Mishawaka will never again have factories like Ball-Band and Dodge, nor will it see another massive coal-burning power plant along the St. Joseph River. The Twin Branch steam plant now belongs to the past and to memory but also to the imagination, where it can power future dreams of great buildings and institutions that will call Mishawaka their home.

Chapter 3

FROM THE RUBBER RE TO CENTRAL PARK

The destruction of a historic flagpole at the Scout Res in 2018 brought back memories of a notable former Mishawaka industry. The flagpole originally stood in front of Rubber Regenerating Company, which was located at "the head of Division Street," according to city directories, where Central Park is today.

The "Rubber Re" plant, built in 1908–9, had its origins in the increased demand for rubber in the early twentieth century. Rubber had long been used for footwear, but the automobile's rising popularity required so much rubber that natural supplies were insufficient. The industry turned to used and scrap rubber as a supplement to help meet demand. Rubber "regenerating" means reclaiming or recycling used rubber.

"Fortunately, rubber, by its very nature, can be used over and over again," according to "A Short History of Rubber Reclaim" by Tom Bartlett. "The problem was to provide a means of breaking up these old out-worn rubber products, replasticising the subsequent rubber mass and producing, finally, a rubber from which products could once more be made."

Raymond Beach Price was the industrial pioneer behind the Rubber Regenerating Company. Price was born in Newark, New Jersey, and graduated from the Massachusetts Institute of Technology in 1894. He was hired by Boston Woven Hose and Rubber Company, where he "founded the first general laboratory in the American rubber industry. It was here that he devised the famous alkali process of reclaiming, which led to great advances in both volume and quality of reclaimed rubber," Bartlett writes.

In 1904, Price patented a reclamation process using high concentrations of acid, which had a boiling point significantly greater than the melting point of sulfur. In *History of the United States Rubber Company*, Glenn D. Babcock explains that the acid process was effective for low-sulfur scrap rubber from shoes and boots, but with high-sulfur automobile tires and other items, "the acid process became impracticable since it merely removed the fabric fiber and did not remove the excess sulfur. In the alkali process the scrap rubber was desulfurized, defiberized, and devulcanized in one step."

Price founded Rubber Regenerating Company of Illinois in 1906, moved his operation to Mishawaka in 1908 and incorporated Rubber Regenerating Company that December.

The October 2, 1908 *Mishawaka Enterprise* reported that work had begun on Mishawaka's newest factory: "Without any ostentation or flourish of trumpets, the Mishawaka Rubber Regenerating Company…have begun vigorously the erection of their contemplated big plant." The article explained that the site was being cleared and excavated in preparation for laying the steel-reinforced concrete foundations of brick buildings that would be three hundred feet long, one hundred feet wide and three stories high. Several hundred workers would be used to construct the enormous factory. The *Enterprise* also explained that the new venture was "capitalized at $900,000 and is backed by experienced and wealthy stockholders from other cities in combination with some of Mishawaka's most prominent manufacturers and citizens."

The 1925 Sanborn fire insurance map of the site indicates that the plant's actual size was far larger than what the *Enterprise* stated: 700 feet long and 275 feet wide. The buildings sat astride the old north millrace, sprawling diagonally across the flat area between the river and the bluffs below Ell Street on the east and O'Connor, Division and Christyann Streets on the west. A road on the west side of the factory provided access to Mishawaka Avenue, and a siding from the Elkhart & Western Railroad entered from the east.

Given its proximity to Mishawaka Woolen Manufacturing Company, known also as Ball-Band, just across the river and a couple hundred yards downstream, this was an inspired location. Mishawaka Woolen, which had been placing its knit boots inside rubber boots purchased from Goodyear, created its own rubber footwear factory in 1897. After World War I, the business's name expanded to Mishawaka Rubber & Woolen Manufacturing Company to reflect its emphasis on work shoes, boots, light rubbers and canvas sports shoes. One can imagine the enormous amounts of scrap

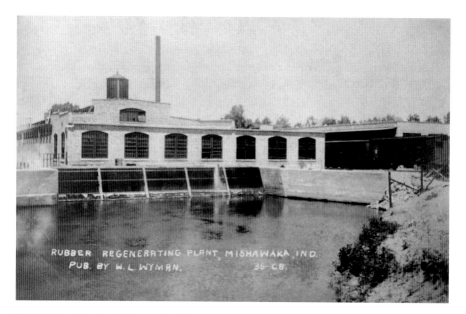

The Rubber Re plant is shown in this postcard image, circa 1910. *Mishawaka-Penn-Harris Public Library.*

rubber available at Ball-Band and the plant's demand for readily available reconditioned rubber. A symbiosis naturally developed between Mishawaka Woolen and its new neighbor. Rubber Regenerating Company was the largest rubber reclamation plant in the world, producing fifty tons of rubber per day.

Once he got the Rubber Re up and running in Mishawaka, R.B. Price turned his eyes overseas. To safeguard his patent in Great Britain, Price founded the Rubber Regenerating Company in Manchester, England, in 1909.

When the Third International Rubber and Allied Trades Exhibition was held in New York City in the fall of 1912, Price's company summarized the extent of its operations and capabilities in the show's *Official Handbook and Catalog*. It listed two factories in Mishawaka (North Race Street and West Water Street) and the plant in Manchester. The entry for Rubber Regenerating Co. also stated the following:

> *Only reclaimers in the world equipped to manufacture reclaimed rubber by Alkali, Acid, Mechanical, and other processes. Our plants are operated by water, electric and steam power, the total of which is 5,000 H.P. We employ 1,000 hands; have a laboratory force of thirty chemists, which is always ready to be of service to our customers, as well as constantly checking*

INDUSTRIES

Rubber Regenerating Company workers prepare tires for recycling, circa 1910–20. *Mishawaka-Penn-Harris Public Library.*

stock for uniformity. Our varied lines of crude material and finished articles made thereupon are worth investigating at Exhibit No. 101.

Shortly after the exhibition closed, Rubber Regenerating Company and its sister factory in Manchester were acquired by United States Rubber Company. U.S. Rubber was created in 1892, part of the wave of consolidation that swept over numerous industries, such as steel, oil and railroads, in that era. Initially functioning more as a holding company, U.S. Rubber retained the names of the businesses in its portfolio and left them largely under local control. To an outside observer, it would have seemed that the factories were autonomous, but they ultimately answered to a distant authority in New York City. U.S. Rubber had gained control of Mishawaka Woolen Manufacturing Company in 1905.

On December 17, 1912, U.S. Rubber announced that it was issuing $6 million in common stock in exchange for Rubber Regenerating Company's capital stock. At the time, Rubber Regenerating Company was also earning $150,000 in royalties annually for its patented process used in manufacturing rubber boots and shoes. U.S. Rubber coveted the anticipated income of perhaps $500,000 a year if it controlled those patents. By acquiring Rubber Regenerating Company, U.S. Rubber also gained the expertise of R.B. Price, who became head of the parent company's development department. According to Babcock, Price had "general charge of laboratories, patents, engineering, and research." He oversaw U.S. Rubber's central research laboratory, "one of the first industrial research laboratories in this country."

To help U.S. Rubber borrow money in the form of bonds, the giant conglomerate had fourteen of its subsidiary corporations deed over their properties to the parent company in 1917. These businesses included Rubber Regenerating Company but not Mishawaka Woolen, which "continued to operate with a considerable degree of independence and in direct competition with the parent company," asserts Babcock. Mishawaka Rubber & Woolen eventually become a wholly owned subsidiary of U.S. Rubber, which took over its active management in 1932. The factory contracted its name to Mishawaka Rubber Company in 1958. U.S. Rubber rebranded as Uniroyal in 1967, and Uniroyal signage was added to the Mishawaka plant at that time. Mishawaka Rubber and the Uniroyal Footwear Division consolidated in 1971, and the Mishawaka facility was known as Uniroyal from then on.

By 1916, U.S. Rubber controlled forty-seven factories and had thirty-five thousand employees. Three years later, it proudly claimed to be "the largest rubber company in the world, largest in value of output, largest in

Industries

The vacant Rubber Re plant is shown before it was razed in 1935. *Mishawaka-Penn-Harris Public Library.*

control of sources of raw materials, largest in number of employees, largest in number of manufacturing plants, and largest in extent of its activities." Glenn Babcock notes that the "excessive cost incurred in operating many inefficient plants is obvious." When F.B. Davis Jr. became president of U.S. Rubber in 1929, he closed many of its factories and consolidated operations.

Rubber Regenerating Company became a casualty of Davis's plans to cut costs and improve efficiency. In 1930, it was consolidated with Naugatuck Chemical Company to form the Chemical and Reclaim Department of U.S. Rubber. The Mishawaka plant closed that year, and its operations moved to Naugatuck, Connecticut.

The former Rubber Re plant was razed in 1935, yet the thirteen-and-a-half-acre site was not entirely cleared. Buildings had been demolished above ground level, but foundations, floors and assorted materials remained. Over the next two years, citizens began using the site as a dump. "Numerous fires plus other objections that a dump always brings caused quite a nuisance to the property owners and the City Administration," wrote city engineer Walter Wiekamp in 1937. "Efforts to minimize the nuisance were to no avail."

After months of negotiating with the City of Mishawaka, U.S. Rubber agreed to sell the property for $30,000 in February 1937. Mishawaka paid $5,000 at the time of sale and $5,000 annually, plus 3 percent interest on the outstanding balance, for five years. The Mishawaka Water and Electric Department carried out the transaction because its budget and bonding powers more easily facilitated such a purchase.

Nearly a year earlier, city officials had begun plans to redevelop the site and had applied for a grant from the federal Works Progress Administration to assist with the project. The WPA typically did not approve funds if the sponsor of an application was not also the owner of the location where the work would be done. In this case, though, the WPA made an exception because it was familiar with the Rubber Re site and the city's plans to acquire it.

Although the City of Mishawaka wanted to clear the blighted factory site and eliminate its safety problems, the land's future use was still undecided in February 1937. Three possibilities were a municipally owned plant to generate electricity for streetlights, a sewage plant and a city park. Although Mayor Edward Went felt Mishawaka was "overparked," the site could be immediately developed as a park and then later used for one of the other projects, as needed. In whatever way the property would be repurposed, it first needed to be cleared, graded and landscaped. That is where the WPA entered the picture.

Mishawaka had an outstanding relationship with the Works Progress Administration, which helped build streets, parks and recreation facilities and utilities infrastructure throughout the city in the 1930s. The WPA's handiwork can still be seen today in such landmarks as the Battell Park rock garden, Eberhart-Petro Golf Course, Steele Stadium and an addition to the Carnegie library on Hill Street. Primarily a work relief program, the WPA used federal funds to cover labor costs, providing temporary part-time jobs that pumped money into the economy and improved the hopes, self-esteem and job skills of the unemployed. Local governments who partnered with the WPA covered the cost of materials, such as brick, stone and concrete.

Mayor Went noted that the city had a shortage of projects for the WPA to work on at the time, a situation that also hastened efforts to buy the Rubber Re site. A $51,000 labor grant from the WPA allowed work to begin on February 4, just three days after the common council had approved the purchase. Initially, 125 men worked on the project, and that number had increased to 200 by February 19. Debris removal, filling, grading and landscaping

continued into the summer. To remove reinforced concrete foundations, WPA workers drilled holes with a compressor and then detonated dynamite. After blasting, the concrete rubble was placed along the riverbank.

Although the land had three possible uses when it was purchased, city leaders soon decided a park was the best option after the municipal utilities determined that a power plant would be too costly to build. Newspaper articles from June 1937 refer to the land being used for a park, and an August 1937 letter from Theodore Garns, the parks superintendent, to the state WPA office in Indianapolis identified the project as "Park and Playground Improvement."

The work that began in February and continued into the summer was not enough to complete the project, and city officials needed to apply to the WPA for additional financial support.

A letter from Wiekamp to John Curry, director of the WPA's Division of Operations, dated September 2, 1937, summarized work that had been done over the previous months. The millrace had been partly filled in, a wooden picket fence installed along the east and west sides and part of the north side of the property, a 100-by-150-foot area along Mishawaka Avenue filled in with four feet of dirt and the slope south of Mishawaka Avenue graded and sodded. Also, remnants of the old factory were removed, as Wiekamp described:

> *The foundations…have been dynamited out, the reinforcement salvaged and the concrete material removed for rip-rap along the river bank. About 4,000 cu. yds. of an original 10,000 cu. yds. have been removed. These foundations include heavy duty mill type bases, basement walls, processing tanks, hydro-electric turbine pits, mill line trenches, power unit bases, and mill race retaining walls constructed of heavy reinforced concrete varying in thickness from eighteen inches to eighty-four inches with reinforcement as heavy as two inches and three inch T rails imbedded [sic] in the concrete.*
>
> *The western half of the property has been cut to grade and slag, oxidized iron, rubber waste, and public dump debris removed and the area brought to seeding grade.*

The city engineer's letter went on to note that the race had been filled halfway with seven feet of dirt. After the remaining fill was brought in for the race, it would add five acres of usable land to the park. Chunks of concrete had been riprapped along the riverbank to prevent erosion, an issue of particular concern because of swift currents below the nearby dam. Still to be

done, according to Wiekamp, was removing the rest of the foundations and bringing in seventy thousand cubic yards of fill dirt, enough for an average depth of twelve feet. One thousand feet of fencing also needed to be installed.

A proposal submitted to the WPA on August 14, 1937, identified a cost of $70,175 for the park project, including $55,440 in federal labor and $14,735 in materials, most of which was provided by the city.

Actual costs kept exceeding estimates as the project went into 1938. Mishawaka submitted a proposal supplement on February 12, identifying $34,201 in additional expenses. This figure included $28,150 in WPA labor and $6,051 in materials. Part of the revised work program included replacing "an ordinary wire fence" with "a combination fence and stone retaining wall." W.H. Jordan, the WPA district director, noted that there was not enough salvaged concrete to complete the wall and that the city would need to purchase fieldstone or concrete at additional cost.

The application and funding process extended into the spring and summer. On May 26, Mayor Went announced that the city was filing a supplementary WPA labor grant. The *South Bend Tribune* noted, "The program is being carried on at present under a $60,918 federal labor grant that supplemented an original allotment by WPA of $102,822." The mayor explained that the second grant would allow work to continue for a while but was not enough to complete grading, landscaping and construction of park facilities. An August 11, 1938 *Tribune* article reported that President Franklin D. Roosevelt had recently approved a $26,505 labor grant for the park and that the city would provide an additional $4,040 worth of materials. The paper noted that this latest allocation brought to almost $190,000 the WPA's total contribution to the project.

By the fall of 1939, Central Park was largely complete. Its amenities included a softball diamond, a baseball diamond, tennis courts, a wading pool, a shuffleboard court and a shelter. Most impressive, though, was the WPA-built skating rink, which Mayor Carl Castleman opened in February 1940. The 100-by-250-foot concrete basin was filled with three inches of water in the winter so that ice would form whenever temperatures permitted. In the summer, the rink could be used for roller skating. A concrete seat ran the entire length of the rink's north side. "City officials believe it to be one of the few of its kind and one of the best in the state," the *Tribune* wrote of Central Park's rink. Though by then it was already operating as a park, Central Park officially opened in 1942 after the five-year purchase process was complete.

In the decades that followed, Central Park was an ongoing challenge to city officials. For example, in the late 1960s, it was used as a dump by local residents, and parents did not feel their children were safe there without adult supervision. The park's low elevation kept it out of sight from Mishawaka Avenue, and the area teemed with bugs and mosquitoes, which also discouraged people from using the park. Consideration was given to finding another use for the land. Parks superintendent Robert Dene supported selling Central Park and using the proceeds to purchase more land, but the money from a sale would have gone to the municipal utilities, which held title to the property. An October 1967 *Tribune* article included this jaw-dropping sentence: "About a year ago, there was discussion of the possibility of the city establishing a nuclear reactor in the park site for the purpose of producing electricity which is now purchased from the Indiana and Michigan Electric Co." In 1973, some city council members proposed moving the police department out of city hall and building a new police station in Central Park, a suggestion that brought strong opposition from members of the Wander Conservation Club. The municipal utilities stayed out of the nuclear power business, and the police relocated into the former

In 1977, Central Park was cleared of WPA structures as part of a major renovation. *Mishawaka Historical Museum.*

U.S. Post Office building on South Church Street. In 1976, the city finally decided to keep Central Park and improve it. Older structures from the WPA days were removed and replaced in 1977 with a new shelter house, three lighted tennis courts, basketball and volleyball courts, expanded parking and outfield fencing and bleacher repairs for the softball diamond. By the mid-1980s, though, the park had become a magnet for after-dark illegal and immoral activities, litter and vandalism. The city considered an arrangement with the Indiana Department of Natural Resources to use the land for a campground.

To their credit, Mishawaka leaders never gave up on Central Park. A two-and-a-half-acre parcel east of the Main Street Bridge was added to the park in 1989, a fish ladder was installed in 1991 to aid the migration of salmon and steelhead trout around the dam and in 1992, a statue of Christopher Columbus was placed near the park's Mishawaka Avenue entrance. In 2001, a new footbridge connected Central Park with the island, race and police station to the south, part of the Mishawaka Riverwalk system that developed over the following years. Center for Hospice Care and Hospice Foundation constructed an attractive office building on the east end of

Central Park, once the Rubber Re factory site, in 2018. *Author's collection.*

Central Park in 2013 and an adjacent inpatient facility in 2019. The most dramatic transformation of the park occurred in 2014 and 2015 when it was entirely rebuilt, including five pavilions, restrooms, a spray pad, climbing equipment and an attractive stone entrance arch that evokes the park's WPA heritage. The park that had once frightened away law-abiding citizens has now become one of the most popular destinations in town. On a warm summer evening, hundreds of people keep the park bustling with all sorts of beneficial activity.

Few Mishawakans alive today have memories of the Rubber Regenerating factory, which survives only in photographs, some rubble along the riverbank and a piece of the flagpole on display at the Mishawaka Historical Museum. Picnickers in Central Park's pavilions, children running about on the spray pad or pickleball players on the nearby court give little thought to the park's history. Concrete walls along the riverbank and near North Pine Street are the last vestiges of the WPA days, and nothing suggests the park was once the site of a massive factory. Perhaps something does remain, though, from the old Rubber Re plant, at least in spirit. Land that was once associated with the reclamation and regeneration of rubber has itself been rebuilt and rejuvenated numerous times over the years—first by the WPA and then by the parks department and other city officials—to provide recreation and renewal to Mishawakans of all ages.

Chapter 4

"SHORTY"

Dodge Manufacturing's Advertising Icon

Upon the death of Wallace Dodge in 1894, his twenty-eight-year-old nephew, Melville Mix, became president of the Dodge Manufacturing Company, one of Mishawaka's most important industries.

Under Mix's leadership, Dodge Manufacturing became an international leader in the field of power transmission equipment. Mix developed a national distribution network for Dodge products, including branch warehouses and sales offices throughout the country. Dodge's Diamond D line was sold to industrial customers all over the United States and in Canada, Mexico, South America, Europe and even Australia. Company historian Temple Williams describes Mix as "one of the master salesmen of his day."

Melville's son, Kenyon, also participated in the family business. He was born in Mishawaka in 1888 and attended Notre Dame and Purdue. Kenyon began his career as advertising manager of National Veneer Products Company in Mishawaka and worked for advertising firms in Detroit and Chicago before returning to Mishawaka in 1916 to become Dodge Manufacturing's advertising manager.

"Kenyon never lacked for ideas," writes Ed Wallis, another Dodge historian. "Many were good but expensive."

One of Kenyon's ideas was to create an advertising symbol or figure for Dodge Manufacturing that would be instantly and widely identifiable. Wallis suggests Mix may have had in mind an icon such as the Victor Talking Machine Company's dog, which appears with his head cocked while

Industries

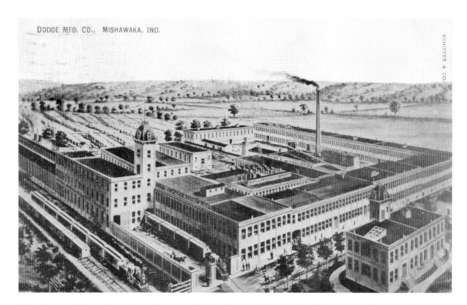

The Dodge Manufacturing plant on Union Street is shown in this postcard image, circa 1910. *Author's collection.*

listening to a gramophone, accompanied by the phrase "his master's voice." The image was based on Francis Barraud's 1898 painting of a terrier named Nipper, titled *His Master's Voice*. In 1900, a modified version of the scene became a registered trademark in the United States. The Victor Talking Machine Company, later acquired by Radio Corporation of America and known as RCA Victor, made the dog and gramophone one of the world's most famous advertising symbols.

To create Dodge's own unique image, Mix consulted with Chicago advertising men. No preexisting statue or classical figure was satisfactory. Eventually, though, Kenyon found his model—right here in Mishawaka.

Frederick William "Shorty" Botset was a millwright who worked in the Dodge plant on Union Street. Botset was born in Decorah, Iowa, on September 29, 1868, the son of Henry and Louisa Botset. The family moved to Plymouth, Indiana, sometime before 1879. Fred grew up in Marshall County and married Mary Lena Gorham in 1892. Fred and Mary had a son, Holbrook, who was born in 1900. By 1905, the Botsets were living at 400 Short Street in Mishawaka, and Shorty was working at Dodge Manufacturing. In the 1910 U.S. Census, Shorty was listed as a machinist at Dodge. The Botsets moved to 524 Sarah Street, according to the 1912 city directory, and then to 203 East Mishawaka Avenue by 1916. Shorty was a foreman at the Dodge factory in the 1920 census.

Out of hundreds of employees, how exactly Kenyon chose Shorty Botset to be his Dodge icon is lost to history. Nonetheless, Mix had his man. One day in 1920, he and Botset traveled to Chicago, where they met artist McClelland Barclay and sculptor George Mulligan.

"Shorty was introduced to the sculptor when Kenyon said rather casually that the sculptor didn't think that Dodge products should be part of the sculpture," Wallis explains. "Shorty, who was quite vocal and loyal to Dodge, cocked his head and made 'mincemeat' of the sculptor at the same time flashbulbs went off. This pose turned out to be the one used for the statue."

The *Shorty* sculpture depicts a man wearing a cap and work clothes, holding a Dodge Pressed Steel Hanger in his right arm and a pipe or other cylindrical casting in his left. Against his left leg leans a pulley wheel, or sheave. In addition to the sculpture, drawings of Botset were made for magazine ads.

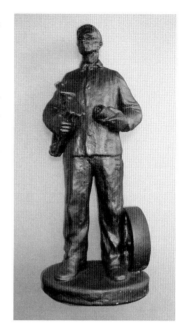

Dodge Manufacturing made thousands of *Shorty* statues, such as this one, for its advertising campaign. *Mishawaka Historical Museum.*

Different versions show him standing amid several Dodge products, holding a Dodge Pressed Steel Hanger and installing one of the hangers.

The first *Shorty* statues were twenty inches tall and sent to Dodge Manufacturing's branches and dealers. A fourteen-inch version was made for more widespread distribution, according to Wallis. A January 1921 article in the *South Bend News-Times* stated that students at the Art Institute of Chicago made plaster copies of the sculpture, which were given to Dodge customers, "leading manufacturing concerns in the United States." It could be placed in dealers' windows or on their counters to show customers that the business sold Dodge products. Interestingly, though, neither Dodge's name nor any logo is on the sculpture.

The drawings of Shorty appeared as advertisements in the *Saturday Evening Post*, the *Literary Digest* and various trade journals in 1921 and 1922. A two-page spread in the March 12, 1921 *Saturday Evening Post*, for example, included the headline "Know your Dodge dealer; be sure he knows you," several paragraphs about Dodge Manufacturing distributors, drawings of

INDUSTRIES

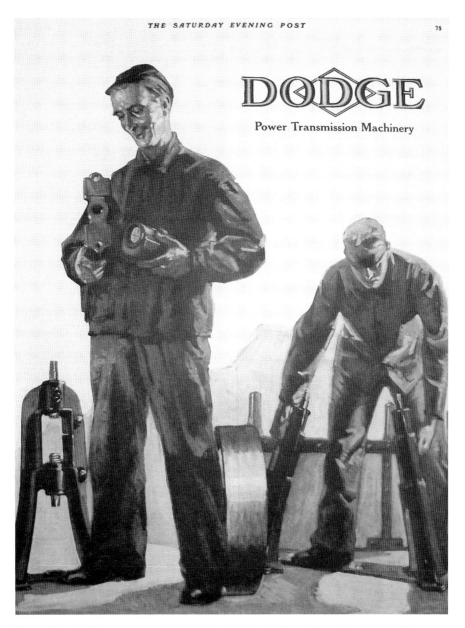

Shorty Botset's likeness appeared in this *Saturday Evening Post* ad from March 12, 1921. *Mishawaka Historical Museum.*

the company's products on one page and a large image of Shorty in a pose like that of the sculpture on the facing page. A search of *Post* issues from 1921 and 1922 found several Dodge ads featuring Botset, the last of which appears on May 13, 1922. Wallis notes that the *Saturday Evening Post* and the *Literary Digest* had a combined circulation of three and a half million readers and the trade publications had 170,000 readers.

According to the *News-Times*, "*Printer's Ink* and the greatest advertising and art organizations of the country have pronounced it [the *Shorty* sculpture] the dominant industrial figure of the year."

Dodge had eight thousand copies of the *Shorty* sculpture distributed. Ed Wallis, though, states, "Dodge overestimated the market," producing more copies than needed. "In due course, several thousand neatly boxed *Shorty*s were removed from the warehouse and destroyed to make room for other things."

Melville Mix retired from Dodge Manufacturing for health reasons in July 1922, and Kenyon became a director of the radio division of Dodge's Lyradion Sales & Engineering Company. According to the city directory, he was vice president of Lyradion in 1923. By 1925, Kenyon was working for Sleeper Radio Corporation, and he was its western sales manager when he died from heart trouble in 1927. Just twelve days after his son passed away, Melville died from a heart attack following an operation. Kenyon Mix is buried in Highland Cemetery in South Bend, and his parents are interred in the Fifer Community Mausoleum at Mishawaka's Fairview Cemetery.

With the change in company leadership, Dodge Manufacturing also took a new approach to marketing. "Dodge reluctantly started advertising more to people not particularly interested in symbols but who wanted to buy Dodge products," Wallis writes.

What happened to the real-life Shorty? Fred and Mary moved to 522 Sarah Street in 1921. After posing for Dodge Manufacturing's attempt at a world-famous advertising icon, Shorty continued to work as a machinist in the plant until early 1925. That April, the Botsets moved to Pittsburgh, where their son lived, and Fred died there on June 8, 1926. He and Mary, who passed away in 1962, are buried in Plymouth's Oak Hill Cemetery.

Dodge Manufacturing did not succeed at creating a universally recognized corporate icon that would endure for decades, but another Mishawaka industry did. American Foundry Equipment Company (later Wheelabrator) relocated to Mishawaka in 1926 and was Dodge's neighbor to the east, occupying the former Simplex Motor Car Company plant on South Byrkit Street. Company president Verne Minich was an admirer of Frederick Hibbard's sculpture *The American Molder*, which

depicts a bare-chested foundry worker pouring hot metal into a mold. The original sculpture was created in Hibbard's Chicago studio around the time of World War I and then cast in bronze. In 1947, *American Parade*, Wheelabrator's company magazine, stated the sculpture was "considered by many critics to be one of the most beautiful and perfect specimens of the industrial worker now in existence."

In 1927, Minich got permission to use a painting of *Molder* for a company calendar. After its distribution, the response was so positive that Hutton Haley, AFEC's sales manager, suggested the image would be an ideal trademark, and arrangements were soon made to use *Molder* to represent the company. American Foundry Equipment saw the sculpture as "emblematic of the foundry industry, one of our largest markets." AFEC and then Wheelabrator used the image in their advertising "so long that it has become one of the best known and respected trademarks in industry," according to the *American Parade* article. The company had a copy of Hibbard's sculpture in the lobby of its Mishawaka office, and thousands of prints of the painting were distributed and displayed in foundries, offices and workers' homes around the country. When Wheelabrator celebrated its fiftieth anniversary of moving to Mishawaka, the *Molder* image appeared on various souvenirs, including pewter mugs, trivets and even neckties. Wheelabrator ceased operations at its Mishawaka factory in 1987.

The *Molder* sculpture predates Dodge Manufacturing's efforts to popularize and distribute *Shorty*, which occurred several years before American Foundry Equipment arrived in Mishawaka. It is possible, though, that Minich and Haley learned about *Shorty* from their counterparts at Dodge and were inspired to find their own popular trademark using the sculpture and image of a worker who represented their industry. Minich also could have been a Dodge Manufacturing customer in the early 1920s and received one of the *Shorty* sculptures.

Long after *Shorty* was discontinued as an advertising image, Dodge Manufacturing remained one of Mishawaka's prominent industries. The company created a steel conveyor pulley in the 1930s and manufactured key parts of ship propulsion systems during World War II. The postwar decades saw continued development of conveyor belt technology, the Torque-Arm Speed Reducer and the Taper-Lock bushing. Dodge was acquired by Reliance Electric in 1967, and the Mishawaka factory was downsized in the early 1980s. Even as late as the mid-1990s, it still included a foundry and was the largest producer of conveyor systems in the country. Soon after, though, the conveyor drives division was shut down, and the

foundry ceased production in 2006, leaving the Union Street plant vacant for the first time in 125 years.

In the Mishawaka Historical Museum's collection are a copy of *Shorty*, a *Saturday Evening Post* advertisement with Botset's image and many Wheelabrator items with the *Molder* icon. In addition to being artistically appealing, these artifacts evoke the efforts of Mishawaka's once-mighty industries to market their name and products to customers around the world.

Chapter 5

THE KAMM'S SPECIAL

Mishawaka's Entry in the 1938 Indianapolis 500

Every Memorial Day weekend, hundreds of Mishawakans attend the Indianapolis 500, their vehicles scattered throughout the capacious parking lots that surround the Indianapolis Motor Speedway. In the early years of the "Greatest Spectacle in Racing," cars from Mishawaka did more than just park at the Brickyard. They raced.

At the inaugural 500 Mile International Sweepstakes Race in 1911, the Simplex Motor Car Company, located on South Byrkit Avenue, entered two of its Amplex cars. The No. 44, driven by Arthur Greiner, crashed on the thirteenth lap, killing riding mechanic Sam Dickson, who became the Indianapolis 500's first race fatality. "Wild Bill" Turner's No. 12 fared much better, placing eighth and completing all two hundred laps in a time of 7:15:56, a 68.18 miles per hour average. Amplex never again entered the Indianapolis 500. Poor business decisions soon led the Mishawaka company into serious financial problems, and all its auto production stopped by 1915.

Accounts of Simplex Motor Car Company or histories of auto manufacturing in the Princess City often mention Amplex's tragic and glorious spin around the big oval in Indianapolis. All but forgotten, though, is the brief return of Mishawaka industry to the Indianapolis Motor Speedway twenty-seven years later. The city did not manufacture any of the cars entered in the 1938 Indianapolis 500. Instead, Kamm & Schellinger Brewery sponsored the Kamm's Special, which carried the pride and hopes of Mishawakans—and Kamm's beer drinkers everywhere—onto auto racing's biggest stage.

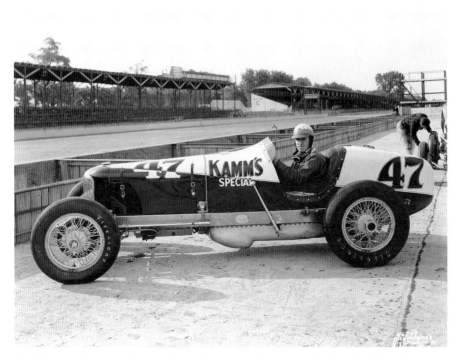

The Kamm's Special, driven by Shorty Cantlon, had the same black-and-white color scheme used at that time on the brewery's labels and delivery trucks. *Indianapolis Motor Speedway.*

Kamm & Schellinger's origins lie with John Wagner, a German immigrant who had operated a brewery and distillery in Mishawaka since 1839. After his business burned down in 1851, he relocated to North Center Street two years later. In 1870, Wagner sold his interest in the establishment to Clemens Dick and Adolph Kamm. A decade later, Dick sold his share of the business to Kamm, who began a partnership with Nicholas Schellinger, Kamm's brother-in-law and a fellow German immigrant. Kamm & Schellinger Brewery expanded and prospered, becoming one of Mishawaka's signature industries. Nicholas died in 1918, and Adolph passed in 1930. Adolph's three sons and daughter then ran the family business. Kamm & Schellinger survived the challenges of Prohibition by producing nonalcoholic beer, soda pop, distilled water and ice. After the Twenty-First Amendment was ratified in 1933, Kamm's was among the first breweries in Indiana to resume production. Happy days were here again.

Seeking to spread its products' names and build brand loyalty, Kamm & Schellinger had long invested in various forms of advertising. Usually, this

marketing included newspaper ads, signs of all shapes and sizes, sponsoring teams in local athletic leagues and even creating elaborate floats for the city's parades. Bringing the Kamm name to the Indianapolis 500 was the most audacious form of advertising the company had ever attempted. If the Kamm's Special could finish in the victor's circle at the world's greatest race, bottles and glasses of Kamm's beer would be raised in toasts across the United States, and sales would soar.

Although this was the first time Kamm & Schellinger had entered the Indy 500, the Kamm family had ties to the Simplex Motor Car Company and Mishawaka's involvement in the 1911 race. Adolph Kamm, the family patriarch, had been a large Simplex stockholder and later bought the company when it was going through financial reorganization a few years later. His son Rudolph was briefly the plant manager at Simplex, and another son, Clarence, also worked there. As leaders of Kamm & Schellinger, Adolph's children made the decision to return to the Brickyard in 1938.

To pilot the Kamm's Special, the brewery turned to veteran driver William A. "Shorty" Cantlon. The Illinois-born Cantlon started racing in 1920 at age sixteen, driving on dirt tracks around the country. Among the highlights of his career were setting a world speed record for a straightaway (144.89 miles per hour) on a dry lakebed in California in 1929 and winning

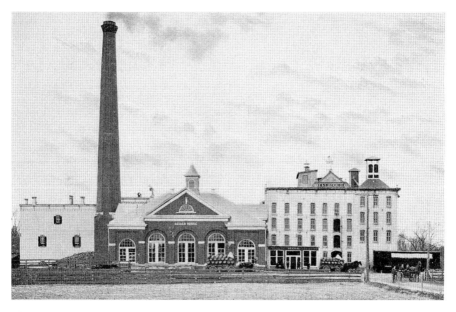

The Kamm & Schellinger Brewery, located on North Center Street, is shown circa 1900. *Author's collection.*

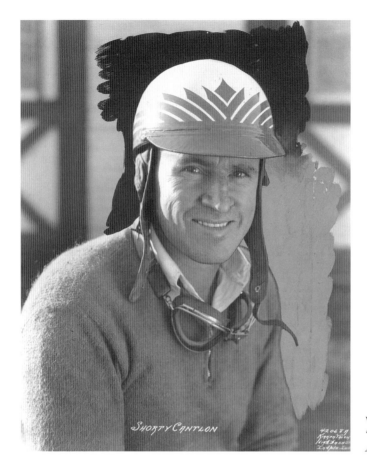

William A. "Shorty" Cantlon. *Author's collection.*

the last race held on a wooden track in the United States in 1931. Cantlon made his Indianapolis debut in 1930, starting on the outside of the first row and finishing in second place behind Billy Arnold. Cantlon also competed in the 1931, '33, '34, '35, '36 and '37 Indianapolis 500s. Mechanical problems forced him out of the race before the halfway point in 1931, '33 and '34. Cantlon completed the full 200 laps and placed sixth in 1935, ran out of gas on lap 194 the following year and was flagged off the racecourse after 182 laps in 1937.

During time trials in 1938, drivers had to complete ten laps of the two-and-a-half-mile oval, the last year that a twenty-five-mile qualification was used. In contrast, today's racers complete just four laps in their qualification runs. On May 26, Shorty Cantlon qualified the Kamm's Special with an average speed of 120.906 miles per hour. His ten lap speeds ranged from a low of 120.112 miles per hour to a high of 122.100. Cantlon's qualifying

mark would be the fourteenth fastest among the thirty-three-car field, earning him a starting spot in the middle of the seventh row.

Despite Cantlon having only two top-ten Indy 500 finishes to his credit, the May 26 *Mishawaka Enterprise* expressed optimism in the headlines of its article previewing Kamm's participation in the race: "Cantlon Among Race Favorites" and "Kamm's Special Given Good Chance at Indianapolis." The *Enterprise* described Cantlon as "one of the prime favorites of the fans" and "one of the small and select group conceded the best chance of winning" the Indianapolis 500. The May 27 *South Bend Tribune* ran a photo of the Kamm's Special with a caption that referred to Cantlon and his mount as "a favorite to win."

The local papers' positive view of Cantlon's prospects was not shared by the Associated Press or the *Indianapolis Star*. In its story published after qualification was completed on Saturday, May 28, the AP noted that the race field included four former winners: Wilbur Shaw (1937), Louis Meyer (1928, '33 and '36), "Wild Bill" Cummings (1934) and Kelly Petillo (1935). Other strong contenders were pole sitter Floyd Roberts and Ronny Householder, who had earned entry into the field with world-record qualification speeds of 125.681 and 125.769 miles per hour, respectively. In addition to these drivers, the *Star*'s preview article mentioned several other contenders, but Cantlon was not among them. The AP described the thirty-three racers as "the fastest field ever assembled." Echoing that assessment, the *Star* referred to "perhaps the greatest array of pilots ever assembled on one track" and waxed metaphorical, describing "33 knights of the roaring gasoline brigade charging on their way in quest of gold and glory" and a "galaxy of anxious heavy-footed heroes of the open throttle."

The Kamm's Special, bearing no. 47, was painted black and white, a color scheme that the brewery used on some of its products and advertising at the time. Indianapolis Motor Speedway records show that the car's Miller 4-cycle supercharged engine had 182.8 cubic inches of displacement. The vehicle weighed 1,965 pounds and was equipped with rear-wheel drive, a Delco starter, Firestone tires, Champion spark plugs, Lovejoy shock absorbers and a Winfield carburetor. The Kamm's Special used Gulf oil. According to the *Enterprise*, the car had "placed in the money" in both the 1936 and 1937 races.

The 1938 Indy 500 featured several important changes. Cars were still able to carry a riding mechanic, but none elected to, making 1938 the first single-seater-only race at Indianapolis since 1929. Rearview mirrors and automatic fuel pumps had obviated the need for onboard mechanics.

Engine size was lowered to the new European formula of 183.06 cubic inches (3 liters) for superchargers and 274.59 cubic inches (4.5 liters) for non-supercharged cars. According to the *Star*, 1938 marked a "rules liberalization," which encouraged diverse equipment to enter the field: 4-cylinder or 6-cylinder, supercharged or non-supercharged, front or rear engine and front- or rear-wheel drive. Racing teams were also allowed to use whatever variety and quantity of fuel they wanted. This meant that mechanics could employ a racing blend that was less than 10 percent gasoline and mostly some mixture of benzol and grain or wood alcohol. Alcohol was preferred for superchargers because it cooled the engine and allowed more fuel to enter the cylinders, thus creating more power. The desirable effectiveness of alcohol fuel was offset by its cost ($1.30 per gallon) and high consumption rate (3 miles per gallon). Powered by the new fuel and unburdened by a riding mechanic's weight, the cars were faster than ever in 1938, and it was expected that whoever won the 1938 race would do so in record time.

As race day, May 30, dawned, clouds hung ominously over the speedway, threatening thunderstorms. Just before the ten o'clock start, though, a glint of sun broke through, reassuring the drivers and crowd alike that the race would not be shortened or delayed by inclement weather.

The AP account written shortly after the start of the race and published in that afternoon's *Tribune* captured some of the pre-race drama:

> *With motors roaring defiantly, 33 racing cars, fastest ever built, were lined up three abreast 11 rows deep for the start of the famous race over the two and a half-mile brick course of the Indianapolis motor speedway. A bomb bursting high in the air was awaited as the starting signal at 10 o'clock. Music from dozens of bands faded in the roar of warming engines. The nerves of 150,000 spectators, here on their annual Memorial Day pilgrimage of thrills, tingled in expectation of dare-devil driving that might result in tragic death. The drivers, attired from head to foot in white-hooded overalls, were anxious to step on the gas.*

Newspaper reports the next day would revise the number of attendees to a record 167,000.

As for the Kamm's Special and Shorty Cantlon, their appearance in the 1938 Indy 500 would be unexpectedly brief. On lap twelve, Cantlon pulled into the pits to talk with his crew about problems with the supercharger. Two laps later, the No. 47 car became the first to drop out of the race when the

supercharger blew. Kamm's high hopes of Brickyard glory ended in a puff of smoke and a disappointing thirty-third-place finish.

The day was over for the Kamm's Special, but the race continued for the rest of the field. Tragedy struck on lap 46 when Emil Andres's No. 42, the Elgin Special, lost its right front wheel, spun, overturned three times and hit the inside guard rail in turn two. The wheel flew one hundred feet, killing thirty-three-year-old spectator Everett Spence, who was sitting on top of a truck in the infield. Andres suffered a concussion and chest injuries but survived. Pole sitter Floyd Roberts led 92 of the 200 laps and took the checkered flag with an average speed of 117.20 miles per hour, shattering Wilbur Shaw's 1937 record by 3.62 miles per hour. Shaw finished second, two laps behind. Roberts's strategy was to lay back and let other drivers "burn fuel and tires while he conserved his resources for the finishing punch," wrote Stuart Cameron of the United Press. As the winner, Roberts took home a $32,075 purse. For his last-place finish, Cantlon earned a $550 prize.

Kamm & Schellinger Brewery's brief taste of the Indianapolis 500 was enough, and the Kamm's Special never again raced there. The company that had survived Prohibition, the Great Depression and two World Wars eventually succumbed in 1951 to the brewing industry's economies of scale, done in by competitors' lower prices and larger advertising budgets. Kamm & Schellinger became one of Mishawaka's lost industries, a list that would grow in the following decades. Long after the brewery ceased production, its buildings still survive, though mostly vacant or underutilized, as part of the 100 Center complex.

Shorty Cantlon drove in three more Indy 500s. In 1939, a main bearing failure after fifteen laps resulted in his thirty-second-place finish. Cantlon returned in 1946 for the first race held after the four-year wartime hiatus and improved to twenty-eighth in the final standings as a malfunctioning clutch forced him out with twenty-eight laps completed. The following year, Cantlon was killed after he swerved to avoid another driver's spinning car in turn one. He hit, nearly head-on, the outer retaining wall at 100 miles per hour, bounced and hit the wall two more times. Cantlon's body was pulled from the wreckage, and according to the *Star*'s account, the crowd made a "heartfelt moan…when the public address system announced he was dead." The "plucky little underdog" and crowd favorite was praised for his "heroic effort" not to hit the other car. After funeral services in both Indianapolis and Detroit, Cantlon was buried in Mount Olivet Cemetery, Detroit. He was the eighth of fourteen drivers who have been killed because of crashes during the Indianapolis 500.

For each Indianapolis 500, race fans from Mishawaka make their annual pilgrimage to the Speedway—or just enjoy the spectacle from the comfort of their living room. Either way, they should pause for a moment to remember the Kamm's Special and Mishawaka's last lap at the Indianapolis 500.

ABOUT THE AUTHOR

P eter J. De Kever is a lifelong Mishawaka resident and the city's historian laureate. He is also curator of the Mishawaka Historical Museum and a columnist for the *Mishawaka Enterprise*. De Kever has written several books that teach about and celebrate Mishawaka's historical identity.

Visit us at
www.historypress.com